50
WATER
ADVENTURES
TO DO BEFORE YOU DIE

Published by Adlard Coles Nautical
an imprint of Bloomsbury Publishing Plc
50 Bedford Square, London WC1B 3DP
www.adlardcoles.com

Bloomsbury is a trademark of Bloomsbury Publishing Plc

First published by Adlard Coles Nautical in 2014

ISBN 978-1-4729-0113-2
ePDF 978-1-4729-0114-9
ePub 978-1-4729-0115-6

A CIP catalogue record for this book is available from the British Library.

This book is produced using paper that is made from wood grown in managed, sustainable forests. It is natural, renewable and recyclable. The logging and manufacturing processes conform to the environmental regulations of the country of origin.

Typeset in Glypha Light by Gridlock-design
Printed and bound in China by Toppan Leefung Printing

Note: while all reasonable care has been taken in the publication of this book, the publisher takes no responsibility for the use of the methods or products described in the book.

10 9 8 7 6 5 4 3 2 1

50
WATER
ADVENTURES
TO DO BEFORE YOU DIE

LIA DITTON

B L O O M S B U R Y
LONDON • NEW DELHI • NEW YORK • SYDNEY

Contents

Introduction 6

Europe

1 Bog snorkel in Wales 10
2 Fly fish for salmon in Scotland 14
3 Compete in the Glen Nevis River Raft Race in Scotland 18
4 Tour Ireland's west coast by RIB 22
5 Go coasteering in the Channel Islands 26
6 Stay at the ICEHOTEL in Sweden 30
7 Wild swim in France 34
8 Try deep-water soloing in Majorca 38
9 Learn to row like a Venetian in Italy 42
10 Go canyoning in Switzerland 46
11 Bathe in Iceland's Blue Lagoon 50
12 Sail on a tall ship in the Canary Islands 54
13 Row the Atlantic Ocean 58

Africa

14 Cruise to St Helena and Ascension Island on the
last working Royal Mail Ship 64
15 Windsurf the Lüderitz Speed Challenge in Namibia 68
16 Dive with sharks in the Western Cape 72
17 Sail the Nile on a traditional felucca 76
18 Night scuba dive in the Red Sea 80
19 Freedive the 'Blue Hole' in Egypt 84

Americas

20 Packraft in Alaska 90
21 Surf a river wave in Hawaii 94
22 Kayak-camp in British Columbia 98
23 Joyride a Hydro Bronc in California 102
24 Swim from Alcatraz to San Francisco 106
25 Try paddleboard yoga in a geothermal crater in Utah 110

26 Inner tube the Colorado rapids 114
27 Stand-up paddleboard the Mississippi 118
28 Master flyboarding in Miami 122
29 Kiteboard in the Dominican Republic 126
30 Fish for big game in Mexico 130
31 Transit the Panama Canal 134
32 Visit the deep sea in a recreational submarine in Costa Rica 138
33 White-water raft the Futaleufú River in Chile 142

Antarctica
34 Go on a cruise to Antarctica 148

Australasia
35 Swim with whale sharks in Australia 154
36 Experience the Panapompom Canoe Regatta 158
37 Heli-hike a glacier in New Zealand 162
38 Snorkel the Great Barrier Reef 166
39 Wreck dive the SS *President Coolidge* in Vanuatu 170
40 Riverboard in New Zealand 174
41 Swim with jellyfish in Micronesia 178

Asia
42 Island hop to Gili Meno 184
43 Bodyboard a tube in Indonesia 188
44 Sail a leg of the Clipper Race 192
45 Go iceboating in Siberia 196
46 Float in the Dead Sea 200
47 Dine in the Ithaa Undersea Restaurant in the Maldives 204
48 Waterski Indian-style in Kashmir 208
49 Cruise on a houseboat in Kerala 212
50 Relax at the Happy Magic Water Cube in Beijing 216

Acknowledgements 220
Index 222

Introduction

Liquid or solid, salty or fresh, water in its many forms offers endless possibilities for adventure. More than 95 per cent of the underwater world remains unexplored. The pleasures to be had on the water, in the water and under water are exciting and boundless.

As a licensed captain and a professional racing sailor, I am fortunate to have spent more than 10 years in and around the water. I've sailed the equivalent of four laps of the globe and am the 53rd woman ever to row the Atlantic. I've also been badly stung by a mauve stinger jellyfish and driven a leaky yacht through Hurricane Kyle, yet the sea, the oceans, the rivers and the lakes continue to fascinate me.

Expert advice, the right equipment and experienced guides, where appropriate, are key to staying safe and each adventure details the requirements for best practice. For each chapter, I interviewed an enthusiast – an athlete, a tour guide or keen participant passionate about the activity chosen. This enabled me to live the experience of the adventures I have not yet personally undertaken and for this I am indebted to my interviewees. Writing this book has already inspired me to get a packraft and visit Alaska, to learn to row like a Venetian in Italy and try iceboating in Siberia, to name but a few.

Choosing only 50 adventures was a challenge in itself. I aimed for a balance of well-known and lesser-known adventures across a broad range of water sports. Then I set about researching where the ultimate place to do each activity would be, if you could do it only once. Each adventure therefore relates to a specific geographical location – not just paddleboard yoga, but paddleboard yoga in a 10,000-year-old geothermal crater in Utah, USA. Not just windsurfing, but windsurfing the Lüderitz Speed Challenge in Namibia.

Furthermore, I was on the hunt for the best experiences. White-water rafting the Grand Canyon in Arizona may be a classic, but white-water rafting aficionados actually rate the rapids higher for their variety on the lesser-known Futaleufú River in Chile, where the scenery is alpine but equally breathtaking. Likewise, Mexico and the Philippines may be popular destinations for swimming with whale sharks, but only the Australian Federal Government enforces interaction guidelines. At Ningaloo Reef in Australia, eco-tourism at its finest offers you the opportunity not only to witness the whale sharks, but to do so while helping marine biologists collect important data about them.

Of course, with affordable flights servicing more exotic destinations every year, the world's watery places have never been more accessible. The adventures span the globe, listed by continent and by country, but it is also worth noting that many of the adventures can be found in all sorts of places around the world. There really is no excuse.

This book offers challenges both achievable and aspirational, carefully considered to accommodate every mood, budget and level of daring-do. Each adventure is categorised in four ways:

- Location
- Complexity
- Cost
- Lasting Sentiment

Adventures range in complexity from 'hardcore' (Row the Atlantic Ocean) to 'as easy as taking a mud bath' (Bog snorkel in Wales) and every variation in between. In fact, in among the incredible tests of endurance lies a healthy range of more practical activities for the general reader. If inner tubing the Colorado rapids isn't quite your thing, lunch for two in the Ithaa Undersea Restaurant in the Maldives just might be!

Cost is an important consideration. Cost and time tend to go hand in hand – the longer the adventure, the higher the cost – so I steered away from highly involved one-off expeditions. The longest adventures, such as packrafting in Alaska and sailing a leg of the Clipper Race, should take weeks rather than months. Each adventure has been given one to five coins to represent the financial commitment involved. This excludes flights unless otherwise stated, but does include all necessary equipment.

Finally, what you might 'take away' from each adventure has been summarised under the caption 'Lasting Sentiment'. From the descriptive 'a wicked wet assault course' (Canyoning in Switzerland), to the observational 'amazing how the body adapts' (Freedive the 'Blue Hole' in Egypt), these sentiments may be your first indicator of which adventure might 'best' suit you.

All the accompanying images have been sourced from individuals who heartily recommend the adventure to others, or from businesses associated with helping you get there. Be it kayak-camping in British Columbia, coasteering in the Channel Islands or a felucca cruise down the Nile, a watery experience awaits you!

So whatever floats your boat, make this book your bucket list. With 50 water adventures to do before you die, get sampling our planet's finest offerings: the weird and the wonderful in water adventures.

Lia Ditton
www.liaditton.com
@lia_adventurer

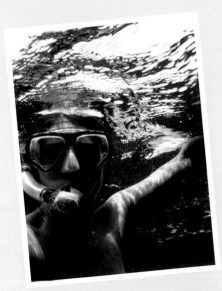

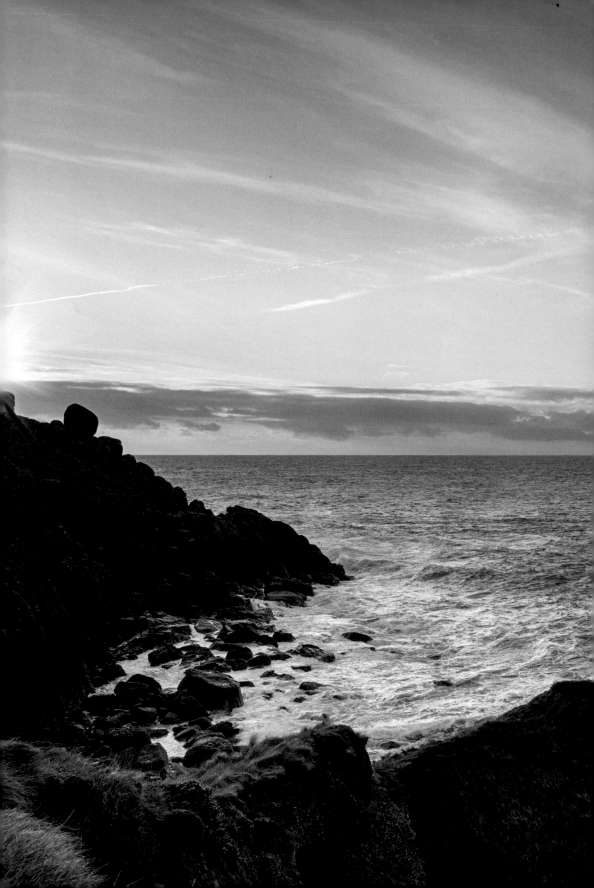

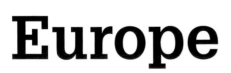

Europe

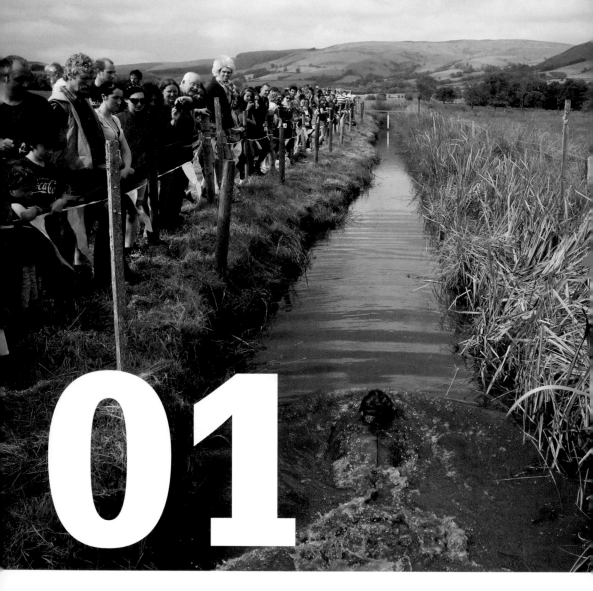

01

Bog snorkel in Wales

Location Waen Rhydd Bog, Wales

Complexity As easy as taking a (mud) bath

Cost ○○○○○

Lasting Sentiment 'I competed at the Bog Snorkelling World Championships!'

Enter a World Championship sporting event without any training whatsoever. Turn up in fancy dress. Participate hungover, sleep deprived or even between drinks. When it's your turn, launch yourself theatrically into the muddy water and snorkel the 60 yards down the bog as fast as you can. Snorkel the 60 yards back trying not to laugh while half under water, and aim for the middle of the channel. Emerge with an amusing story that you can tell for the rest of your life!

Drive down a forest track between rolling green pastures of farmland and find a space in the grassy car park. The area is designated an SSSI (Site of Special Scientific Interest) so look out for rare plant and aquatic species. A path of wooden boards will lead you to the two trenches cut into the peat bog, the famous 60-yard course.

At least one stag and one hen party is usually among the participants excitedly eying up the course, everyone cracking jokes. There may be a man dressed as a Teenage Ninja Turtle for absolutely no reason, or as Wonder Woman or in a lime-green mankini! Doing such a daft, crazy thing in this company is strangely unifying.

Your name is called. Your swimming cap is on. It's your turn to take the plunge… By now, several hundred supporters have lined the length of the course, most of them participants. Revel in the cheering as you stand shivering in your outfit, snorkel dangling down your face before you enter the water, spurred on by more whooping and hollering. The visibility is nil, so you probably won't get very far before you bump into the mud on the right bank. In fact, expect to zigzag from side to

Opposite © Christopher Foster / chrisfosterphotography.com **Below left** © Hannah George / green-events.co.uk
Below right © Christopher Foster / chrisfosterphotography.com

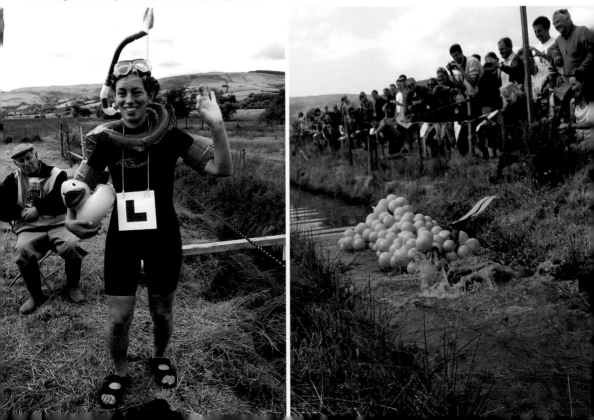

side. You may need to pop your head up to regain your bearings or even untangle a web of floating vegetation from your head. After touching the halfway post triumphantly, there's only the home run to go. Crossing the finish line, you will step out of the bog dripping runny sludge but still receive an Olympian reception. Accept the applause graciously!

Getting to the famous Waen Rhydd Bog, nestled in the heart of Wales, involves driving through Llanwrtyd Wells, the smallest town in Britain. Many people travel some distance to the event, with international entrants coming from as far afield as South Africa, Australia and Canada. To cater for the line-up of competitors, two lanes are snorkelled simultaneously. If you go along to watch, take a towel and a swimsuit with you *just in case*. Snorkels and masks are available for hire, so spontaneous entry is entirely possible. There are safety wardens in high-visibility vests, volunteer first-aiders and divers on hand, although there is no danger of drowning. Burger and tea vans are in situ, adding to the sense of festivity, and there is always a party afterwards at the Neuadd Arms Hotel in town; the owner is the chairman of the event.

The use of fins is permitted, though duck diving is not. The event does not necessarily attract the most well-honed athletes and a surprising number of people do not complete the course. Cramp from dehydration and the cold water is cited as the most common reason for this, but nobody takes the race seriously. Everyone who completes the course is awarded a medal and there are prizes and much kudos for achieving the fastest time.

Having grown in popularity and scale since its conception in the 1970s, the Bog Snorkelling World Championship is now part of The World Alternative Games, staged over a two-week period in late August. The games include the Mountain Bike Bog Snorkel and the Bog Snorkelling Triathlon.

Unique, off-the-wall and truly eccentric, if you need a reason to visit Wales, bog snorkelling is it. Bring your sense of humour and become a hardy outdoor adventurer. Well, for a few minutes at least. You may not rush back to beat your time on the course, but bog snorkelling is so impressively pointless that it is worth doing once.

Opposite © Christopher Foster / chrisfosterphotography.com **Below** © Hannah George / green-events.co.uk

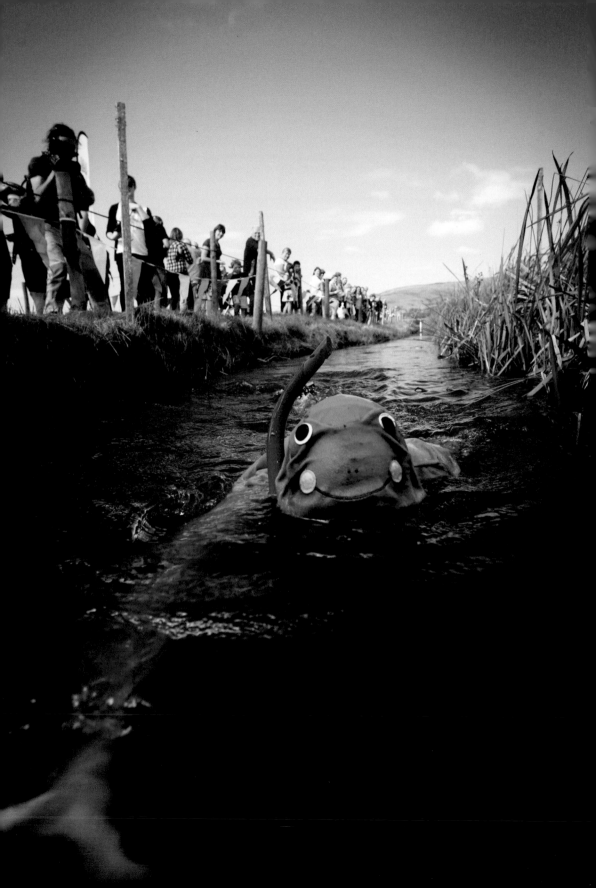

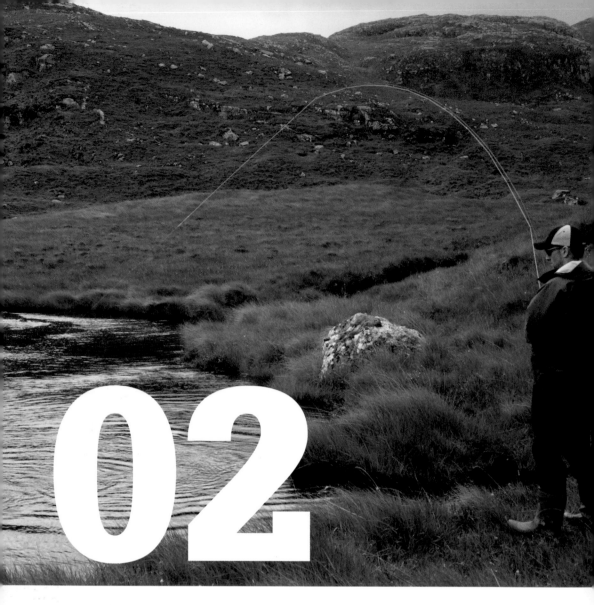

02

Fly fish for salmon in Scotland

Location Isle of Harris, Outer Hebrides, Scotland

Complexity Practice makes perfect

Cost ⬤⬤⬤◯◯

Lasting Sentiment It's all in the cast

Push off from the loch shore and fish Hebridean-style from a boat. Prepare and then cast your fly into the water and start 'dapping', letting the fly dip and bob lightly on the water. Remote and unspoiled, appreciate the raw beauty of the landscape, the wild grassland reaching down to the bank sides and the purple-hued hills beyond. Cast and cast again, waiting until you get that unmistakable tension on the line.

Acting as both your guide and assistant, your 'ghillie' will drive you to the start of the old pony path that leads to Loch Ulladale. The hike, the 4x4 drive, the getting there, are all part of the pleasure as you wind through a palette of intense greens and rich earthy browns. The setting is undeniably alluring. Trudging through moorland wilderness, listen to the delightful soundtrack of birds chirping and water running over rock. Your ghillie may even stash a beer or two in the river to chill, ready for you to collect on your walk back.

Seated comfortably near the stern of a wooden boat, enjoy the row out into the loch looking down through water so tantalisingly clear that it could be bottled to drink. In the middle of the loch, the boat drifts slowly in the gentle breeze. 'Distance is achieved through a rhythmic combination of wrist, hip and shoulder,' the ghillie coaches as he whisks his fly into the water. A thing of beauty and ease, a ghillie's cast may appear like ballet, the fly placed exactly where intended with the accuracy of a marksman. Time and time again you strive to finesse your cast as the hours slip delightfully by.

Suddenly there is a discernible tug on your line. A close encounter with a freshwater salmon may finally be imminent – and this is what you came to achieve. Judging by the tug alone, your ghillie can

Opposite and below © Amhuinnsuidhe Castle / amhuinnsuidhe.com

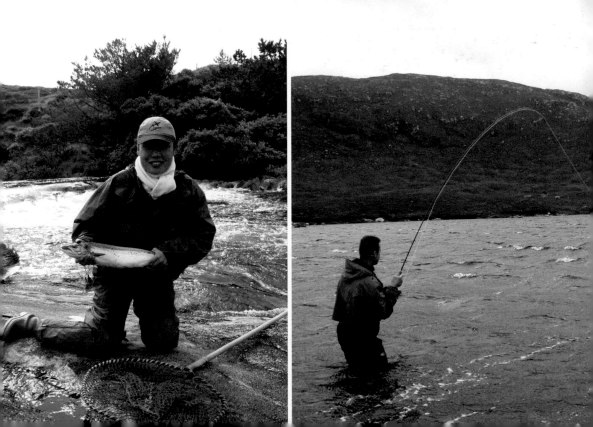

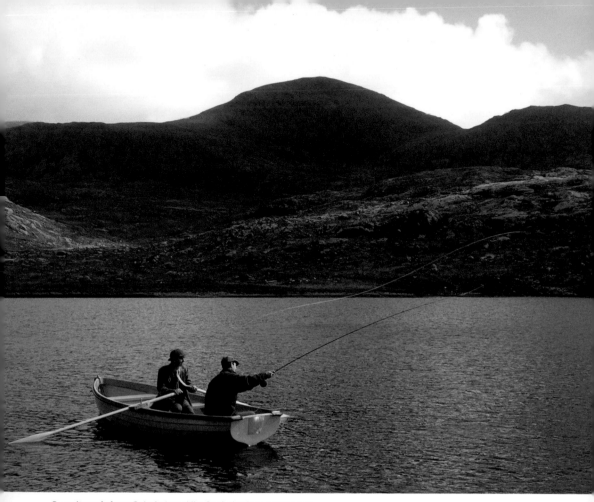

usually estimate the weight of the fish. He stands by with the net as you continue to grapple with the writhing line. The moment is all about you, the loch and the fish. Nothing matters but reeling in your beautiful catch.

Conservation demands that you return your salmon to the water immediately if it is smaller than 650 grams or larger than 1.3kg, but as you hold the fish in the water to re-oxygenate its gills, it's hard not to feel that nature, albeit momentarily, may have been conquered.

While it takes a lot to rival the thrill of landing your own wild salmon, the dramatic backdrop of Scotland's rugged mountains, complex geology and pristine wilderness is in itself seductive. From Glasgow, drive north via Glencoe, Fort William and the Isle of Skye and catch the ferry from Uig over to Tarbert. Alternatively, fly to Stornoway on the Isle of Lewis and drive south to the Isle of Harris.

The weight of the fish on the Isle of Harris is comparable to those found in similar waters in other parts of Scotland, but fish numbers are usually higher. The Isle of Harris is also the home of Harris Tweed, the durable moisture-resistant woollen fabric that every self-respecting fly

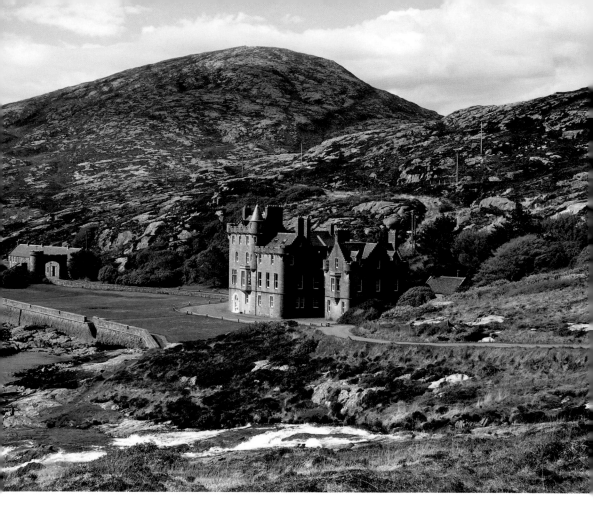

fisherman wears. Fish on the vast Amhuinnsuidhe Castle estate and choose from nine 'beats', each a separate freshwater loch or river system. For the quintessential Hebridean experience, stay in the Amhuinnsuidhe Castle itself, which was built in 1865 for the seventh Earl of Dunmore. You can even book the entire country house for you and 17 friends.

Since the Salmon Fisheries (Scotland) Act of 1862, you are not allowed to stop or attempt to stop the passage of migrating fish on a Sunday. The salmon start running at the beginning of July and the season ends on 15 October. No prior fly-fishing experience is necessary and you can easily rent a fishing rod and tackle. Mimicking the insect, with a lure so enticing that a salmon darts to the surface, is part of the secret of netting the perfect fish. Fortunately, an experienced ghillie knows the lochs, can read the water and knows exactly what fly the fish will be after.

Take to a Hebridean-style boat. Cast your hook into waters bubbling with salmon and drift on a Scottish loch. A meditative pastime, the addictive nature of fly fishing is said to lie in the elusive complexity of the cast, of preparing and then positioning the fly. All the same, you tell yourself that if there is a salmon lurking under the glittering surface, soon he will be yours.

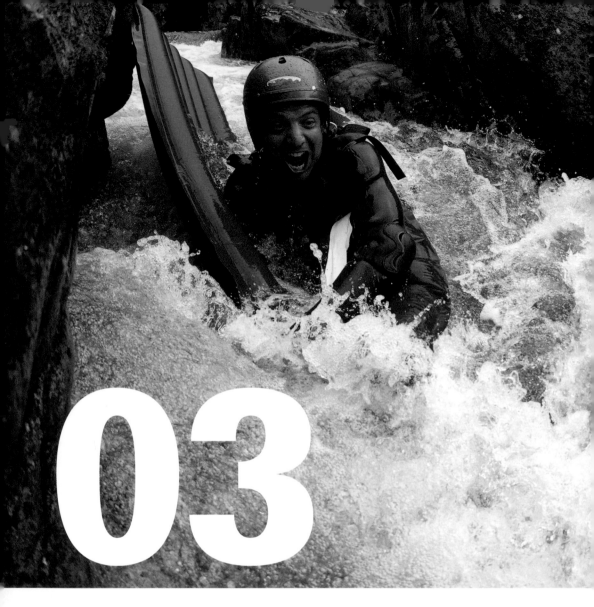

03

Compete in the Glen Nevis River Raft Race in Scotland

Location Glen Nevis River, Scotland
Complexity More bravado than brawn required

Cost ○○○○○
Lasting Sentiment Mad fun

Choose an inflatable doll, a giant blow-up sheep, a crocodile, a dolphin, an air mattress or a pool lilo as your ride and launch yourself down the Glen Nevis River as fast as you can. Spreadeagled on a colourful inflatable, paddle your arms through the rapids. Negotiate thundering white water. Push off rocks. Career off waterfalls face first. Just hang on to your craft and do your best to compete for the highly coveted title of 'World Extreme Lilo Champion'!

Your number is called. Shouting over the roar of the waterfall, a man counts down from three. Driven by the noise of the crowd, you must leap into the abyss and plunge into the broiling foam of 'Dead Dog Pool', a swirling mass of white water 12 metres below. Several interminable seconds later you resurface and hopefully see your lilo. With one arm flung over the airbed, swiftly mount your craft and straighten up before the next competitor plops into the water. The river race is on!

Down the Gurgling Gorge, you may crash gracelessly as you go through the first set of rapids. Attempt to paddle with your arms, but expect for the most part to be whisked along by the river. The experience of coming off your raft is intense. With one hand outstretched clinging desperately to the lilo, the other pushing off rocks, wriggle back on top as fast as you can. You need your trusty inflatable for protection and speed.

The first major obstacle is the 2.5-metre waterfall. Before you know it, you are over the edge, descending headfirst into the scarily named 'Leg Breaker Pool'. The river then turns 90 degrees. You fumble with your laughable novelty device to line up ready for the next series of drops. Buoyed along by the lilo, you may entertain delusions that you are invincible. Four descents later, each a 2-metre drop, and the delusions will be gone as the mother of all terrors looms – 'Lower Falls Leap'. The inflatable disappears from underneath you as the river plunges 6 metres. Momentarily you are airborne. The water is soft and aerated but finding the surface proves tricky in the hydraulic swirl. Finally you emerge, both delighted and disappointed that it is over.

The Glen Nevis River Race has been run annually for over 30 years and is considered a right of passage by local teenagers. Every year the event draws a large number of spectators, who line the

Opposite and below © Andy MacAndlish / nofussevents.co.uk

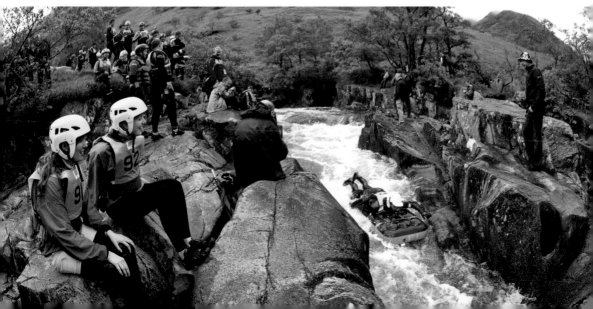

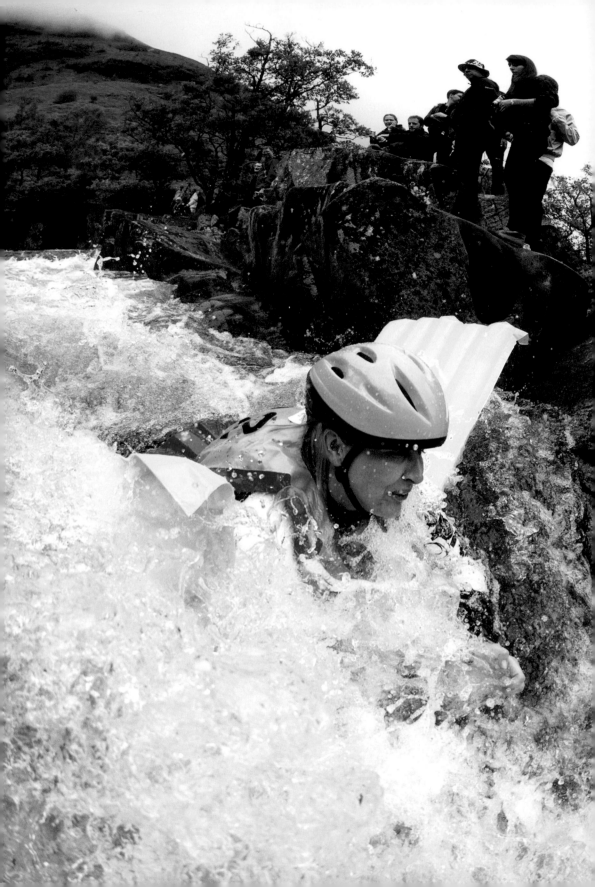

granite banks along the length of the course. There is a small fee to enter and all entrants must be over 18 years of age. In order to find the fastest route down the river, many keen competitors practise beforehand. A group of local enthusiasts even descend the Glen Nevis River all year round.

For protection, competitors must arrive kitted out in full-body 3mm wetsuits. Knee and elbow pads are advisable, as are running shoes with a sturdy sole. A crash helmet with drainage holes designed for white water is mandatory and your buoyancy aid will be float tested at check-in. Fancy dress on top of your wetsuit is, however, optional. The rules state that 'athletes' must use an inflatable craft without sides, so expect to see a huge variety of inflatable paraphernalia. Any other swimming aids, including fins, are banned.

Approximately 160 kilometres north of Glasgow, the river race starts near the town of Fort William on the Glen Nevis River. Come for the weekend, camp out at the base of the glen near the foot of Ben Nevis and enjoy the carnival atmosphere in the run-up to the big event. Persuade your friends to join you and enter as a team. Each competitor is timed and the time taken to complete the course is totally dependent on the water levels on the day. Finish times vary from a record-breaking 15 minutes to over an hour.

Pick an inflatable with as many compartments as possible so you avoid clinging, perhaps quite literally, to a dead duck. Use a roll of duct tape to make a couple of handholds. Dress up like the river warrior you are and revel in your moment of true daredevilry as you fling yourself into the white water. Surf the Glen Nevis River on anything from an inflatable whale to a robust canvas lilo, for memories you will always laugh about and your chance to win a prized bottle of whisky.

Opposite and below © Andy MacAndlish / nofussevents.co.uk

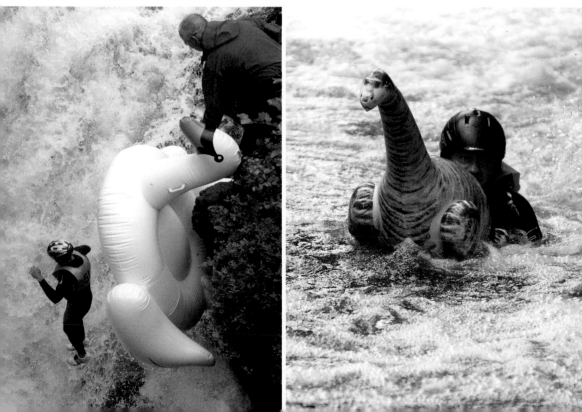

04

Tour Ireland's west coast by RIB

Location Dingle Peninsula, County Derry, Ireland

Complexity Sit and marvel

Cost ●●○○○○

Lasting Sentiment A fascinating boat ride through history, geography and religion

See Ireland in a more unusual way. Rather than looking out to sea from the cocoon of a moving car, gaze in at the land from the deck of an open boat. Stop off at the islands and step back in Irish history with a wander around the ancient monastic settlements. Take in great expanses of scenery, a contrast of dark and medieval-looking tenements juxtaposed with concentrations of green. With mountains in the distance and craggy beaches in the foreground, enjoy miles of breathtaking coastline.

Straddle the padded box seat, lean back against the comfy backrest and hang on. The boat is a RIB, a 'rigid-inflatable boat' and for a few seconds the boat ploughs through the water. Once up on the plane, however, the RIB tears effortlessly across the surface, spray flying. The speed is exhilaratingly fast, the sea air brisk and fresh. You need to grip the handhold as the boat banks eastwards for a loop of Tralee Bay.

You learn from your guide that 24 galleons belonging to the Spanish Armada were shipwrecked along the coast between Antrim to the north and Kerry to the south. Two galleons, so the legend goes, are rumoured to be in Tralee Bay. The bay is an area of magnetic anomalies, rendering sonar and other deep-scanning equipment useless. Exactly where the ships lie and whether they still hold gold bullion can only be guessed now.

Running at 20 to 35 knots, the boat quickly takes you to Derrymore Island Nature Reserve, a pile of shifting sand that is ever increasing in size. The boat slows for you to take a closer look at the striking plateau of tropical-looking beach that seems an incongruous sight in western Ireland. You cruise on round Rose Rock, a jagged and unadorned protrusion that was an island until thousands of years of erosion wore it down. Past Little Samphire Island Lighthouse you see the two islands of Mucklaghmore and Illaunnabarnagh. A pod of bottlenose dolphins erupt from the water and start surfing in the bow wave of the RIB. Amazingly, they can swim as fast as the boat, often diving back and forth under the hull just for fun. One or two squeal as they rise up for a breath, clearly having a good time.

With fabulous names like Illaunimmil and Illaunturlogh, the seven Magharee Islands are collectively known as 'The Seven Hogs'. Spend the afternoon exploring Illauntannig Island and

Opposite and below © Phillip Fitzgibbon / waterworld.ie

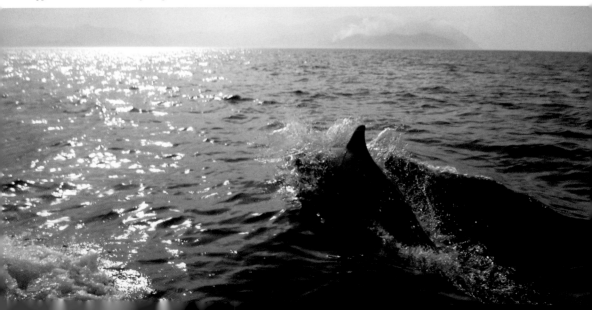

check out the curious drystone huts with corbelled roofs called 'beehive huts' or 'clocháns'. There are also the remains of a 6th-century monastery, along with a ruined medieval church, two oratories, two stone altars or 'leachts', three burial platforms and a Celtic cross, all contained within a thick cashel wall. A secret tunnel called a 'souterrain' runs from one of the huts to a long chamber within the wall, in which 20 to 30 monks would hide during Viking raids. If you like, you can experience life on the island by renting the only dwelling, a hut without electricity, which can be booked between April and September for a week at a time.

Fly into Limerick or Cork, rent a car and book your own accommodation on the Dingle Peninsula, choosing from holiday cottages to family run B&Bs. Most RIB tours last two hours, which, unless you are hardened to this type of fast-moving open motorboat, is usually long enough. Without the hundreds of slippery steps that often provide the only access to other monastic island settlements, the Magharee Islands are accessible whatever your level of athleticism. The islands are only a few kilometres offshore, so the ride out to reach them is short and sweet. None of the boats will go out when the sea is forecast to be rough, but always be prepared for rain even in the warm season between May and September.

Framed by the peninsula's mountain range and its highest peak, Mount Brandon, the panorama from a RIB is nothing short of spectacular. Comfortable and fast, a RIB tour is by far the best way to see the Dingle coastline. Let your knowledgeable driver be your guide as he edges the boat near the seal colony, slows to watch a pod of pilot whales pass by or navigates close to a 9-metre-long basking shark filtering the water for food.

Opposite © Phillip Fitzgibbon / waterworld.ie © **Below** Alastair Maher

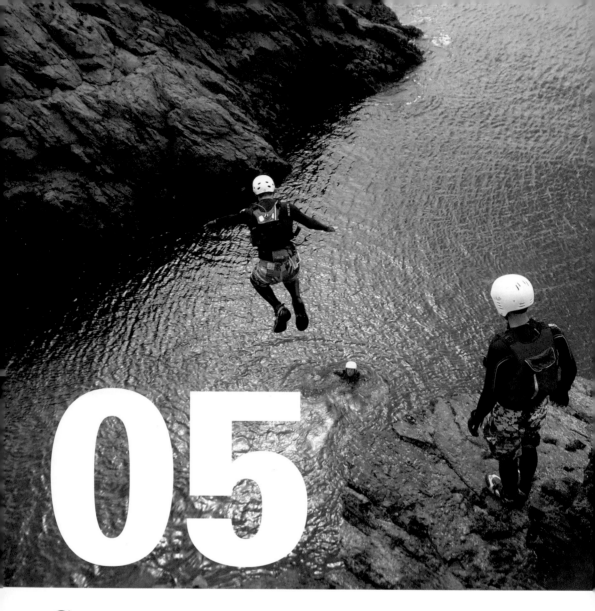

Go coasteering in the Channel Islands

Location Island of Sark, Channel Islands
Complexity Challenge levels vary from
route to route

Cost ○○○○○

Lasting Sentiment Take the plunge!

Traverse stretches of wild and beautiful shoreline on foot. Clamber up rocks. Jump off rugged promontories into tiny bays. Swim down narrow gullies and enter caves and cavern systems only accessible by coasteering. Ride the tide round small islands and experience the exhilaration of exploring the coastline at sea level.

Decked out in a 5mm wetsuit, buoyancy aid, helmet and suitable footwear, scramble down a large natural chimney of granite gneiss. The rocks lead into the boulder-strewn cavern, the main cave of the world-famous Gouliot Caves. The walls of one cave in particular, 'Jewel Cave', are lined with brilliantly coloured anemones, sponges, giant barnacles and cup corals, but to see them you need to be there at low tide, when they are exposed. When you leap into the sea, the tide whisks you through the cave. Out and round to another bay, go with the flow, bobbing in your buoyancy aid.

Scramble out of the water and prepare for your first cliff jump! The water is nearly always pea green and incredibly clear. The rock slopes down towards the water, so choose the height you want to jump from. Your instructor will go first for safety reasons, demonstrating how to jump correctly. The aim is to draw your arms in and keep your legs together so that you can pierce the water in the most streamlined fashion. Watch carefully as he gleefully descends into the pool of unsuspecting mullet swimming below!

Climb up rocks further along and leap again! Scramble out and prepare to jump into a lagoon. With heights varying between 5 metres and 12 metres depending on how daring you feel, each jump is a terrific rush. The thrill is in the flight through the air, followed by the surprise when you hit the water and submerge.

The next part of the route involves clawing your way along the rocks, feet dragging behind you in the tide until one of the instructors throws you a tow line to pull you round the corner. Out of the water, a natural rocky platform offers the highest jump of the route. You may consider chickening out and leaping from a lower ledge, but watching your peers whoop with such delight as they plummet down hopefully gives you the courage to also launch yourself off the higher platform. You then swim through the main cave for a second time, entering from the other side and experiencing a different

Opposite and below © Rosalie Smith / adventuresark.com

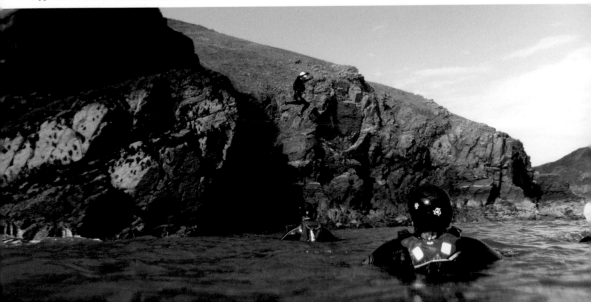

perspective, before continuing on to explore further challenging water features.

At just 5 kilometres long and a little over 1.5 kilometres wide, the island of Sark has more than 64 kilometres of spectacular coastline. One of the smallest of the Channel Islands, situated between England and France, Sark offers all the elements required for exceptional coasteering. On the island's westernmost headland, the Gouliot Caves are open to the sea on both sides, allowing water to sweep through with both the ebb and the flow of the tide. The combination of fault lines in the granite and the constant pounding of the sea have resulted in a number of spectacular grottos. On the same route, on the same day, you can flow with the tide, scrabble against it, swim in and out of caves, jump from various different heights and climb up impressive granite structures. And as an added bonus, the backdrop of scenery is pristine, peppered with wildflowers and butterflies.

Fly to the neighbouring island of Guernsey and catch the ferry from Saint Peter Port to Maseline Harbour. Walk up the hilly footpath to the village or take a seat on the 'toast-rack', the tractor-drawn bus. There are no cars on Sark, only bicycles, horses and carriages. If you choose to stay overnight, your luggage will be taken directly from the ferry to your accommodation by one of the island carters.

Coasteering in Sark is possible at any time of the year, even around the Christmas period and New Year, although the water will be chillier. You need to be reasonably fit to enjoy the sport and relatively confident in your ability to move over rock. Most routes are suitable for non-swimmers.

Conquer your fear of the unknown and jump safely from a series of great heights into the sea below. Swim in and out of enclosed spaces and admire stretches of coastline that are rarely seen. Come rain or shine, let the caves and rocky pools, lagoons and cliff tops become your playground. Coasteering is the great outdoor adventure the weather can't spoil.

Opposite and below © Rosalie Smith / adventuresark.com

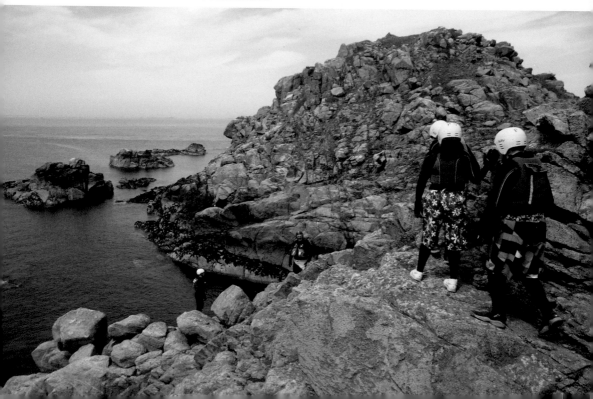

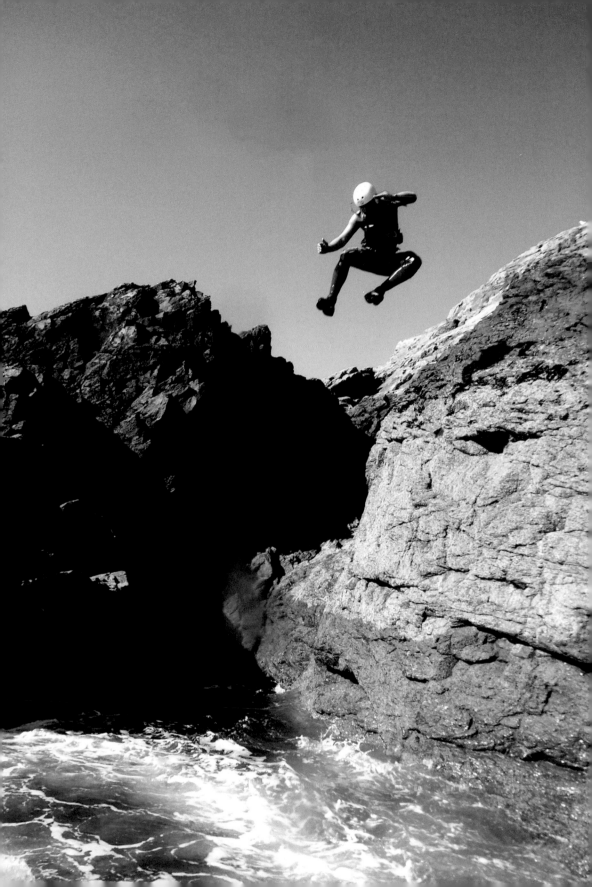

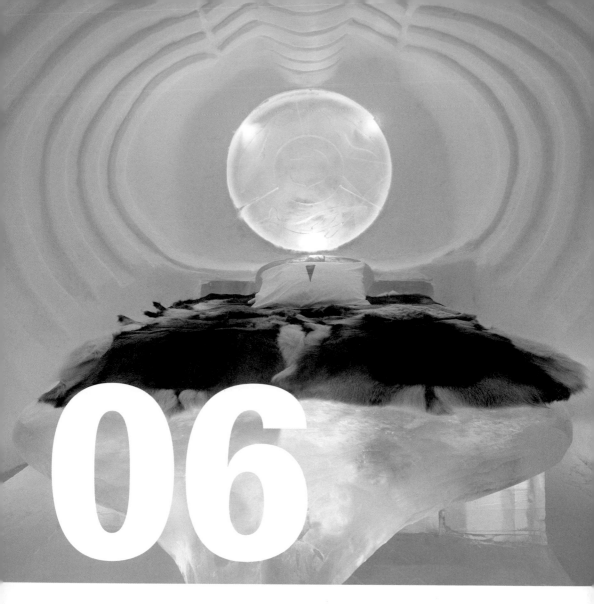

06

Stay at the ICEHOTEL in Sweden

Location Jukkasjärvi, Sweden

Complexity Turn up and chill out

Cost OOOOO

Lasting Sentiment Out of this world

Sleep in a palace built entirely from blocks of frozen water. Lie back on a bed of ice, in a room made from ice and snow. The bedside table, the chairs, the floor, the walls – everything is familiar but not quite normal. Carved to mimic the texture of fabric, function as pieces of furniture or just for the sheer artistic joy of it, the ice has been manipulated into something mind-blowingly other. A stay at the ICEHOTEL is a water adventure of the frozen kind.

From the outside the ICEHOTEL appears unimposing, a giant single-storey igloo of modern design. You step inside to discover a warren of intriguing spaces, of fabulous arched passageways and snow-walled corridors. You recognise the material as ice, but this is ice transformed, water sculpted into fantastic three-dimensional shapes. Outside temperatures range from -20°C to -40°C, but inside the temperature is only just below freezing. Kitted out in a special ICEHOTEL suit with insulated boots and mittens, you will not be cold.

On the guided tour you will learn that the building is constructed from high-density 'snice', a hybrid of the words 'snow' and 'ice', which is carefully packed to reflect the sun's rays and protect the hotel from melting. The décor, fixtures and fittings are all made from 3000 tonnes of ice blocks harvested from the Torne River and it is back to this same artery that the meltwater from the hotel eventually flows.

Art museum by day, novelty hotel by night, spend the afternoon strolling around the 65 suites of this magical space. Marvel at the ice chandelier in the hallway, translucent and sharp like cut glass. Wander into the sanctuary of the chapel, which is frequently used for weddings. Designed and sculpted by different artists from around the world, no two spaces in the building are the same.

There are 'snow rooms' and 'snow features', where the medium is white and opaque, giving the appearance of softness and warmth. Then there are whole crystal caverns with transparent walls and see-through sofas and armchairs. Each room is artfully lit, the light reflected, absorbed and dispersed by the interior furnishings – furnishings being an understatement for the features fashioned inside.

Opposite Paulina Holmgren / icehotel.com. Artists: William Blomstrand & Andrew Winch **Below left** © Ben Nilsson photobigben.com / icehotel.com **Below right** © Paulina Holmgren / icehotel.com. Artists: Jens Thoms Ivarsson, Marinus Vroom & Marjolein Vonk

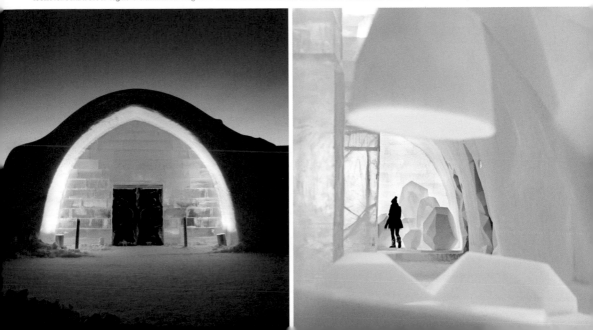

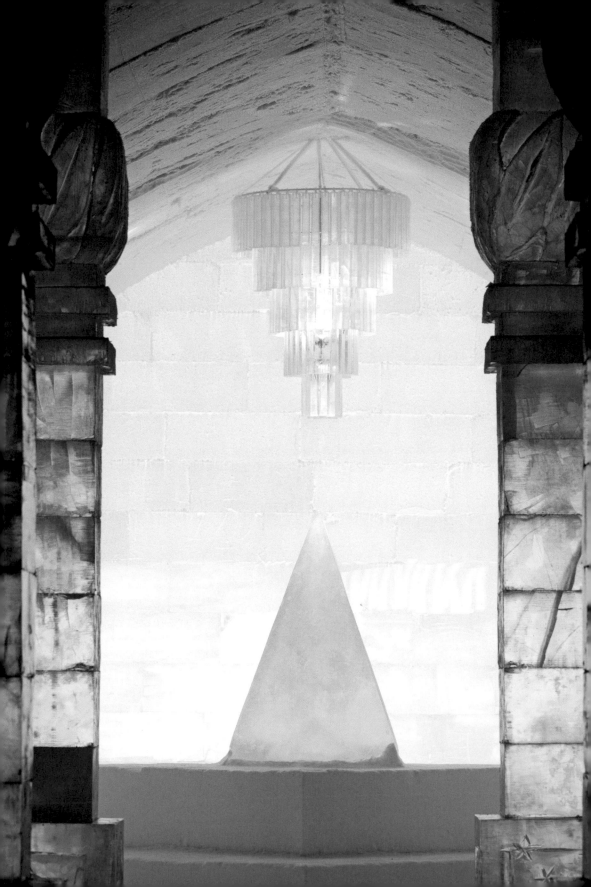

The bed frames may be blocks of ice, but with luxurious soft mattresses on top covered in reindeer skin you will hardly be able to wait to go to bed.

After a colourful nightcap, drinking from a glass made of ice, head to the reception desk to collect your thermal polar-tested sleeping bag. Earlier you will have stored your other clothes and personal items in a locked luggage room in the warm building, to prevent them from freezing in your room overnight. The bed is remarkably comfortable and once zipped up in your sleeping bag, you may be too excited to sleep! While there are no doors per se, only privacy curtains, the bed is tucked away and the 'snice' walls absorb all sound. Warm and cosy, expect to drift off cocooned inside the set of a futuristic galaxy.

Fly via Stockholm to Kiruna airport, which is about 20 minutes by car from the hotel. Spend a single night in a cold suite and a couple more in the 'warm accommodation', the chalet-style complex next door. While the ICEHOTEL is one of six located in Scandinavia alone, the Jukkasjärvi ICEHOTEL was a world first in 1990 and remains the largest. Situated 200 kilometres north of the Arctic Circle, the Jukkasjärvi ICEHOTEL is nestled in the heart of Lapland. Built anew every year, the hotel opens room by room until the building is fully operational by mid-January.

Daytime excursions include reindeer sleigh rides and husky sledding across frozen lakes towards distant hills and through forests of white-coated fir trees. Ice-sculpting classes are an option, but an outing by snowmobile to see the Northern Lights is a must.

Bring plenty of warm layers to insulate your body and remember to avoid using water-based facial moisturisers as these can cause frostbite. Double occupancy sleeping bags are available, although sleeping in thermal underwear, long johns and a long-sleeved vest is still recommended.

Seemingly frozen in time, yet obviously ephemeral, your visit is a special moment in the finite existence of the hotel. A place of stark contrasts, of brief sunshine and long hours of night, of temperature and of striking colour, you may wake up wondering if the ICEHOTEL was just a dream. But however otherworldly your experience, the ICEHOTEL will definitely still be there in the morning – at least until the end of March!

Opposite © Christopher Hauser / icehotel.com. Artists: Sofi Ruotsalainen, Mats Nille Nilsson & Lena Kristrîm **Below left** © Paulina Holmgren / icehotel.com. Artists: Alessandro Canu & Jose Carlos Cabello Millan **Below right** © Ben Nilsson photobigben.com / icehotel.com

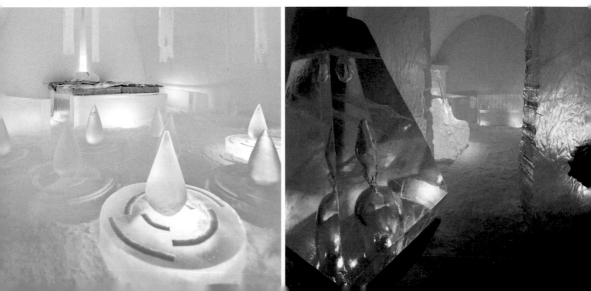

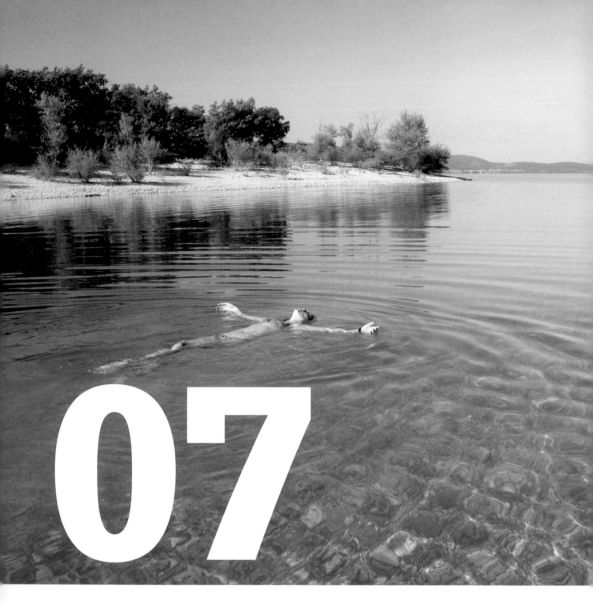

07

Wild swim in France

Location Lac de Sainte-Croix, France

Complexity However you feel motivated

Cost ⦿⦿○○○

Lasting Sentiment Naturally refreshing

Stretch out your arms and launch into the lush turquoise blue. Feel your body cool off as you glide through clear mountain spring water in the summer heat. Follow the ripples emanating in ever-widening circles as you move. When you've swum a distance, stop and float, allowing the water to draw in around your face. Absorb the stillness of your surroundings until you feel revitalised. Then touch down on the smooth pebbles and step out to bask on a warm, flat rock, letting your body dry off naturally in the breeze.

For the cleanest, most tantalising waters in Europe, pack your swimsuit and head to the south of France. Kick back for a few days and soak up some superb swimming in the great outdoors. Less than two hours' drive inland from the crowded beaches of the Mediterranean lies a forgotten gem, an oasis of water divided between the Var and Alpes-de-Hautes-Provence regions of France. The second-largest man-made reservoir in France, the Lac de Sainte-Croix is a mountain pool framed by the Haut-Var and Valensole hills. Through the combination of white limestone bedrock and glacial flour (glacial silt that becomes suspended in the water), the lake appears iridescent. The colours on the surface of the water range from intense azure blue, emerald and jade through to soft pastel hues.

Base yourself in the south-eastern corner of the lake in the medieval village of Bauduen, with its pretty terracotta-tiled roofs. A rural mountain village, Bauduen was run-down and derelict prior to 1974, when the lake was formed and the hydroelectric dam was commissioned. Now situated at the lake's side, the village boasts a gorgeous beach and clear water for snorkelling. Enjoy a cool glass of Sauvignon Blanc as the sun melts over the hills to the west. At very low water, look out for the

Opposite and below © Daniel Start / wildswimming.co.uk

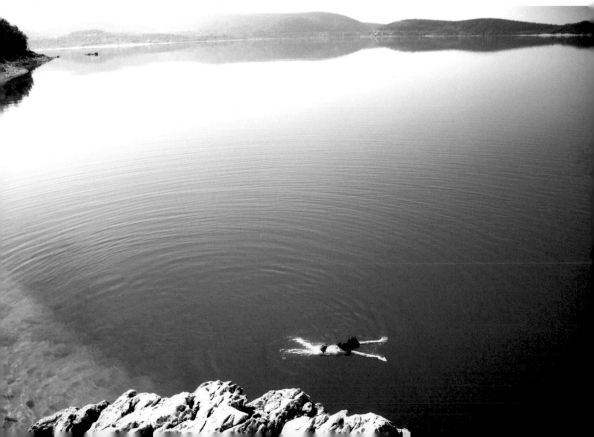

spire of the old church of Sainte-Croix-de-Verdon, the village that was submerged when the Lac de Sainte-Croix was created.

Further along the southern edge of the lake from Bauduen lies 'La Défens', a scrubby forested headland several kilometres long and one of the wildest sections of landscape in the area. Climb up the sheer cliffs to take in the view and take a plunge into the deep pool glistening below. Long white stretches of sand outline the mid-section of the lake and there are a number of busy campsites set back from the shore. Hike a short distance and find an inlet with a secluded beach. If there's nobody else around, be bold! Strip off and take a refreshing dip 'au naturel'. Gliding into the lake, you can take sips of pure alpine spring water as you swim along.

At the north-eastern neck of the lake, don't miss the opportunity to swim down the Verdon Gorge. An almost invisible slot in the mountain wall hides the wild and deep chasm where the rushing green waters of the Verdon River enter the lake. Smaller but with geology similar to the Grand Canyon in Arizona, the Verdon Gorge formed as a result of earth movements when the Alps were 'growing'

Opposite and below © Daniel Start / wildswimming.co.uk

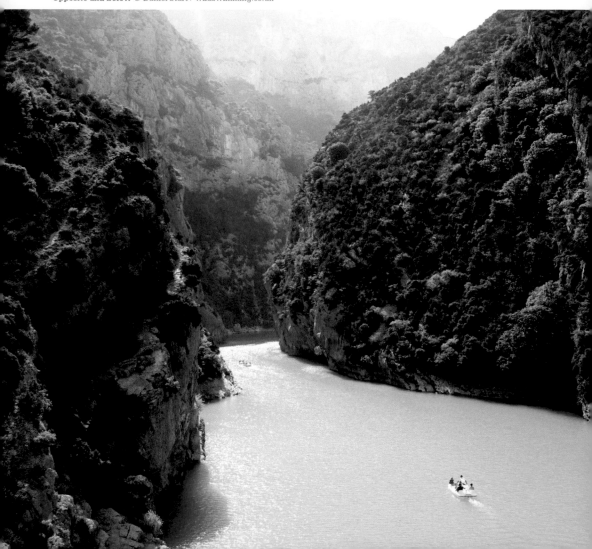

upwards, and from erosion of the Jurassic limestone by the Verdon River.

Before you leave, take a scenic drive along the road that follows the river. Stop to explore the three distinct sections: the Prégorges ('pre-gorge') which goes from Castellane to Pont de Soleils; the gorge itself, from Pont de Soleils to l'Imbut; and the Verdon Gorge, which flows from l'Imbut down into the lake. Swim through the winding passage of 'The Styx', at l'Imbut, the part of the gorge that gets progressively narrower, until it is just metres across. Shady and deliciously cool, follow the river until it disappears underground in breathtaking fashion, beneath vast rock structures.

Situated 475 metres above sea level on the open Plateau de Valensole, the Lac de Sainte-Croix has a feeling of endless space and light. From inlets to deserted coves, from rocky cliff promontories to white pebbly beaches and the spectacular Verdon Gorge, the lake has abundant natural bathing spots and atmospheric plunge pools. Whether you swim or clamber along the glacial rocks, prepare to marvel at the incredible geology and gorgeous turquoise-coloured water. Delightfully off the tourist trail, look beyond the busy French Riviera and swim free – in the wild.

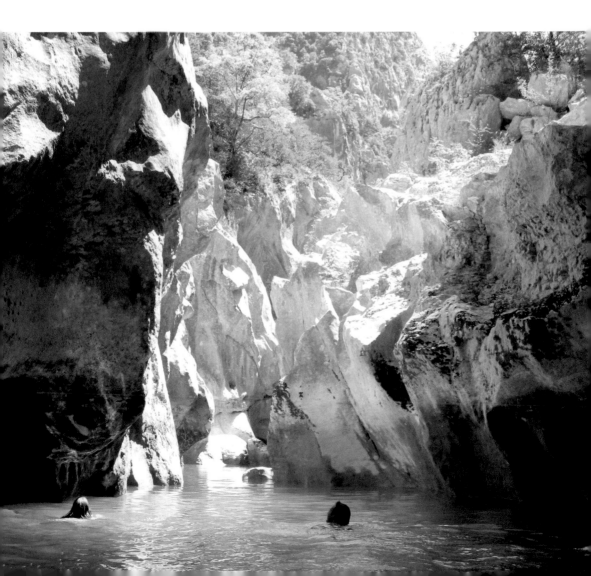

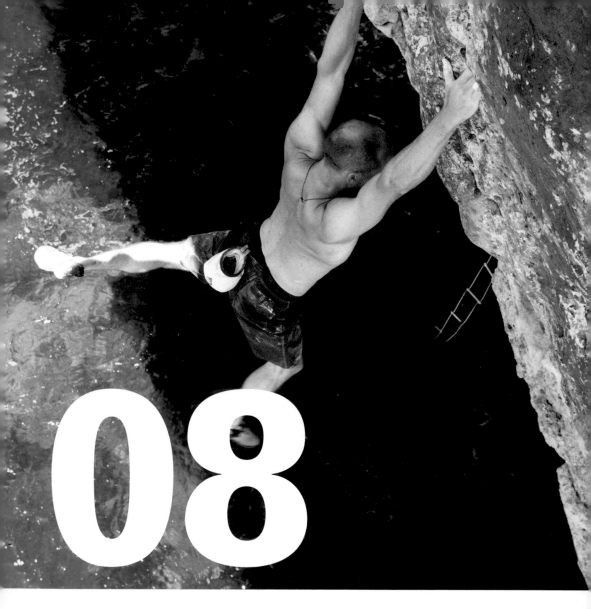

08

Try deep-water soloing in Majorca

Location Majorca, Balearic Islands, Spain

Complexity Whatever your ability, there's a route with your name on it

Cost ○○○○○

Lasting Sentiment 'I never want to go up again!' 'I'm going up again!'

Climb as if your life depends on it. Grip the rock wall with your hands and make your first move out over open water. Wearing only swimwear – no harness, no ropes, no belay – embark on a climb that is as much a challenge for your mind as it is for your body and understand why the Majorcans call deep-water soloing 'psicobloc', short for 'psycho-bouldering'. Your safety mat is water, several metres below. This is climbing without aid, uninhibited, climbing at its purest. Be bold, aim high and do not look down!

The trails take you down to the base of the cliff. With your climbing shoes fastened tightly, push off from the ledge and commit yourself to the wall. Your chalk bag should contain a handful of dust, nothing more, as the chalk will be unusable once it is wet. Your shoes should be synthetic leather so as not to absorb the water. The rock against your body becomes your universe as you scan to find the next handhold and foothold. You try to keep your movements small and fluid, blocking out thoughts of falling and of the drop below. 'It's only water,' you tell yourself. 'It can't hurt!'

Up you go, step after step, performing a vertical ballet. The sound of the waves lapping the bottom, resonating up the rock, may start to invade your head. As the cliff begins to overhang more dramatically, edging towards you like a bad dream, a firm grip is required. Your friends shout advice and encouragement, but when the muscles in your right leg begin to spasm you know that you will fall into the sea. Your fall is imminent, but for a split second nothing happens. Then you are falling. You shriek, realising your body has detached from the wall. Hopefully you remember to tense, drawing in

Opposite and below © Rasmus Kaessmann / kaessmannphotography.com

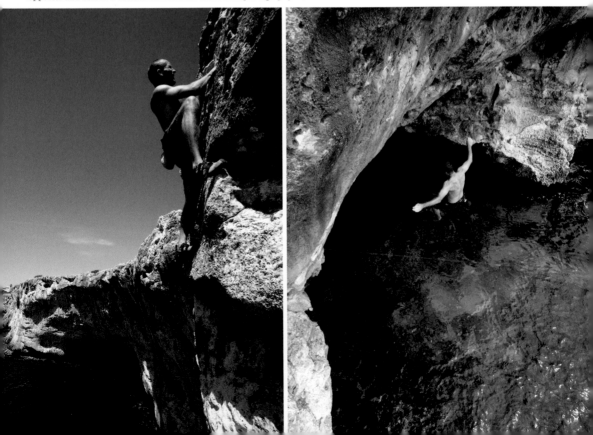

your arms and legs protectively to bomb safely through the water. Into the gorgeous blue you descend, cool, wet relief slapping your body, bubbles streaming on your way up. Ah! The thrill of being alive!

Blessed with warm water in the summer and early autumn, the Balearic Island of Majorca remains the ultimate deep-water soloing destination. Frustrated with aid climbing, it was here in 1972 that Miquel Riera, then a local high-school boy, looked to the sea cliffs and began mapping out climbing routes.

For your first taste of soloing over deep water, head to Cala Ferrera near Santanyí on the south-eastern corner of the island. Choose from 95 different routes with fabulous names such as 'La Manicura' (the manicure) and 'Efecto Especial Verbal' (special verbal effects). A great wall for beginners, Cala Ferrera offers every type of rock configuration: slabs, roofs, overhangs, bulges, holes and rock horns. Sample short climbs close to the water and complex routes 20 metres high. Easily accessible by foot, climb down, traverse out to the line you want and begin. If you are reasonably agile, you will improve very quickly. A quick dip in the clear blue Mediterranean Sea is all that awaits you when it goes wrong.

Opposite and below © Rasmus Kaessmann / kaessmannphotography.com

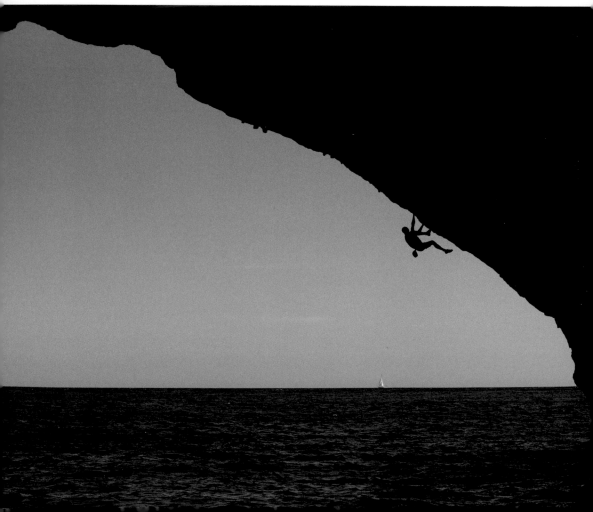

The best time to climb depends on the angle of the sun in relation to the rock. Acting as a mirror, the sea reflects the sun, which heats up the rock. On the other hand, you want the cliff overhang to be dry. Scale Cala Ferrera in the morning or early evening, but be aware of the wind direction and check out the state of the sea first. A little chop is preferable to break up the water for a softer landing. Anything more, however, and you may need a dinghy or kayak to help you return from the sea.

Deep-water soloing as a variation on sports climbing is comparatively dynamic and quick. Ten people may test their mettle on the same rock face with little hanging around. You are either clawing your way up the rock, swimming in the water after a fall, or shaking out your arms while resting on a ledge. Expect to fall hundreds of times into the big crash pad of the ocean. The beauty is that in order to conquer the section that plucked you off the wall, you must climb from the beginning again.

As much a social pastime as it is an introverted experience, enjoy the sensation of solo climbing unencumbered. Halfway up the rock you may berate yourself, but once in the water, climbing up again is all you want to do.

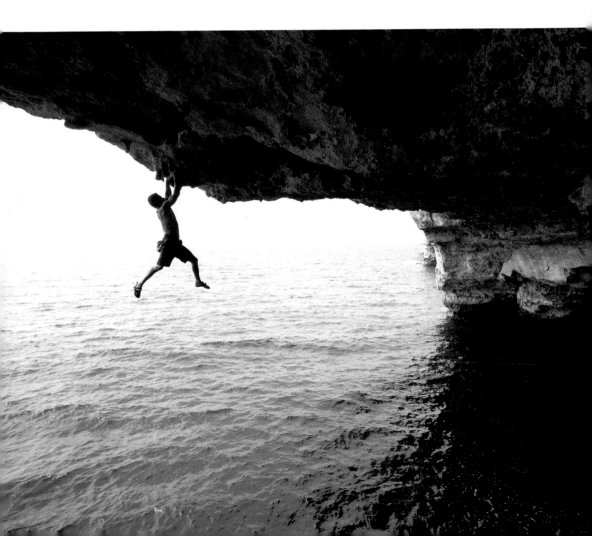

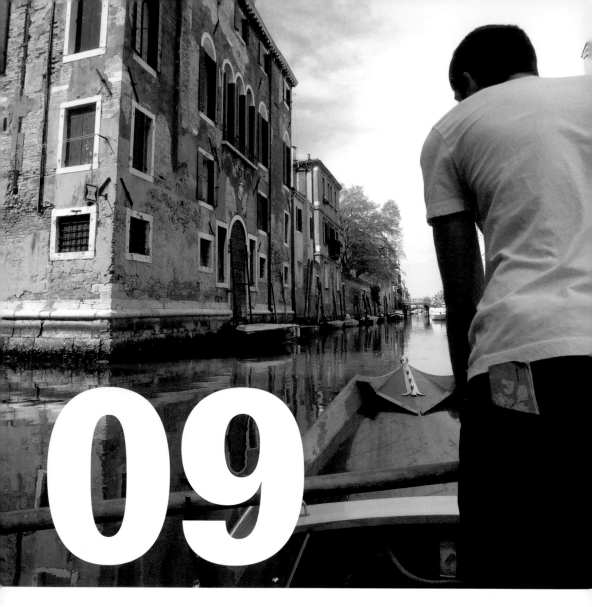

09

Learn to row like a Venetian in Italy

Location Venice, Italy
Complexity Practice makes perfect

Cost ⦿⦿○○○
Lasting Sentiment Float your own boat

When in Venice, do as the Venetians do: row your own gondola! Take a gondoliering lesson and row yourself into the heart of Venice. Skirt the tourist bustle of St Mark's Square and see the historic Rialto Bridge from an altogether different perspective – on the water and with oar in hand.

Standing on the back deck of a beautifully varnished wooden boat already feels special. Having practised your stroke standing inside the boat facing forwards, you are ready to try the classic gondolier rowing position on the stern. One leg bent, one straight, you will be instructed into the correct stance. You may find the 5-metre paddle unwieldy at first, the oar jumping out of the oarlock or 'fórcola', but before long you will find your rowing rhythm.

Unlike punting, which involves pushing off from the bottom, or gig rowing where you pull the oar towards you, gondoliering requires the oar to be pushed away from you. You twist the oar to cut into the surface of the water, an action called 'feathering', then push through the water to engage the stroke. Then twist again to lift the oar out efficiently. How you twist the oar is the main technique you are aiming to master, since each stroke has a dual function. The oar is used as a means of propulsion and as a rudder to steer the boat in the desired direction.

Past the pretty spires of the Madonna dell'Orto and Sant'Alvise churches, past the casino and the busy Rialto market, enjoy being more than just a spectator. When dredged of silt and dried mud, the water in the canals can be surprisingly clear. Past bars and cafés and churches with bells that ring on the hour, a rowing lesson can take you right into the thick of city life. At high water you may

Opposite © Betsy Shaw-Cope **Below** © Melissa Britton Henderson

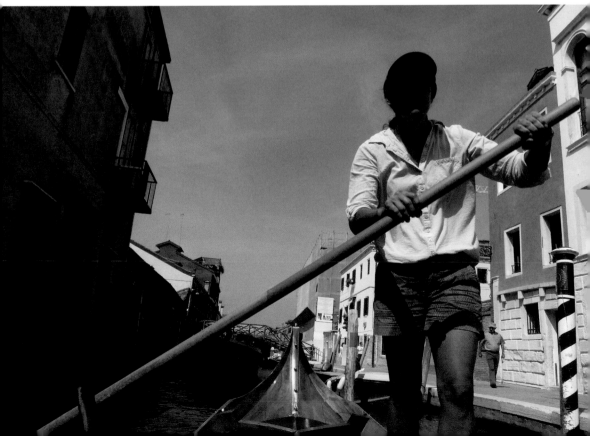

have to duck under a number of bridges, particularly while exploring the alleyways. Intimate, yet not intrusive, the view of the streets and houses from the water is unrivalled. Be sure to acknowledge a nod of respect from another passing gondolier. In harmony with the surroundings and using the traditional means of transport, rowing a local boat is one of the most authentic Venetian experiences available and a real pleasure with friends or family along for the ride.

Book a two-hour lesson with 'Row Venice', operated by VIVA Voga Veneta, a not-for-profit organisation promoting the presence of traditional boats in the Venetian canals. Head for the marina at Sacca della Misericordia in Cannaregio, the northernmost of the six historic districts. For teaching purposes, a 'batela' is used rather than the slimmer, lighter gondola, which is a highly technical boat to row. The batela and gondola are rowed in exactly the same way, by one person at the back, or by two people, one at the bow, one at the stern. Originally used to transport goods in the 1930s, the batela is a cart rather than a carriage. The advantage of having a sturdier, more stable platform while learning to row is that there is less chance of falling in! The boat, if not your rowing skill, is guaranteed to attract looks of admiration from locals who recognise its rarity.

From the pulsing energy of summer to the more peaceful clear winter days, every time of year in Venice has its charms. Escape the heat by gliding down shaded backways or bask in the sun by rowing out into the surrounding lagoon. Whenever you go, enjoy the privilege of being able to try your hand at gondoliering without having to complete the six-month course, pass the driving test or get a licence! Historically a working-class profession, gondoliering is now one of the top-earning careers in Venice with licenses fetching a quarter of a million Euros and upwards. Only the very best rowers are accepted; only 500 licences are in existence and up until recently those licences were passed down solely from father to son.

Some 100,000 visitors flood into Venice every day. There is a huge amount of foot traffic, but down on the water there is often a refreshing breeze and relative tranquillity to be found. Learning to row a traditional boat is the finest way to navigate one of the most beautiful historic cities in the world.

Opposite © Betsy Shaw-Cope © **Below** Nigel Clayton

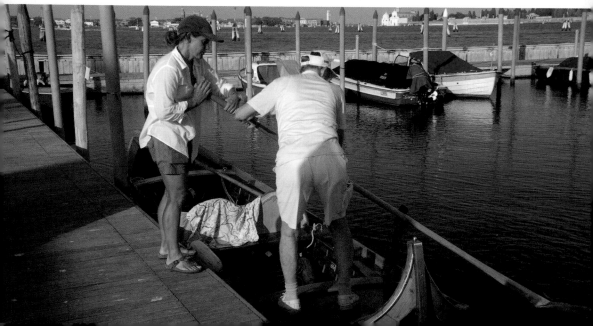

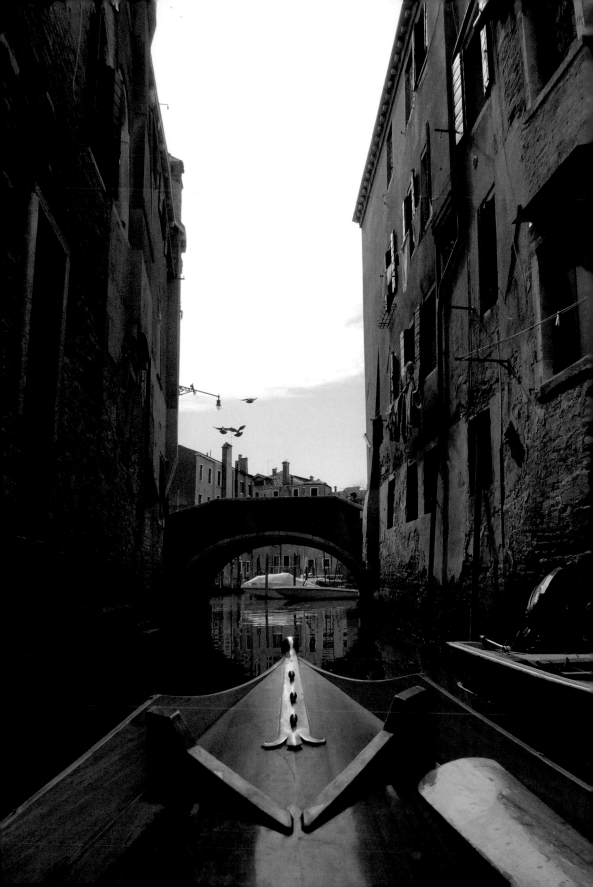

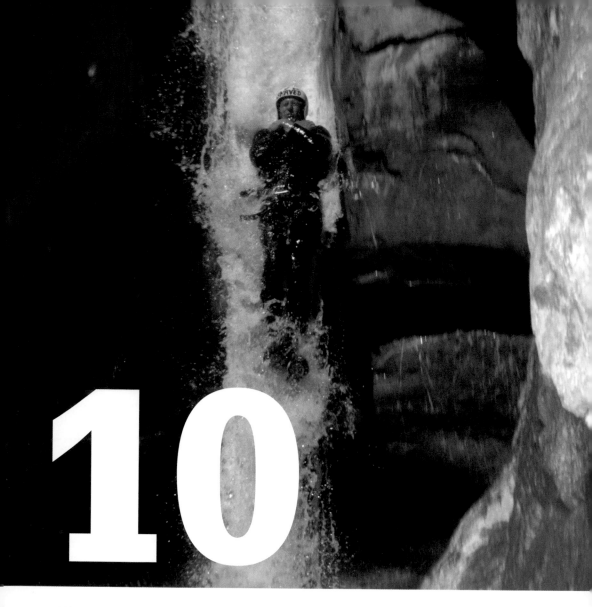

10

Go canyoning in Switzerland

Location Chli Schliere, Switzerland
Complexity Adventurous mind and body required

Cost ⬤⬤⬤○○
Lasting Sentiment A wicked wet assault course

Live dangerously. Under the guidance of qualified canyoning instructors, step out of your comfort zone. Jump into deep pools of running spring water several metres below. Abseil from great heights. Slide down fast waterfalls and explore hidden gorges that are difficult to reach or even inaccessible by foot. Surrounded by spectacular rock formations and alpine greenery, transition from pool to pool however you are directed – be it an exhilarating jump, a fun slide or a controlled rope-descent.

Experience the adrenalin the minute your feet leave the rock. Your mind may say yes and your body no, as you leap over the edge and plunge into a deep pool 10 metres below. The 15-minute hike through the forest to the canyon, the short slide into the first pool, nothing can prepare you for this. Wearing wetsuit long johns, a wetsuit jacket, buoyancy aid and neoprene booties means you will surface quickly. Now swim to the ledge of the high-walled basin you find yourself in. One guide goes ahead. The second remains to instruct you on your next obstacle. You must trust your guides completely, as they know what lurks underneath the surface of the water.

'Jump. Then slide,' the instructor repeats. It is hard to believe you need to throw yourself at the wet canyon wall in order to slip down into the pool below! Try not to think too hard about it, and on the count of three aim for the rock face. With so many layers of padding you feel virtually no impact and the water will quickly sluice you down. This is the most outrageous way to travel down a river canyon that you may have experienced yet. Tackle a 20-metre waterfall by rappelling blind, feet first, as water rains on you. The challenges keep mounting. It's nerve-racking stuff.

Opposite and below © Outdoor Interlaken / outdoor-interlaken.ch

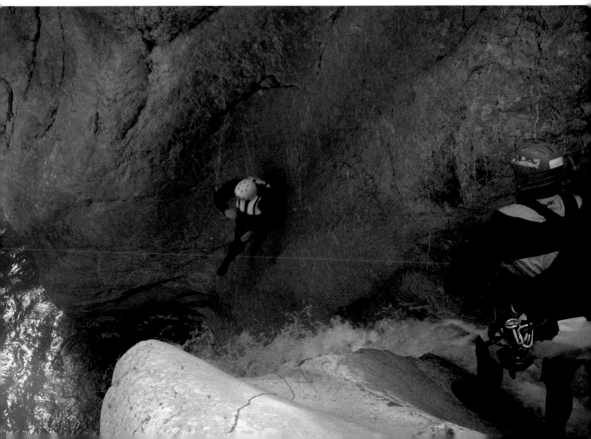

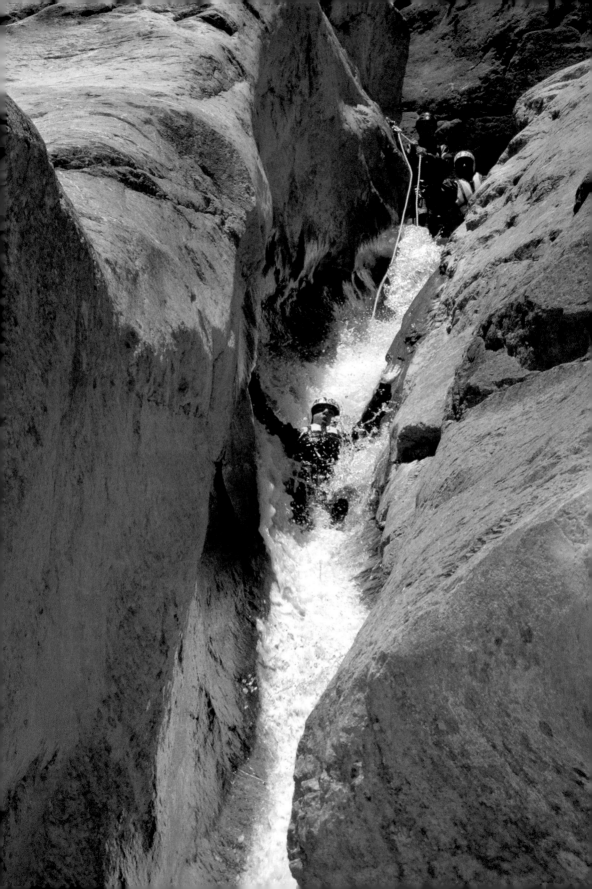

Sunlight should greet you at the bottom and by now the other members of your group all look bright-eyed and smiley. Out of the water again, peer down a natural tube worn into the limestone rock. Take in the colour of the water, gushing a translucent green. 'Ready?' the instructor asks when your arms are crossed over your chest in the right position. The rock is smooth, the slide steep, the water is pushing you, the sensation, the free fall, is intense. Suddenly you are under water. You just got flushed out from a giant natural plumbing system. You may want another go and luckily for you another slide is exactly what you will get! This time the shoot is 25 metres in length, a proper final descent.

For a physically demanding and technical canyoning experience, head to Chli Schliere in Switzerland. Carved over time by meltwater running off the Alps, here the rocks are delightfully smooth, the water channels clearly defined and the route offers a variety of demanding obstacles. The canyon is suitable for confident, athletic people who want to be challenged, although fixed ropes throughout offer abseiling alternatives if you opt not to jump.

No prior experience is necessary, but when you pick a helmet, choose carefully! Most companies print nicknames on their helmets. An idea born out of necessity to improve communication between you and the guides, your nickname may cause much hilarity among your group. Expect a briefing beforehand on how best to move about the canyon and full instruction before each stage.

Arrive by train from anywhere in Europe and stay in Interlaken or Lucerne. Bern airport in the town of Belp is the closest, although Zurich airport is the main hub for travel into Switzerland. The lower the water level in the canyon the better, since more water increases the flow rate rather than the depth of the pools or height of the jumps. In winter the pools are frozen over and snowed in. In spring the flow rate can be dangerously fast, so the only time to experience canyoning in Chli Schliere is during the summer months, from June to September.

Laugh at the expressions of shock, surprise and delight on your canyoning partners' faces. Then leap and make your own. Scramble across big rocky ridges as you pluck up your courage for the next great drop. Feel the purity of the alpine water as it gushes around you and take home the memory of the hypnotic sound of water falling. Under the watchful guidance of qualified instructors, do the unthinkable. Take a deep breath and launch into the unknown.

Opposite and below © Outdoor Interlaken / outdoor-interlaken.ch

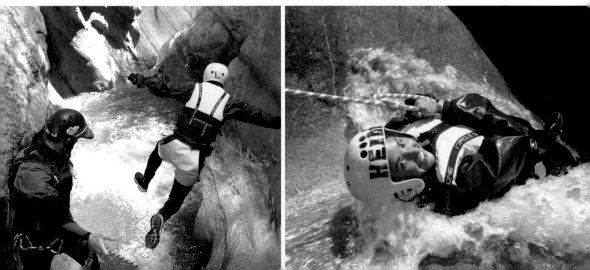

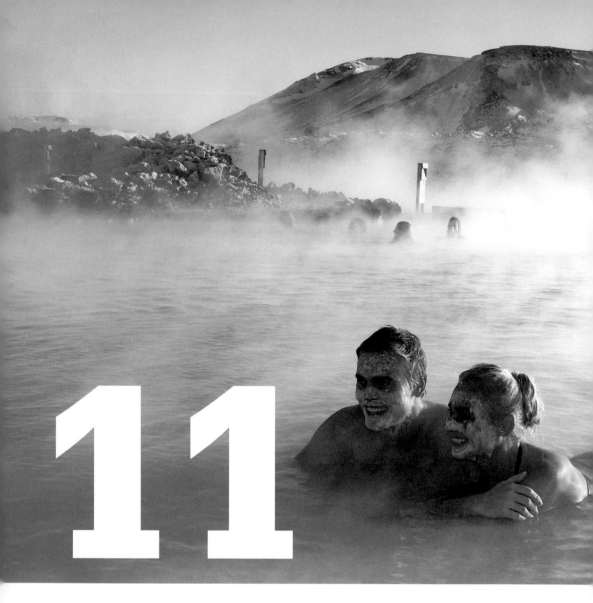

11

Bathe in Iceland's Blue Lagoon

Location Blue Lagoon, Iceland

Complexity A pinch of salt

Cost ●●○○○

Lasting Sentiment Beauty is skin deep

Pamper your skin in rich healing waters. Step into the fairy tale pool of Iceland's natural geothermal lagoon. Surrounded by nothing but rocky basalt landscape and buoyed by the ancient mineral salts in the water, lie back and watch the steam drift upwards towards the sky. Time your visit for the evening in winter and wait for the Northern Lights to spectacularly illuminate the world around you.

Look out across an incredible pool of milky blue, spilt across an ancient lava field, a pool barely contained by the jagged black rock of the adjacent volcanic mountains. A geothermal power plant adds to the atmosphere with its vent of steam blowing clouds into the wind. Step into the lagoon and out of the cold winter air. Wade in deeper to really snuggle in the warm water and feel the active ingredients working on your skin,

The silica, you have been told, will improve your skin's elasticity. The coccoid algae and filamentous algae are proven anti-ageing compounds that are supposed to leave you feeling revitalised. Spread a thick layer of the mineral deposit across your face and feel complete.

From the range of beauty treatments available, book an in-water massage in advance. To enjoy this unique experience, head over to the private area of the lagoon. Here, your specially trained masseur will await you in the water and direct you to slide on to a thin floating mat. Draped in a warm blanket, lie back feeling warm and cosy, embalmed by the lagoon. Gradually the tension in your body will release as you close your eyes and drift off into aquatic heaven.

Opposite and below © Blue Lagoon / www.bluelagoon.com

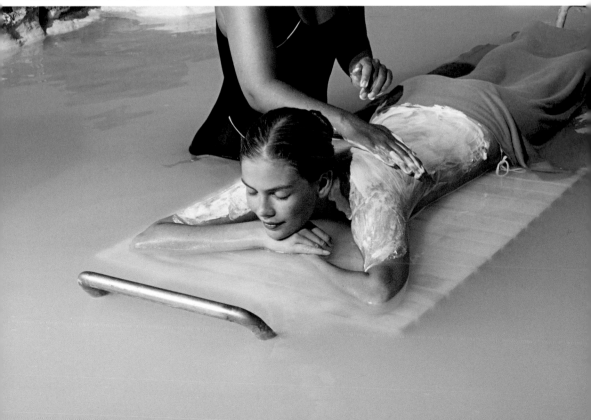

As the atmosphere darkens into night, the blue of the lagoon usually intensifies. Soak looking up at the stars and wait, with an uninterrupted view, for the Northern Lights to appear. If you are lucky, you may see a brilliant green aurora that jostles and blazes above you – the Aurora Borealis and her great sweeps of colour dancing across the sky.

Located 40 minutes by car from the capital city of Reykjavík in south-west Iceland, the Blue Lagoon spa and thermal complex is open daily, all year round. Entering the warm geothermic water when the air is particularly cold is delightful. So the best time to go is between October and April, during the winter. The temperature difference also creates the famous mist that rises evocatively from the water.

For a more intimate experience than in the main lagoon, the Exclusive Lounge offers you a private lagoon 'cell' for up to two people with direct access to the main part of the lagoon, a private shower room for one to two people as well as complimentary towels, bathrobes, slippers and refreshments. Alternatively, book the whole suite for a party of 12 people.

The lagoon has a smooth rock floor and is accessed by walkways, so protective footwear is not necessary. The deepest part of the lagoon is 1.6 metres, so you do not need to be able to swim either.

Below © Leif Petersen

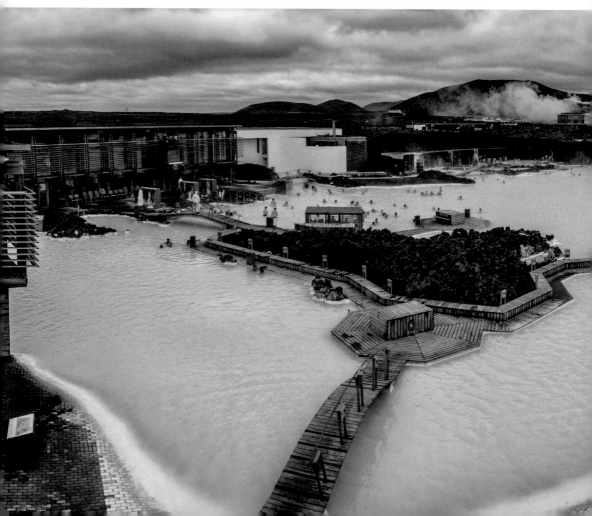

Inflatable armbands are available for children and throughout the 3000m^2 open-air pool there are many shallower areas.

Pumped from beneath the surface of the earth, the water in the lagoon is drawn up to generate electricity and is completely renewed every two days. Three hours is the recommend immersion period and in order to help you remain hydrated, water fountains are located near the edge. Iceland has a strict code of hygiene so it is mandatory to shower before you bathe. Also, washing your hair with conditioner before entering is advisable, unless you like your hair stiff with full body!

If you are Icelandic and suffer from psoriasis or any other skin conditions, you may be interested to know that the entry fee is covered in most Icelandic health insurance policies. The healing benefits have been universally acknowledged, based on chemical analysis of the water.

When you visit the Blue Lagoon, you enter a realm of water, vapour clouds and sky. One or two degrees warmer than a warm bath, the lagoon spa makes for a blissful winter treat. For the most heightened experience, time your visit to catch the Northern Lights. Float in the lagoon as it smokes around you and look up at the incredible array of light in the night sky. A mere 20-minute drive from Reykjavík-Keflavík International Airport, the Blue Lagoon is worth stopping off for.

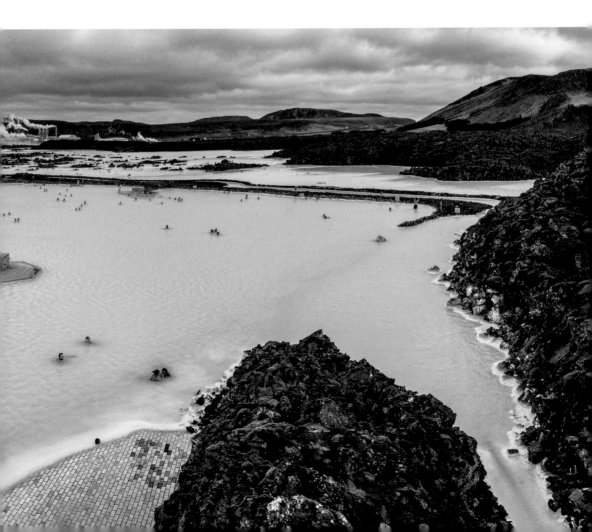

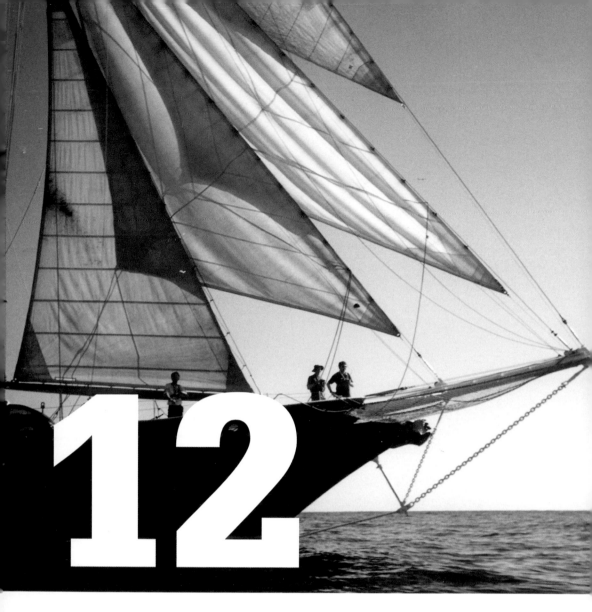

12

Sail on a tall ship in the Canary Islands

Location Canary Islands
Complexity Get out what you put in

Cost ⬤⬤⬤○○
Lasting Sentiment 'I wish I'd done this sooner'

Head for the horizon on a traditional sailing vessel built in the early 19th century. Heed the call for all hands on deck and help pull together on thick, coarse ropes. When the foresails are set and the main sheeted in, feel the surge of power course through the planking beneath your feet. Take in the raw salty smell, the brush of wind fingering your hair and enjoy the simple freedom of sailing away from the shore.

Grip the handles of the big oak wheel: it is your turn at the helm. As the wind drums the edges of the canvas aloft, the sails quiver. The harmony is blissful. A fishing boat lingers in your vicinity. A tanker skims the horizon then drops out of sight. You will learn all the time how to read the environment around you. Listen to the intense rush and fizz around the hull as the ship powers along. Then note when something changes – the sails and rigging start pounding, canvas fighting against rope or a wave ships over the bow and cascades down the deck. The wind has shifted direction.

There are no winches for hauling the ropes as on modern craft, only people, so the skipper will take control of the wheel while you do your duty. More crew members need to be summoned. When the bosun cries 'heave', a slick sequence of organised teamwork unfolds. Finally the sails refill with a glorious puff and the satisfaction is visible on everyone's faces. Order has been restored. A light spray flies across the foredeck as 98 tonnes of boat resumes its purposeful march onwards through the white-flecked waves.

Whether you go for two days or two months, for a week or a fortnight, your departure point has to be the Canary Islands. Part of the traditional clipper route, which made use of the trade winds to transport heavy cargo – coal, grain, rum as well as slaves – to the West Indies and South America, the Canaries are blessed with glorious sunshine as well as a breeze of sufficient strength to drive a tall ship along. Although the islands are popular as a holiday destination, a tall ship experience will sail you away from the busy tourist hubs to the forgotten parts of the archipelago. Resting at anchor in the empty bays of the less frequented isles of La Palma, El Hierro and La Gomera, set foot in communities where bananas rather than tourism is still the main industry.

Opposite © Chris Maurer **Below** © Sail Training International / sailtraininginternational.org

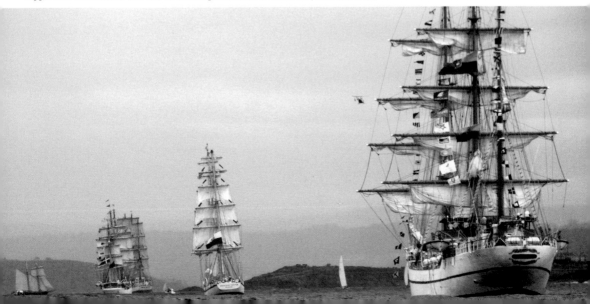

Tall ships usually have two or three masts, which carry square sails including the mainsail, topsail, the sky or moon sails, outer and inner jib and staysails. It can take up to 14 people to hoist one sail, so reasonable fitness is preferable, both for your own enjoyment and in order to be able to play an active part in the working of the ship. There is no age limit so crew age can range from 12 to 80 years old.

For the best vantage point from which to photograph dolphins cavorting around the bow, don't miss the opportunity to climb up the 'ratlines', a series of ladders that run up the sides of the masts. Since Napoleonic times, when crew would switch boats in the dark, nearly all historic tall ships are rigged with similar deck layouts. This is handy, since it is highly likely you may want to return to participate in the Tall Ships Race held annually in Europe.

All voyages are fully catered and while participation in night watches is required, cleaning of the interior is not. Unlike an activity holiday with youth hostel-style accommodation, many of the tall ships are voluminous inside with cabins for two to eight people with either doors or curtains for privacy. There will be a primitive shower on most boats and all offer inductive hot water and flushing toilets. Basic foul weather gear is provided – a jacket and salopettes, although you may wish to purchase your own. Many of the tall ships have a bar inside and tales of camaraderie resound, of singing and music at night.

Whether it is the pleasure of getting away from the land, your time at the helm, the experience of sailing at night under a star-pricked sky or whether it is the wildlife or opportunities to explore remote islands that you seek, in very little time you will become attuned to the seafaring way of life. Reset your senses to the melodic hum of the wind in the rigging. Give yourself over to the simplicity of putting canvas in the air and enjoy the spill and turn of the waves as the wind moves you through the water.

Opposite © Sail Training International / sailtraininginternational.org **Below** © Debbie Purser / classic-sailing.co.uk

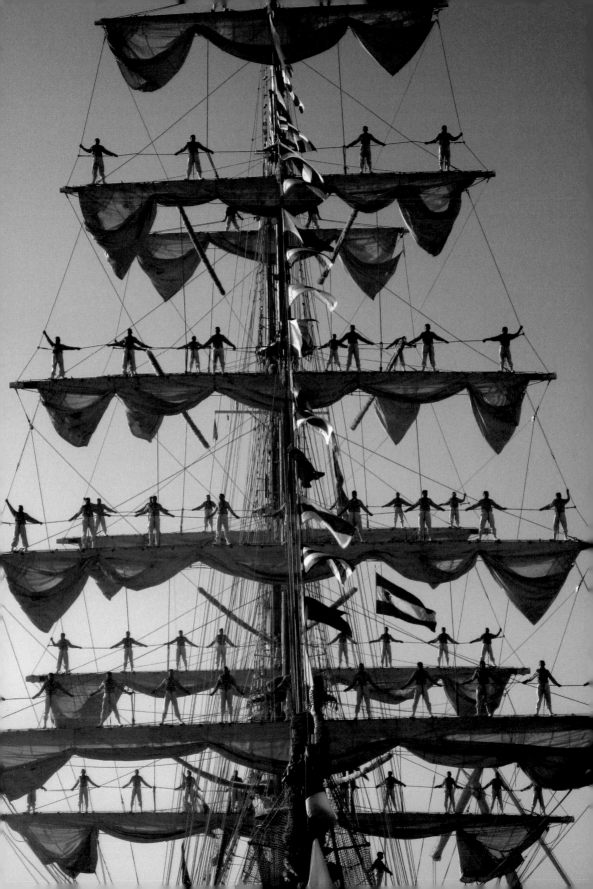

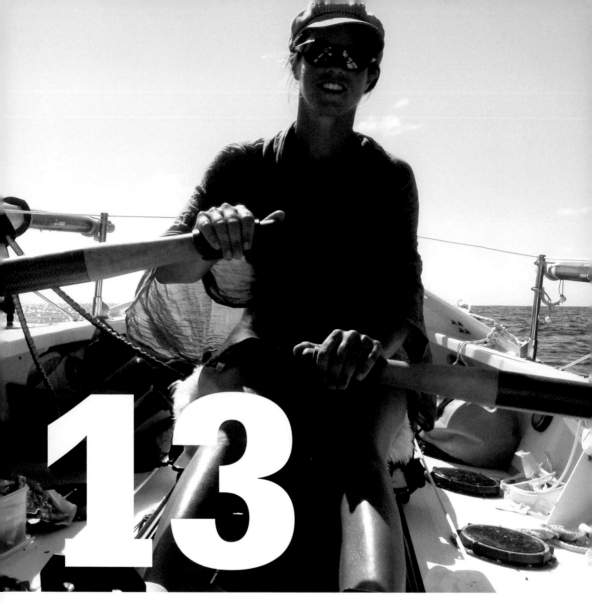

13

Row the Atlantic Ocean

Location Atlantic Ocean: Canary
Islands to the Caribbean
Complexity Hardcore

Cost ⦾⦾⦾⦾⦾
Lasting Sentiment 'Sorry, but did you
just say you had *rowed* the Atlantic?'

Achieve a feat beyond your wildest dreams and row an ocean. Experience the extraordinary magic of living at sea. Encounter an 18-metre whale so close to you that it makes you gasp. Feel the texture of the water change through wind and rain, rowing as the sun rises and sets, beneath a moon so bright you can read a book by it and through endless nights streaked with brilliant shooting stars.

Considered the 'toughest rowing race on earth', the Atlantic Challenge starts in December every other year. Made famous by New Zealanders Rob Hamill and Phil Stubbs and again more recently by Britons James Cracknell and Ben Fogle, the race unfolds over 2500 nautical miles of some of the planet's finest ocean. Starting at the Canary Island of La Gomera and ending at Antigua in the Caribbean, the route follows the traditional course taken by the clipper ships and runs south of all major shipping lanes. Hurricane season is all but over and so conditions are normally favourable.

With help from your friends and family, fundraise to buy and equip an ocean rowing boat to enter the Atlantic Challenge. Your boat must be designed to counteract possible capsize and may have been rowed successfully across before, but your imagination will still run away with excitement and fear of the unknown.

The starting gun fires. You wave your family an emotional goodbye and find your first night at sea physically and mentally gruelling. Once out of sight of land, you will row into sunsets so blazing that the colours fill the whole sky and spend shifts at the oars with porpoises somersaulting and diving merrily around you. For several weeks a shoal of dorado fish may swim beside your boat's hull. When barnacles and weed start to grow, attracting more fish, jump in the water to scrape them off. What you discover could astound you – whole families of fish tagging along for the ride!

Lying in the cabin, you imagine the joy of seeing your loved ones again and fantasise about land and land-based luxuries – drinking a cold beer, sitting on a real toilet and sleeping in a stable bed. Then close your eyes and listen to the whales breaching nearby and fall asleep to the rhythm of the waves gently rocking your boat.

Norwegians Franky Samuelson and George Harbo were the first people to set out to row across

Opposite © Lia Ditton / liaditton.com **Below** © Billy Swinton-Clark

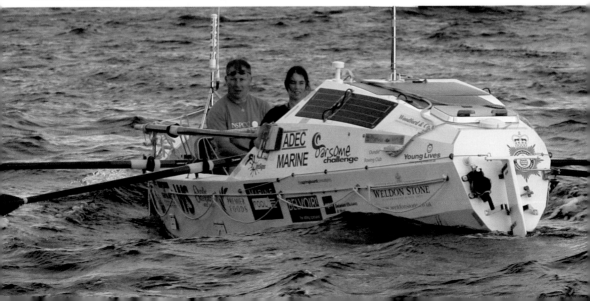

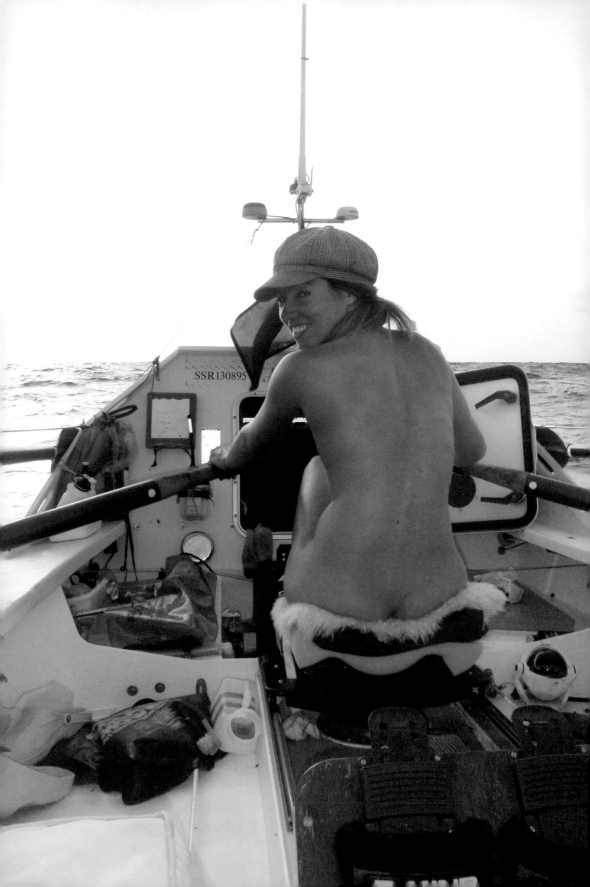

the Atlantic. Leaving Manhattan for the Isles of Scilly in 1896, their record of 55 days and 13 hours stood for a surprising 114 years. It was only recently that ocean rowing developed into a kind of extreme sport and challenges could be made to this long-standing record, with boats being built out of carbon or glass fibre rather than wood. Modern ocean rowing boats have an enclosed cabin at one end and room for storage at the other. The boats are decked out with global positioning systems and satellite communications, with desalinators to make drinking water and active echo transponders to increase radar visibility. However, most rowers prefer to be naked in order to avoid chafing issues and there is nothing hi-tech about that!

Taking between 40 and 70 days to complete as a pair, or as little as a month with six or more crew, your trip across the pond is guaranteed to be a profound experience. While buying and kitting out your own boat could set you back a five figure sum without sponsorship, some of the larger boats are run as pay-per-seat enterprises. A good level of fitness is key, but a compelling drive to do it is more important. Be prepared to get an enviable tan and lose 6–10kg of body weight in the workout of your life. If you're not super-fit to start with, you certainly will be afterwards!

Seafaring experience has so far proved non-essential. In fact many crews go to sea having neither rowed before nor crossed a stretch of open water on anything smaller than a ferry! Certificates for astronavigation, emergency first aid and sea survival courses, however, are a must and many port authorities won't let you cast off without them.

Thousands have reached the summit of Everest, hundreds have trekked to the North and South poles, but more astronauts have been into space than there are people who have rowed an ocean. The oceans remain man's original adventure frontier.

Row into the history books and experience land anew. Take home the feeling that you can achieve anything in life that you set your mind to, knowing that if you row for long enough, you too can row an ocean.

Opposite © Lia Ditton / liaditton.com **Below** © Ted Martin / photofantasyantigua.com

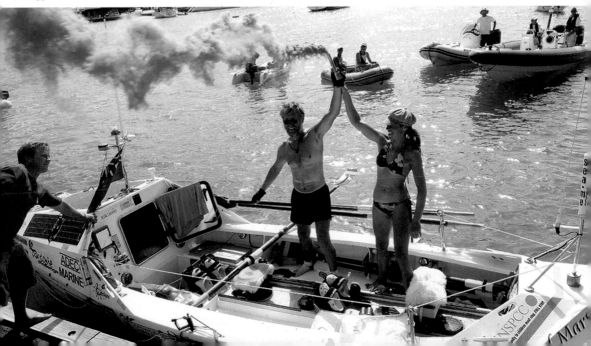

Africa

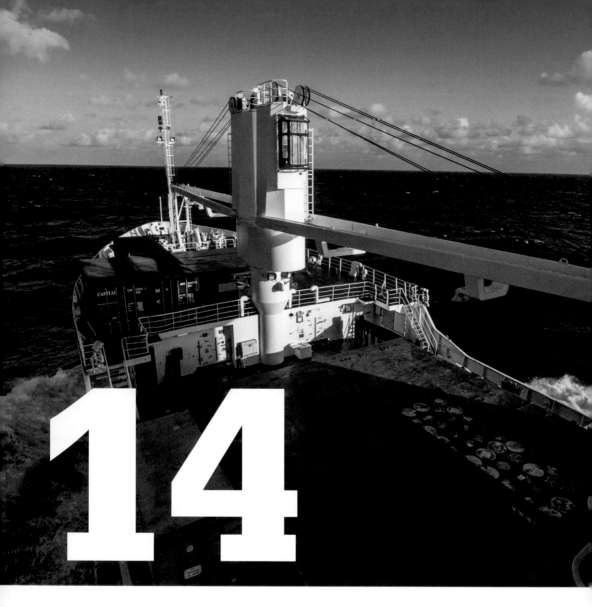

14

Cruise to St Helena and Ascension Island on the last working Royal Mail Ship

Location Cape Town, South Africa to St Helena & Ascension Island
Complexity Cruisy!

Cost ○○○○○
Lasting Sentiment A delightful trip back to a bygone time

All aboard the RMS *St Helena*, the last commercially operating Royal Mail Ship! Follow in the wake of generations, travellers and explorers alike and cruise on a cargo passenger liner to an island where an airport has yet to be completed. Experience the boundless ocean in sunshine and moonlight. Contemplate life. Read books. Swim in the onboard pool and ultimately explore one of the last outposts of the British Empire, St Helena and Ascension Island.

Embark in Cape Town for the five-day bluewater passage and watch as Table Mountain with its impressive cloth of cloud diminishes into the distance. Make yourself at home in your cabin and then head back on deck with a copy of the daily *Ocean Mail*, which gives details of life on board. As you soak in the gorgeous sunshine beside the pool, read about the array of entertainment you have to look forward to. From deck cricket and deck skittles to quiz nights and sunset barbecues, make a note to sample a bit of it all.

At the formal Captain's cocktail party you will find yourself sharing a dining table with a fascinating mix of passengers from around the world. Many are 'Saints' (residents of St Helena) going home to visit their families. For the Saints, the ship is a lifeline ferrying passengers and supplies that range from wind turbines to automotive parts, goats to Christmas turkeys. Expect entrées of St Helenian delicacies such as spicy fish cakes and pumpkin stew followed by an excellent choice of tropical fruit. After a tasty brew of St Helenian coffee, go for a breath of fresh salty air. Alone on deck, you may just sight a pod of whales passing by.

Opposite and below left © St. Helena Tourism / sthelenatourism.com **Below right** © Jon Tonks / rms-st-helena.com

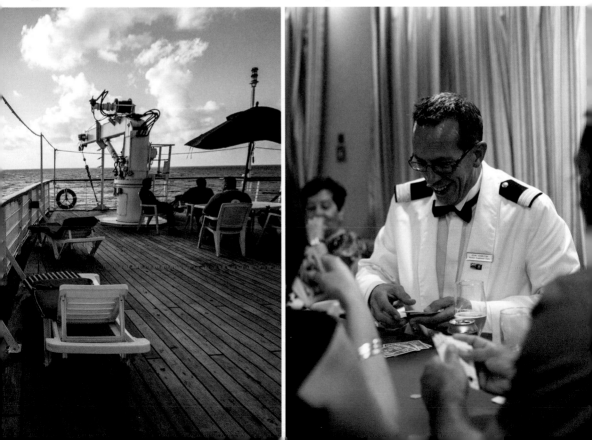

The rumour of 'land ahoy' spreads among the passengers as the bronze, volcanic, wind-chiselled rock of St Helena starts to grow on the horizon. Once ashore, scale the 699 steps up 'Jacob's Ladder' to take in the jaw-dropping view. Contemplate a hike through the subtropical National Park, the habitat of many endemic species such as the wirebird and the bastard gumwood tree, or opt for a taxi tour instead. A visit to Longwood House, where the French Emperor Napoleon Bonaparte spent his final years in exile in the early 19th century, will leave you debating whether Napoleon could really have died from the arsenic in the wallpaper. Visit the tombstone that marks the spot where he was buried until his body was exhumed, and say hello to Jonathan, the giant waist-high tortoise who was born in 1821, on the day after Napoleon died. Considered one of the oldest, if not the oldest living reptile on earth, you may be surprised to discover that Jonathan is still pretty active, particularly with the three other Seychelles tortoises half his age!

Back on the RMS *St Helena*, the passenger mix changes as many young Saints go to Ascension Island to find work, to fly to the Falklands or to the UK. Watch the machinations of a working ship as essential supplies are unloaded, from bags of cement and containers to cars and quad bikes.

Book a cruise between December and early March and take in a night excursion on Ascension Island, organised by the Conservation Office. Comparatively barren, but with a lush green volcanic cone in the middle, Ascension Island has a very different geography to St Helena. Watch the giant sea turtles waddle up the beach to lay their eggs before swimming back to Brazil. Check out the feral goats, wild donkeys and land crabs along with the island's many other wonders and then fly back to Cape Town or the UK in your own time on one of the RAF charter planes.

From the Napoleonic legacy to the abundance and diversity of exotic flora and fauna, the islands of St Helena and Ascension are as rich in history and geography as they are economically poor. Experience the mode of transport of bygone times and arrive by boat. Take a cruise on the RMS *St Helena*, and go on a voyage in the truest sense. Spend quality time on the ocean. Rediscover the joys of time. Then set sail again with bags of St Helenian coffee beans, the most expensive and hardest to procure beans in the world.

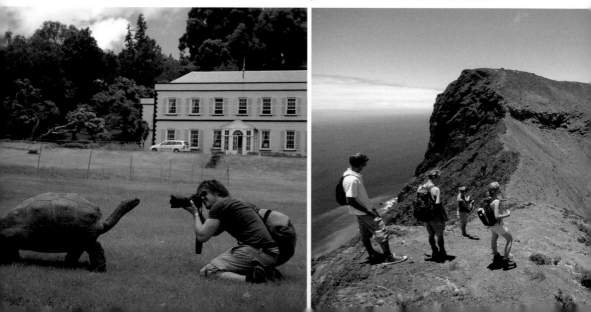

15

Windsurf the Lüderitz Speed Challenge in Namibia

Location Lüderitz, Namibia
Complexity Fast learners may excel

Cost ○○○○○
Lasting Sentiment 'Oh my god, I want another go!'

Fasten your GPS watch and snug up your weight belt. Get ready to zip across water. With nothing more than a lightweight sail in your hands and a section of board beneath your feet, harness your body to pure unadulterated wind power. Sail as fast if not faster than the speed of the wind. Rush down the custom-built speed strip in Lüderitz. The flatter the water, the faster you rip. Then take the shuttle back up, your body still zinging from the incredible shot of adrenalin, and windsurf it all over again.

Head down to the beach mid-morning and like clockwork the breeze will pick up, 20 knots at first then 45 or more. Get dressed in a wetsuit with a Motocross jacket for extra protection over the top. Strap your helmet on well. You are about to go as fast as you've ever gone in your life, propelled by the wind alone. At least, that's what you're hoping.

When you place your board in the water, you step on with healthy measures of fear and anticipation. For a couple of seconds you are in the acceleration zone. Then the wind angle shifts as expected. The channel was purposely designed to slingshot you down the runway. The edge of your board is now tearing at the water's smooth surface while the rest of the carbon-epoxy board flies, levitated by the back fin. Concentrating this hard, you may almost forget to breathe. As you near the end of the track, the mountains moderate the wind strength and you decelerate naturally. A flood of relief follows the endorphin rush, as you wade out of the water trying to digest some of the most intense, exhilarating seconds of your life.

Opposite and below © Eric Bellande / luderitz-speed.com

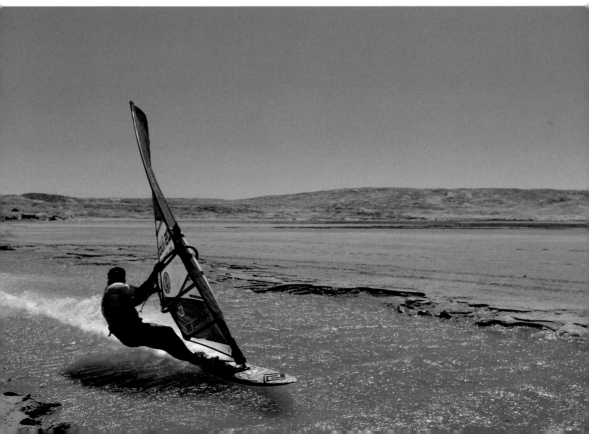

Head where the wind is stable, the water is warm and the conditions are perfect to improve your windsurfing. Even come to learn to windsurf from scratch.

Fly into Lüderitz, or hire a car and drive up from Cape Town through some of the most wild and rugged scenery Africa has to offer. When you cross the border into Namibia and enter the desert, the adventure begins. You will pass beautiful swathes of red sand piled up into rippled dunes, rocky mountains strewn with rubble and dry bush.

Take off up to six weeks if you can afford the time and book yourself a hotel room, guesthouse or self-catering accommodation. Explore in a 4x4 or with a quad bike. Go mountain boarding then head down to the beach. A mere 3km from town by bicycle, the beach is the real lure. From September through to February, the southerly wind blows reliably and warm, straight off the desert.

While chasing records and windsurfing for speed is like car racing and isn't for everyone, it is possible to better your game and simply have fun. Learn from some of the very best professionals in the world. Arrive several weeks before the Lüderitz Speed Challenge begins and receive coaching in a unique way. Watch and copy your teacher as you follow him or her along the lagoon. The water is shallow and fluctuates in height according to the tide, so you will need to be guided at first in any case. From water starts to how to control the force of the wind by angling the sail, benefit from instruction. Windsurf at the right time of day for the amount of wind that matches your ability and you will be surprised how rapidly you progress. Picture yourself sailing faster and faster and, before long, you too will feel the sail communicating with the board. Then, decked out with the safest and most efficient equipment on the market, take a run down the strip. Push your limits and set your own speed record.

When the wind is really pumping during the Lüderitz Speed Challenge, the shared excitement is electric. Spectators scream and holler. Record numbers flash up on the screen. Everybody is willing you to improve. Each run is your own race as much as it is a fight for a potential speed record, so the event attracts professionals and those just fuelled by passion. The camaraderie is outstanding. You take advice and tweak the footstraps, the sail and the board, to finesse the combination and be more efficient on the water. Some of your most incredible windsurfing experience is packed into those 30 seconds. Focus is key. Don't expect to break records right away, but with patience and persistence, you are bound to achieve personal success.

Opposite and below © Eric Bellande / luderitz-speed.com

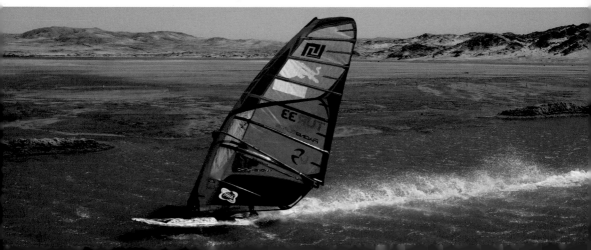

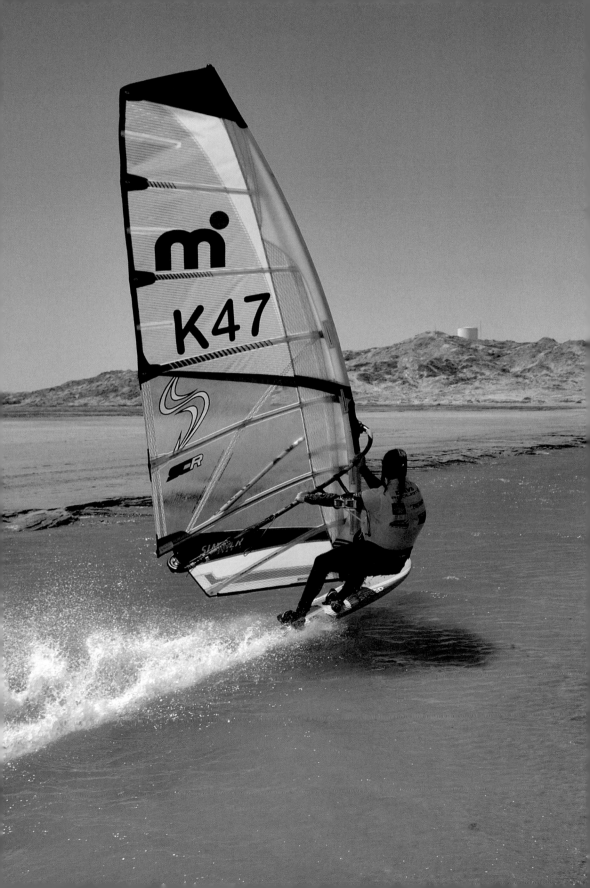

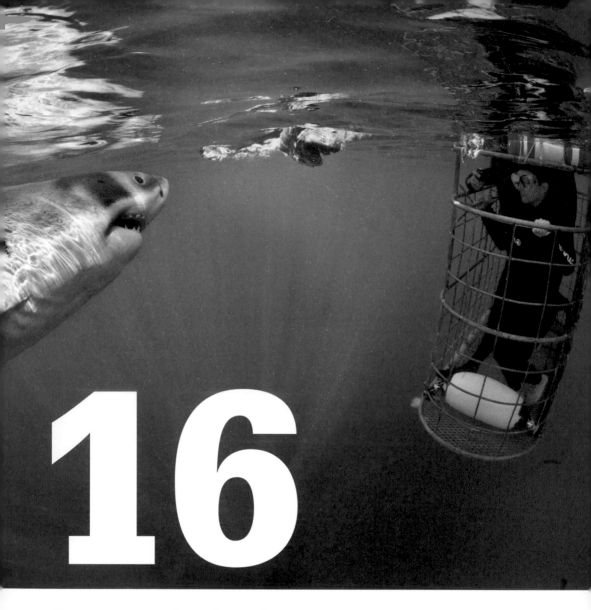

16

Dive with sharks in the Western Cape

Location Gansbaai, Western Cape,
South Africa

Complexity Child's play!

*PADI Open Water certificate and at least 10 dives required to dive with blue and mako sharks

Cost ●●●○○

Lasting Sentiment Close but in comfort!

Share space under water with several of the world's most revered creatures, sharks. From the safety of a cage, watch a great white shark snatch a chunk of bait. Dive among mako sharks and prehistoric-looking cow sharks and interact with the playful blue shark with its big googly cartoon-like eyes. Embrace fear for what it really is, an emotion induced by a perceived threat.

'Go down!' shout the boat's crew. Grab a breath and duck under the water. Within the frame of your mask, look out for a rope being dragged towards the cage. A shadow appears and a great white shark some 3–4 metres in length plunges into view. Transfixed, frozen even, you feel a terrific rush of adrenalin. Like a switch, the shark's eyes flick back into its cranium. You flinch. He lunges blind for the bait. When the shark's eyes reopen, you find your trepidation gives way to awe and fascination. Face-to-face, you are inches apart. Another one, a 1-metre newborn, arrives. In an effort to swallow the bait, he breaches clean out of the water. It's the lack of warning that makes your pulse race. By now your reluctant friend, who was watching the spectacle from the comfort of the boat, has slipped into the cage beside you.

Your next shark encounter takes place some 30–40km off Cape Point. Here in the warm waters of the Agulhas Current, shafts of sunlight seem to spiral down to infinity and the water is an exquisite crystal blue.

Snorkel as mako sharks zoom in, edgy, cautious, but drawn by the smell emanating from the barrel of 'chum' submerged below the surface. With pointy noses and flashes of little white teeth, they could be mistaken for baby great whites. Thankfully the dive company briefed you well on what to expect. Quickly the mako sharks work out that the chum is just tuna pieces and anchovy oil creating an oily slick and they move on.

With breathing apparatus you can spend much longer with the blue sharks under the surface. Relaxed and curious, the blue shark is everything the mako is not. A young one may nuzzle you playfully like a puppy dog or try to nibble on your regulator. Right up to your face he comes, until his nose hits your mask. Just nudge him away gently with your gloved hand. They normally don't mind.

Opposite and below © Dave Caravias / sharkbookings.com

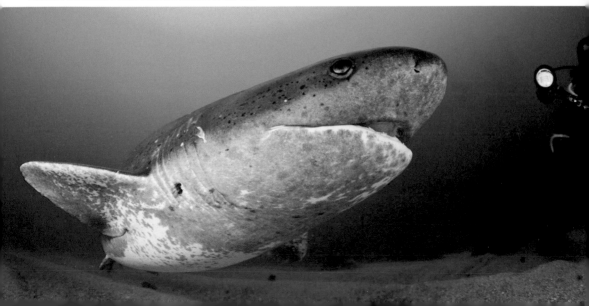

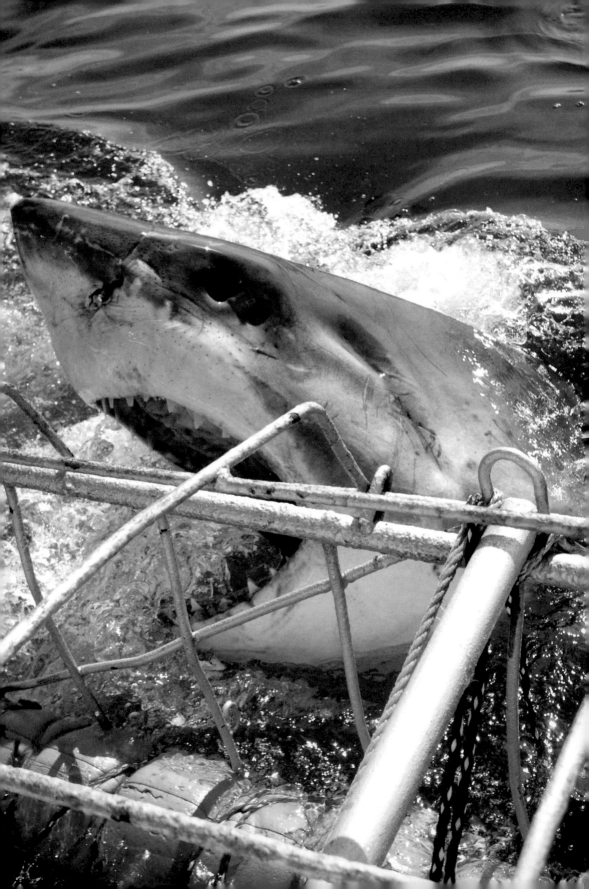

Watch his body twist and curve gracefully to move through the water. The blue sharks look at you while you look at them, seemingly with equal fascination.

Finally you visit the seven-gilled cow shark. Down into the cooler water of the Atlantic, descend for the most relaxed dive of the day. You spot one cow shark moving slowly and nonchalantly and then a second. Like dinosaurs of the deep, they have an antiquated beauty. Dull grey and brown in colour, but with spots, they are extremely photogenic against the backdrop of channels they swim through.

Head for Cape Town, South Africa, one of few places in the world where you can see up close several different species of sharks in one day. A PADI Open Water certificate with 10 or more dives is the only qualification required to dive with blue, mako and cow sharks, although more experience is preferable as the diving takes place up to two hours offshore by boat. To encounter great white sharks, you don't need to be a diver at all. In fact, noise, vibration and bubbles deter great whites, so you hold on to the handrail inside the cage and simply float, either holding your breath or breathing through a snorkel.

All passenger vessels that run the 15-minute boat ride out to Dyer Island, known as 'Shark Alley', are checked frequently and are tightly regulated by South Africa's Marine and Coastal Management Agency. The cages must be strapped to the boats with the ceiling above the water's surface and a lid that flips up to ensure easy access in and out. Great white sharks are attracted to spectator boats for the same reason as they are attracted to fishing boats: to supplement their natural diet of tuna and other fish. Skilled crews work constantly to keep the sharks interested, but as soon as they realise there is no reward, most of the sharks disappear.

The opportunity to be among and often directly interact with blue, mako and cow sharks affords an unusual intimacy with nature, but for a one-of-a-kind experience, any close encounter with the endangered great white shark is guaranteed to shock, fascinate and awe.

Opposite and below © Dave Caravias / sharkbookings.com

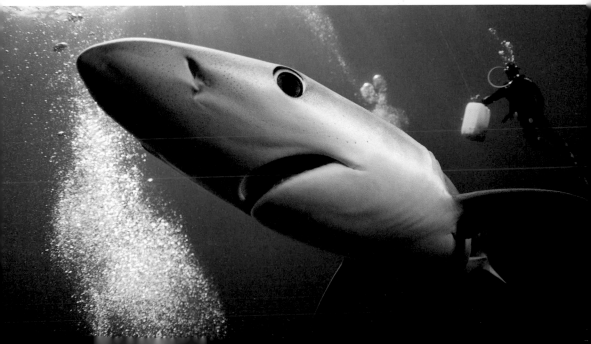

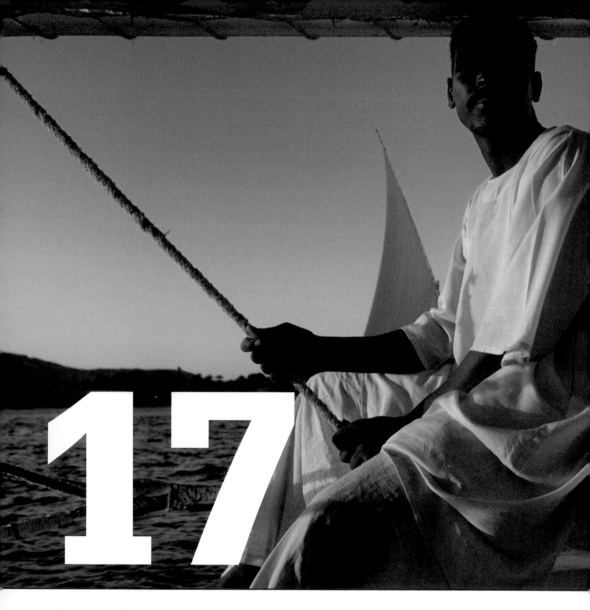

17

Sail the Nile on a traditional felucca

Location Aswân, Egypt

Complexity The ability to relax
is essential

Cost ❍❍❍❍❍

Lasting Sentiment An adventure into
ancient history

Escape the streets of Egypt's busy tourist spots by sailing off gently down the Nile. Step aboard a traditional felucca, a pretty wooden boat with a triangular sail. Take a relaxing tour of a section of the world's longest river, flowing with the current and driven by a refreshing breeze. Watch rural life go by – wandering mules, donkeys and cows. Pass massive sand dunes and sudden oases of green. Stop for blissful swims and fall asleep on deck under the African night sky pinpricked with stars.

Looking back at where you joined the boat, you start to see why Aswân is considered one of the most attractive cities in Egypt. The contrast between the patches of vegetation and sandy grey rock is stark. Aswân is perched on one of the famous Nile 'cataracts', a large granite outcrop found only on this stretch of the river. It was these steep banks of rock that made navigating the river difficult and, as a result, the city became a fortress against invasion and a strategic gateway to the trading routes of the south.

Gracefully your boat glides past Elephantine Island in the middle of the river. You are captivated by the island's small but ancient step pyramid and the temple dedicated to the ram-headed god Khnum. Expect the 'Tombs of the Nobles' dug into the cliffs of the west bank a little further north to whet your appetite for a visit to the larger 'Valley of the Kings' in Luxor. Small villages, which depend upon the river for their livelihood, appear intermittently. You may have expected desert scenery of sand and rock. Instead you will see rich, fertile soil, astonishingly green pastures and pockets of dense palm trees. You will witness intensive cultivation and how prosperous the Nile Valley can be.

There are two bridges, which usually cause some excitement on board. The sail must be collapsed

Opposite and below © Explore! The Adventure Travel Experts / explore.co.uk

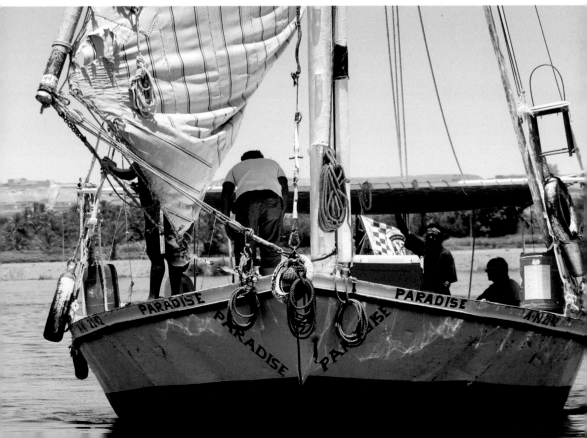

and the lateen rig lowered in preparation for passing underneath. Most voyages are otherwise leisurely and informal, the soundtrack of water rippling interrupted only occasionally by wildlife. Lulled by the smooth rhythm and the pleasant breeze, you may find yourself dozing after lunch or choosing to read in the comfort of the cockpit in the shade.

The boat does pull over for sightseeing stops, at the temple of Kôm Ombo for example. Here you can pay homage to Sobek the crocodile god, who was much needed in times when the river was notable for the number of crocodiles living in its waters.

Feluccas can moor alongside the riverbank or stop for the night beside any one of the mid-river islands. After enjoying fresh food, cooked on board, the camaraderie around a wild camp on the land will leave you with more happy memories.

Since the Nile flows north towards the Mediterranean, board a felucca in Aswân. Take the overnight sleeper train down from Cairo or a direct flight to Luxor. Between Aswân and Edfu there is a rich concentration of things to see and do. From camel treks and the 'Sound and Light Show' at

Opposite © Explore! The Adventure Travel Experts / explore.co.uk **Below** © Hannah Green / explore.co.uk

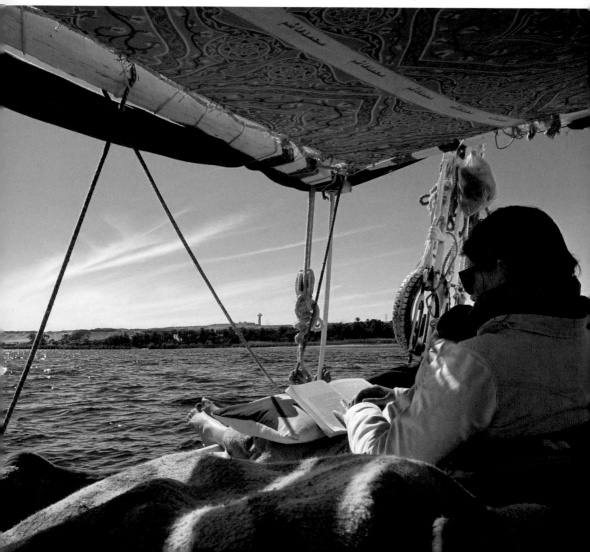

the Sphinx to a trip to the Egyptian Museum, there is also plenty to do before and after your cruise. All-inclusive packages abound. Bring your own sleeping bag for the cool desert nights or rent one to save lugging it around. While some boats do have toilets on board, don't be put off by the alternative. 'Regular pit stops' means literally using a hole pre-dug in the ground. Three nights and three days is the optimum amount of time on board, with May and September being particularly good times to go as temperatures are hot, but not unbearably so.

With only wind in the sail for propulsion, travelling by felucca is a wonderfully peaceful way to experience the Nile. Sail unobtrusively through Egypt and see locals going about their daily lives. The primary mode of transport for centuries, the felucca is still in active use. Where you moor overnight depends on how far you manage to travel during the day. This gives the cruise a timeless quality. Rise with the sun and bed down after sundown, falling asleep under the stars. Swim off the boat in the early morning and go for a dip in the late afternoon. As you drift down this famous river, allow yourself to be transported back to the time of the Pharaohs.

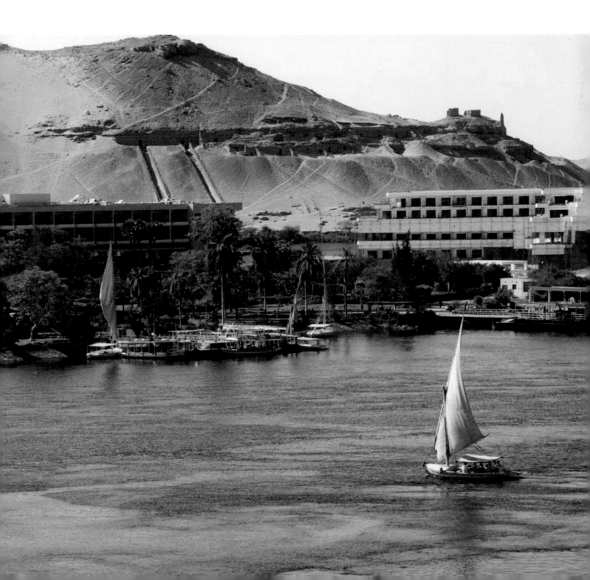

18

Night scuba dive in the Red Sea

Location Sharm El Sheikh, Red
Sea, Egypt
Complexity PADI Open Water or PADI
Advanced certificate, with at least 15
dives, briefing and a buddy

Cost ⦿⦿⦿○○
Lasting Sentiment Who's afraid of
the dark?

Dive into the unknown. Scuba dive at night and see more and larger creatures than you would during the day. Watch the curious nocturnal behaviour of familiar wildlife, such as parrotfish tucked up in the coral asleep. See creatures that only venture out at night and witness aquatic life hunting or being hunted, your heart racing with the thrill of observing the chase.

The moon brushes the water's surface around you with silver light. When your buddy is ready to descend, you leave the stars behind and delve into the shiny black water. At 18 metres your buddy makes a big round movement with his flashlight to ask if you're okay. Once you have equalised the pressure in your ears, circle back, drawing a similar shape with your light. The dark instils a sense of anticipation. Let the show begin!

Attracted by your light, a large octopus approaches, pulsing vibrant colours. He reaches out an arm to stroke your flashlight, as you look on bemused. You count the lionfish, their black, white and red striped gills swaying between poisonous dorsal spines as they start following your buddy around. The lionfish are not interested in him, but are using the light of his flashlight to search for something to eat! A mean-looking barracuda longer than your arm and with big white teeth passes by. You turn away to investigate a coral head and discover as many as 12 different species of crab, which usually hide away during the day. Rabbitfish are everywhere, cowering in small holes. They too only become visible at night. A pufferfish dozing on a coral pinnacle is almost perfectly camouflaged until you swim past shining your light. He rouses, startled like a human woken up suddenly. You watch him apologetically and steer your light away from a sleeping turtle.

As you search along the sandy bottom, you may get a funny feeling. Try not to let your imagination run wild. What lurks around you, only your light can reveal, but the presence of your dive buddy will be reassuring. At night it is easier for you both to keep an eye on each other since the direction of the light beam shows when you are happily absorbed. You are always in company. Looking at the gauge on your regulator, you decide together when it is time to return to the surface. In the mid-water between you and the boat, you make your decompression stop. The phosphorescence here is

Opposite and below © Chris Taljard

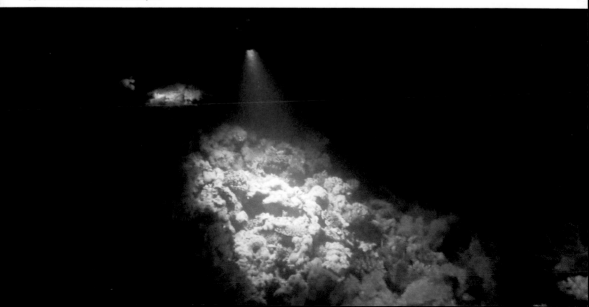

magical, like glittering fairy dust. A light stick on a line dangles in the water above you. You have no trouble finding your way back to the boat.

Join a liveaboard dive boat based at Sharm El Sheikh on the southern tip of the Sinai Peninsula in Egypt and enjoy up to four dives per day in the Red Sea. Staying on board the boat enables you to access brilliant night diving spots that are out of range of day boats. Liveaboard boats range from basic to luxurious, depending on how much you are prepared to pay, but packages normally include a number of dives, cylinder and weight hire, as well as food. You can dive at any time of the year in the Red Sea, which is renowned for its water clarity and exquisite reefs. For warmer water the best time to visit is between June and September.

You don't need to be particularly experienced to dive at night, but you do need to be qualified with a minimum of a PADI Open Water certificate and have a buddy. It is important that you receive an appropriate briefing, as the signals used to communicate are different at night. If you want to draw attention to something exciting or dangerous, for example, you must waggle your flashlight from side to side. Otherwise maintain a nice steady beam. Your primary flashlight should be left on permanently and it is vital you take a tested backup flashlight.

Night diving is an intense experience. Navigating the pitch black, you reach a heightened sense of awareness. The beam of your flashlight creates a focused field of vision. As you start to notice more and more remarkable invertebrates, the time simply whistles by. Octopus, squid, slipper lobster and king crab – if you would like to know what else lurks on the seabed at night, dive down and find out!

Opposite bottom right © Kirsty Andrews **Opposite top left and below right** © Chris Taljard **Opposite top right, bottom left and below left** © Nikki van Veelen **Below right** © Chris Taljard

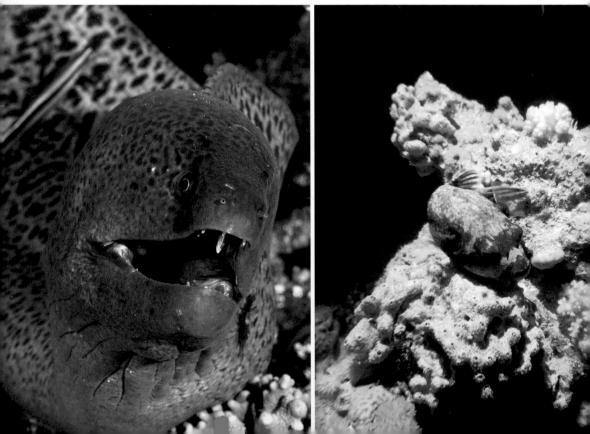

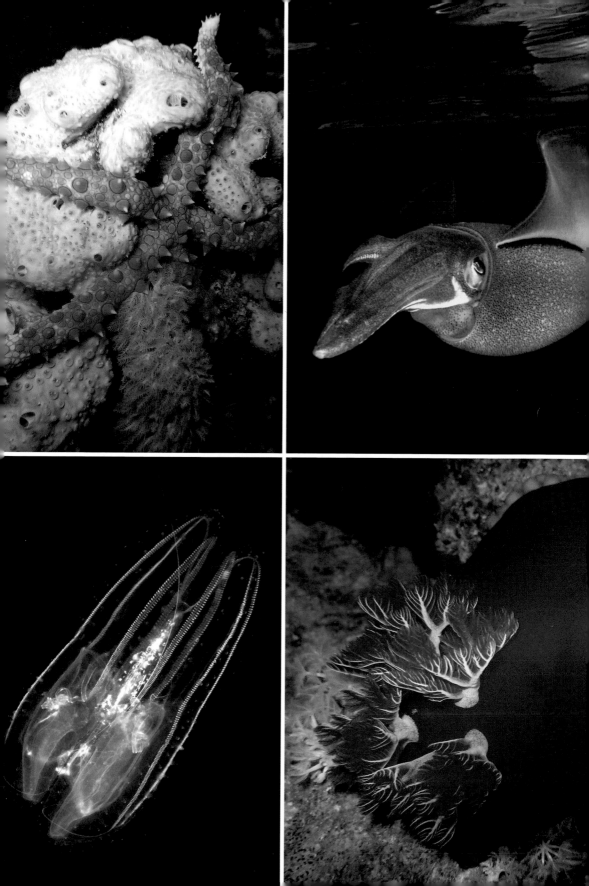

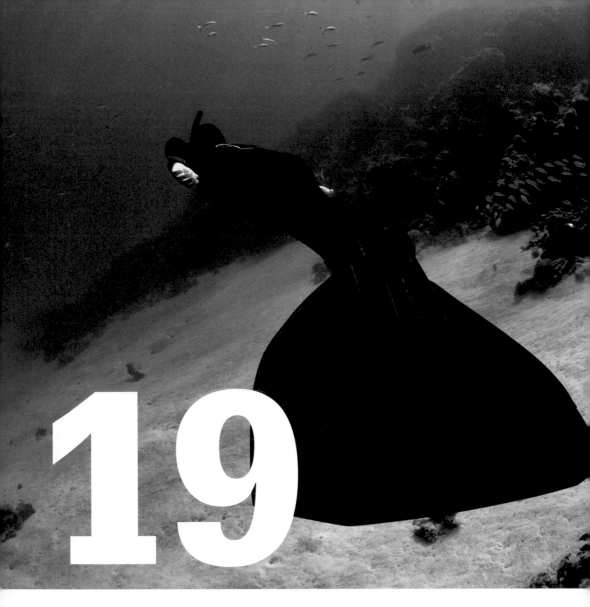

19

Freedive the 'Blue Hole' in Egypt

Location The Blue Hole, Dahab, Egypt
Complexity Freediving is the art of learning to relax

Cost ●●●○○

Lasting Sentiment Amazingly, the body adapts

Immerse yourself in the beautiful blue. Take a deep breath and duck dive into the sea. Feel the power in your body as you kick like a mermaid with your monofin. Follow the rope down towards the seabed and momentarily become part of the ocean. Learn to breathe deeper, more fully and more efficiently and come away with techniques for relaxing the mind and body that may benefit every aspect of your daily life.

Hold on to the floating buoy, close your eyes and drink air into your lungs as if it were a liquid. Leaving your buddy and the instructor watching you on the surface, dive down, swiftly equalising as you descend at roughly 1 metre per second. Random thoughts may come and go. You pass the 10-metre mark effortlessly. Halfway to the 20-metre mark on the rope, you may feel amazingly relaxed. You know that you are human and that soon you must breathe. For now, you manage not to feel this need. Your heart beats calmly, slowing down as rays of sunlight dance around you.

When the urge to breathe arrives, you know this is mainly a physical symptom. Your diaphragm is contracting, trying to make you exhale. Like a car when the fuel gauge reaches the mark to signify empty, you know you can keep going for a much longer time. The water darkens in shade as you push further towards the abyss. Apart from your internal dialogue, the silence presses on your ears. You pause at the 20-metre mark for 30, maybe 40 seconds and a feeling of immeasurable peace washes over you. The negative buoyancy pulling on your whole body is enticing you down.

You remember the sky and look up towards the light. You see the figures of the instructor and your buddy, silhouetted against the sun. The lighter blue looks inviting. Now your body craves air. The

Opposite © Jacques de Vos / jdvos.com **Below** © S. Ellermann

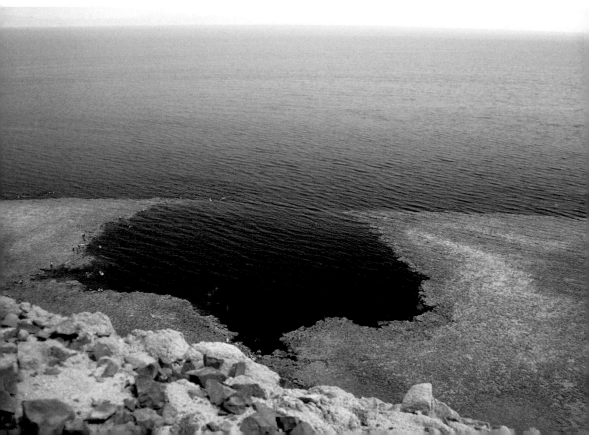

craving becomes more desperate but you exercise control. As you ascend, you rediscover your body, metre by metre. Feel the volume of air captured in your lungs expand. Finally you break the surface and breathe. You heave air gloriously into your lungs. You have just taken your body beyond the limit of what you ever thought was possible.

For calm, current-free conditions underwater, head to Dahab, Egypt. Situated 100km north of Sharm El Sheikh, partway up the Gulf of Aqaba in the Red Sea, Dahab boasts a submarine sinkhole, an open underwater cave called the 'Blue Hole'. The Blue Hole is situated 30 metres from the beach and plunges to a depth of 130 metres, making it the perfect playground for freedivers. The walls of the hole and surrounding area support an abundance of coral and reef fish. The visibility is more than 30 metres in most directions and you may share the water with turtles, barracuda and eagle rays.

Considered the purest form of diving, freediving as a sport is all in the mind. You need to be capable of moderate exercise only and comfortable in the water. A two-day course will introduce you to the mammalian diving reflex triggered by cold water hitting the face and how to initiate your best response. Starting off poolside before venturing out into open water, you will learn about the safety protocol and pressure-related issues, as well as equalisation techniques, techniques for oxygen conservation and efficient movements to carry you down to 20 metres.

Book with an established freediving school and look for instructors with reputable experience. Courses are certified either by the SSI (Scuba Schools International) or AIDA, the association for the development of freediving. Expect basic equipment to be included – a wetsuit, weight belt, long freediving plastic fins for entry level divers and a lower volume mask to save air on the way down. You can freedive in Dahab all year round, although September and October are the optimum months for warmer water and more moderate air temperatures.

As a child, did you ever try to see how long you could hold your breath? Maybe you wanted to touch the bottom of the swimming pool, to see how deep you could go? Italian freediver Umberto Pelizzari wrote that if the scuba diver dives to look around, the freediver dives to look inside. Face down and underwater, you gain a different perception of the environment both within and around you. Every breath-hold is a new experience.

Opposite and below © Linda Paganelli / freedivedahab.com

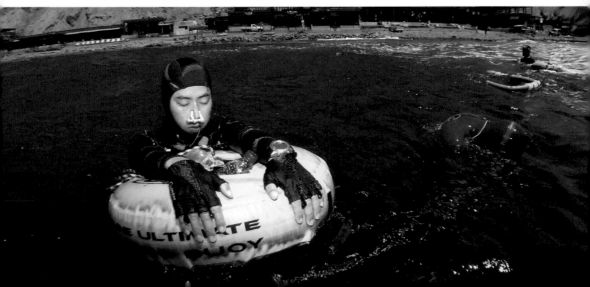

Americas

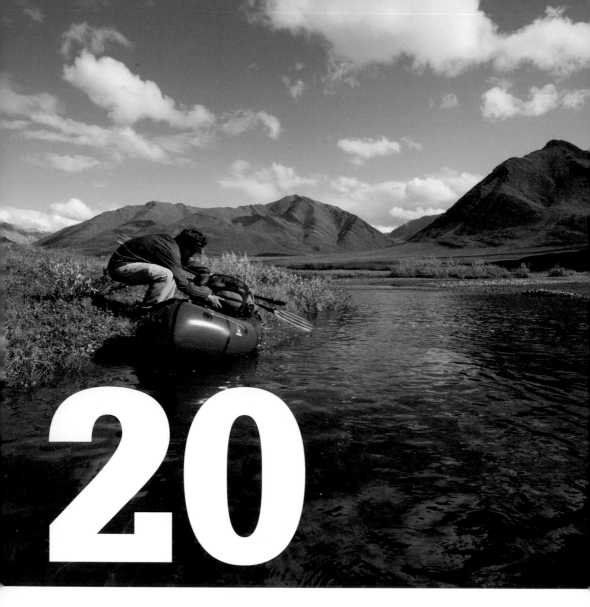

20

Packraft in Alaska

Location Brooks Range, Alaska
Complexity Pack-hiking fit and basic ability to read water

Cost ⦿⦿⦿⦿○
Lasting Sentiment Lightweight freedom. Leave the shore and explore!

Expand your horizon. Stuff a packraft and a paddle in your backpack and go on a boundless adventure. Hike unimpeded by rivers and lakes. Cycle beyond waterways by putting your bike on a packraft and continuing your ride on the other side. Descend waterfalls and float down white-water runs. Without the need for storage space, a car or help launching your vessel, simply take a bus into the countryside and paddle wherever you fancy.

Introduced into Alaska as a practical way of crossing rivers, packrafting has evolved into a popular backcountry pursuit. Whether you need to cross a body of water or just want to try a different mode of travel, unroll your packraft. Screw the nozzle of the inflation bag into the raft and scoop air into the bag. The air is cleverly squeezed into the boat when you hug the bag to your chest. No need for a pump. Two minutes later, strap your backpack to the bow, settle yourself comfortably in the rear and draw the elastic of the spray deck around your chest. Insulated against white-water spray, wind and rain, like a fish you can head into the flow. The packraft feels light and responsive. Simply turn your bow 45 degrees upstream and stroke your way across to the other bank.

You may decide to continue on downstream. Even though everything you need to survive is contained within your boat, the raft remains stable and easily manoeuvrable. You can cover miles of open water while your feet enjoy the respite from hiking. Finally, when you are ready to hop out, pull up at your leisure and deflate the raft's single air chamber. The size of a sleeping bag, the packraft stashes nicely in your backpack. Less than 2–3kg in weight, soon you are hiking up through the forest, with your sights set on the next meandering creek.

Opposite and below © Roman Dial / packrafting.blogspot.com

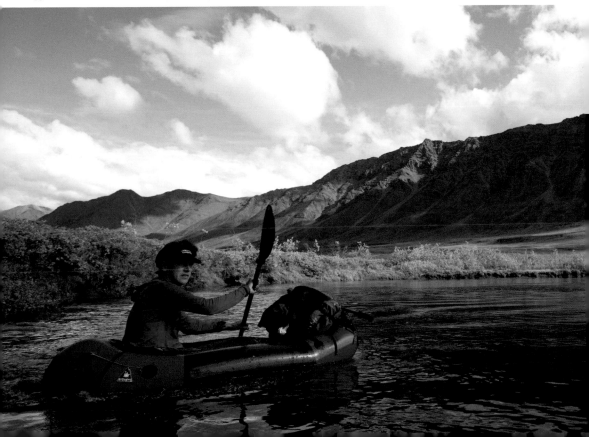

For a classic packrafting trip, travel to the Gates of the Arctic National Park in northern Alaska. Seventy-five miles south of the Arctic Ocean, here you will find thousands of acres of dramatic scenery descending towards Kotzebue Sound. If you have the time, cover the entire 400-mile route from east to west. Paddle sections of the Anaktuvuk River, the John River, Wolverine Creek, Pingaluk River, Alatna River, Circle Lake, the Noatak River and the Ambler River, trekking up and over the ridges and mountain passes in between. Through crystal clear mountain spring water, paddle at every pace. From slow moving to Class 3 white water, navigate rivers banked by brush-free Arctic tundra and stunning boreal forest and every variation in between. For a more abridged version, coordinate with the pilot of a floatplane. Get dropped off near the iconic Arrigetch Peaks and you will understand why 'arrigetch' is an Iñupiaq (Eskimo) word meaning 'fingers extended'. When you hike-raft from here, enjoy incredible views of the spiralling granite peaks.

Available to rent or buy, packrafts come in different models to accommodate variations in body height and situational use. Designed to make wilderness boating accessible, there is no other boat this versatile. A partially inflated packraft also doubles as an air mattress. The packrafting paddle is equally ingenious. It deconstructs into four pieces to provide a tent-pole for a pyramid tarp. Add a map to your backpack, a GPS unit and a gun or canister of pepper spray to ward off any bears and you are ready to explore one of the world's harshest landscapes.

However far you choose to travel through 'The Gates of the Arctic', the best time of year to go is August, when the insects are sparse, the days are long and the bush colours are beginning to intensify. Plan ahead and mail food parcels to the post offices in Anaktuvuk Pass, Circle Lake or Pingo Lake and definitely hire a satellite phone for emergency use.

If a hard-shell kayak is the road bike of watercourses, the packraft is the all-terrain mountain bike. Go where there are few people and no trails. Step off the grid and traverse through jaw-dropping expanses of rugged wilderness. Hike up over mountain passes and down into vast rocky valleys, following the trails of sheep, caribou, wolves and moose. When you reach a body of water, you have the best tool for the job. Inflate your packraft and free yourself from the constraints of land.

Opposite and below © Roman Dial / packrafting.blogspot.com

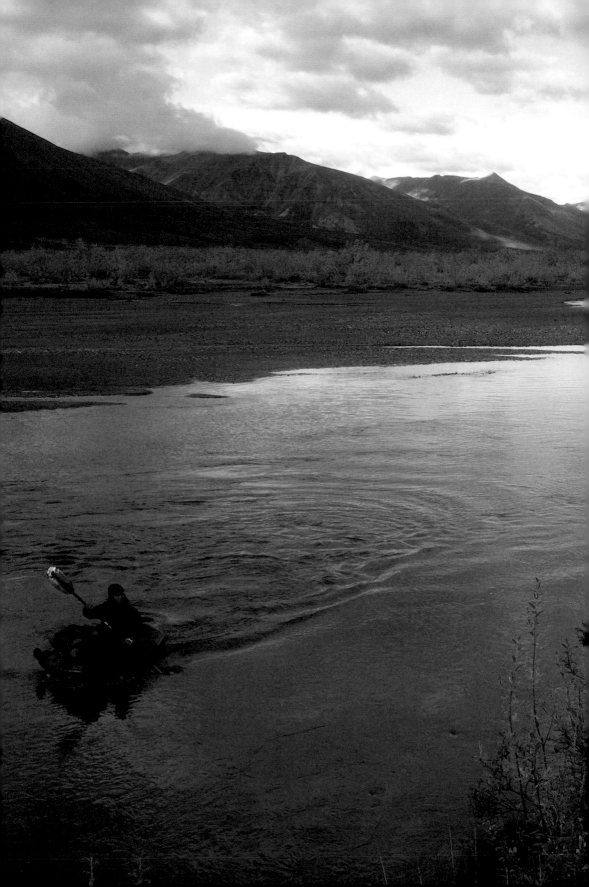

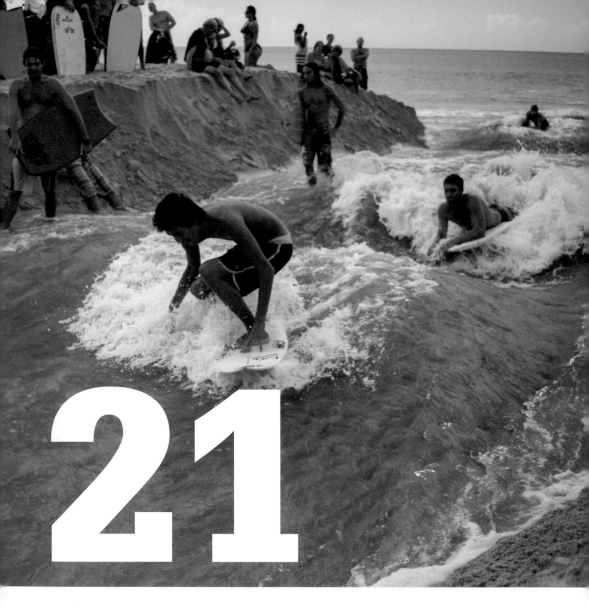

21

Surf a river wave in Hawaii

Location Waimea River, Oahu, Hawaii

Complexity From bodyboarders to experienced surfers

Cost ○○○○○

Lasting Sentiment If a body of water can be ridden, surfers will always find a way

Live the dream of surfing a perfect never-ending wave. Launch yourself into the Waimea River and carve back and forwards on an endless ribbon of water. As hundreds of tonnes of water pass underneath you, it is hard to comprehend how you are able to stay in one place. Put your skills to the test, over and over again. Ride until you are ready to step off. Then allow that beautiful lick of water to propel you into the sandy bay.

Every two or three years, a natural phenomenon turns fantasy into reality. The location is Waimea Bay, Hawaii, on Oahu's North Shore. The time of year is January or February and you are needed to help make the event happen. When locals, professional surfers and lifeguards put out the call for assistance in opening the Waimea River, hop on a plane, pick up a spade and head for the beach.

At first the rivulet may be narrow and shallow, but soon the flow will begin to pulse, carrying sand out into the bay. With everyone shovelling sand out of its path, the river should soon really begin to rip. Two-foot, then 3-foot standing waves, the waves climb spectacularly high as the banks widen.

It's your turn to launch in and surf. By now, some 200 spectators have lined the banks. 'Go, Go, Go!' they shout encouragingly. Some 30 surfers are already in the water – there are that many rollers to play with. Surrounded by high banks of forgiving sand, step up and enjoy your moment of serenity. Surf the wave that just keeps on giving, until you bury your board or the current happens to catch you out.

Surfing on the Waimea River first started in 2005, when a mass of water from the river broke through the sand berm, a high ridge of sand that usually separates the river from the ocean. The ensuing stream began pouring into the sea and a fast-flowing surfable wave-stream was born.

Opposite and below © Matt Catalano / neverendingsearch.net

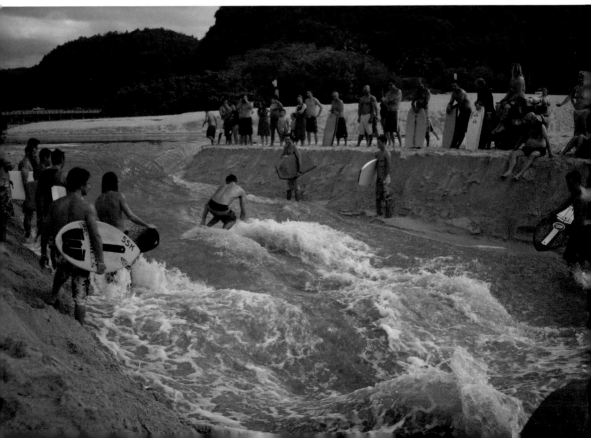

Since then, whenever a strong storm hits the beach and the sand creates a natural dam that blocks the outlet of the river, or the water level in the river backs up with winter rain, surfers leap at the opportunity to help redirect the bulging river.

Each surf session only lasts two or three hours, before the bank silts up and the channel must be dug again. Moving the sand artificially does not damage the environment or disturb wildlife that lives in and around the water. The river would eventually burst its banks anyway, so the process merely helps nature along.

Expect to meet surfers and bodyboarders, teenagers and adults of all nationalities as you muster on the beach. The occasion attracts a crowd and surf pros like Kelly Slater have turned up in the past. There is never any competition to catch the waves. Nor do you need to chase the waves down as they always break in the same place. Use a short board with fins to give direction and provide stability, or a small but wide board with good flotation to launch into the flow.

Riding a standing wave is technically more difficult than riding an ocean wave. The challenge is neither the power of the wave nor the depth of the shoal, but the art of maintaining control in the stream. You may be quick to pick up the nuances of how the wave operates – where the power spots are, where the wave is flushing through really fast and which parts of the wave are retentive. If you've never ridden a single wave, this may not be the occasion to try, but throw on some boardshorts all the same! You can still slide into the flow and try; ride the train and bodyboard out into the bay.

With its incredible surfing history, Oahu is worth a visit even when the river wave is not in action. Famous for its long days and big waves, Oahu has inspired surfers for generations, and it was here that tow-in surfing began in the 1990s, prompting surfers around the world to attempt to ride the biggest and baddest waves on the planet. More recently, the Waimea River wave gave a local bodyboarder the idea for a new type of wave machine, which can now be found in some 3000 water parks worldwide.

A natural phenomenon, surfing the Waimea River is an event with no schedule. Conditions simply have to be right. When the opportunity arises, don't miss the scene. Witness a standing wave in the making. Rather than hunting intermittent waves in the sea, enjoy the rarity of surfing a non-stop river wave and joyride as many rollers as you physically can.

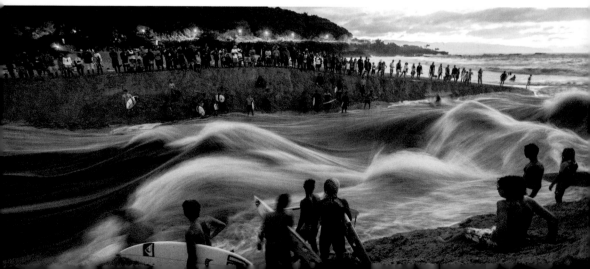

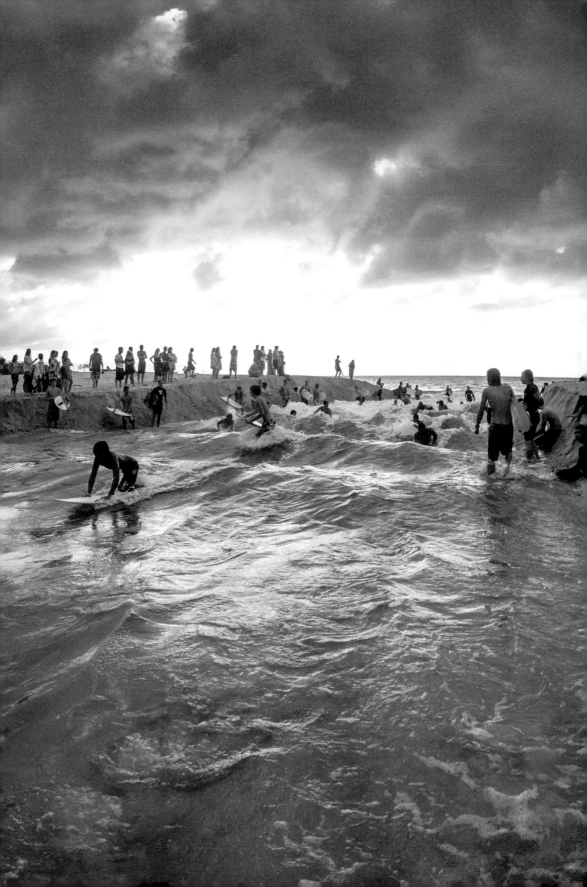

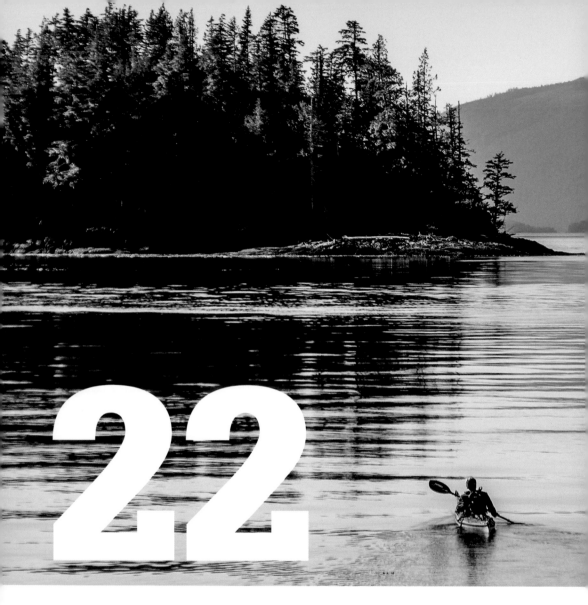

22

Kayak-camp in British Columbia

Location Broughton Archipelago, British Columbia, Canada

Complexity As challenging as you make it

Cost ○○○○○

Lasting Sentiment Into the wild

Explore with the freedom that only a kayak affords. Power yourself in the direction you want to go and carry in your kayak everything you need to camp and survive. Take in great sweeping vistas as you glide, countless picture-postcard panoramas of fairy-tale forests and faraway mountains. As you draw your paddle through the shimmering crystal blue, a very special encounter may jolt you from your reverie – a pod of dolphins, a curious humpback whale or a seal poking his nose up to say hello.

Kayaking allows you to weave your way deep into the heart of places of outstanding natural beauty. Enjoy each day as an amazing sea safari. From Telegraph Cove, potter along the shore of Vancouver Island. If your guide has a research-grade hydrophone, once in the vicinity of a pod of orcas he will be able to deploy the hydrophone so that you can hear the killer whales communicating.

Paddle between tiny islands, remote and uninhabited, where breathtaking views await you round every corner. Even when the glassy flat water becomes peppered with raindrops, there is something quite magical about the sudden broken stillness, the rain drumming away on your boat. The cloudburst clears the air and the smell of lush green vegetation often lingers afterwards.

Finally you reach your target campsite for the night. As the tide rolls away, pluck fresh oysters straight off the rocks and clams from the exposed sandy beaches. For supper, enjoy freshly caught salmon sliced open to cook in a camp-made wooden skillet of burning cedar. Then watch the light fade and the stars begin to shine through the dark night sky. Lying comfortably in your sleeping bag,

Opposite and below © Jaime Sharp / worldwildadventure.com

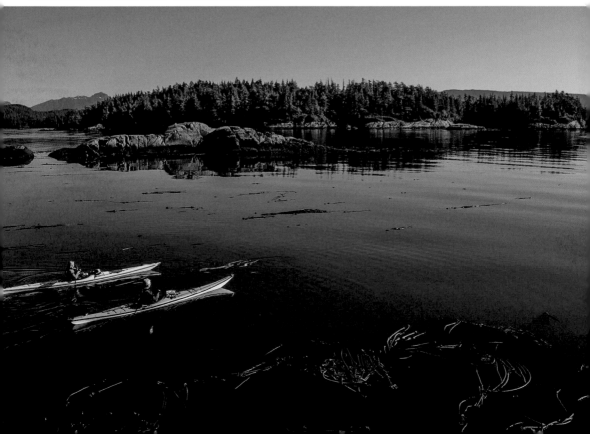

listen to the silence, punctuated only occasionally by the melancholic cry of a gull on a nearby rock or the growl of a sleepy seal.

Situated to the north-east of Vancouver Island, the Broughton Archipelago is a touring kayaker's dream. With an array of islands and ancient glacial fjords to explore, the area caters for all abilities. You needn't be particularly fit or experienced a paddler; the right gear will suffice – a solid North American-style sea kayak with large hatches for plenty of food storage and a rudder system for power steering. Waterproof clothing and a rain tarp are also recommended.

Plenty of options are available out of Port Hardy, Port McNeill and Telegraph Cove, including water taxis and boat rental outlets as well as guides offering to take care of the planning for you. Known as 'float and bloat' trips or 'gourmet wilderness paddling', book a guide-cum-chef and lap up a menu of tasty seafood dishes along the way. A minimalist approach of army ration packs and snack food is an independent option, although you needn't rough it. It's easy to catch your own fish, either with a rig off your own kayak or by jigging around the rocks for lingcod and greenling. Leave a folding crab trap in the bay while out kayaking and you can even pull in crab for breakfast.

Opposite and below © Jaime Sharp / worldwildadventure.com

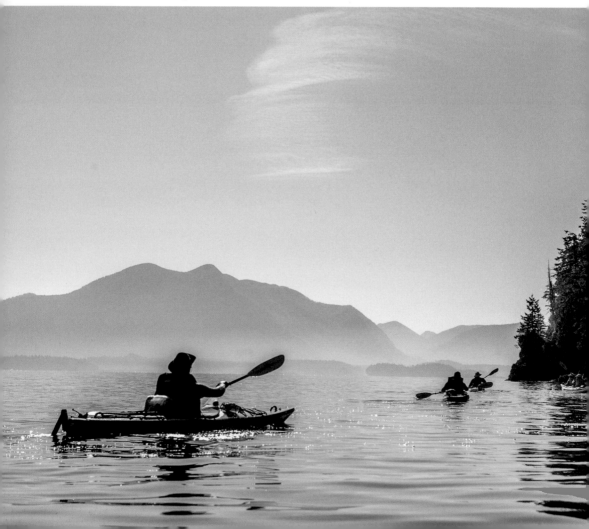

There are several designated campsites and even a handful of lodges run by micro-communities that live out on the islands all year round. These offer B&B (Burger & Bed) especially for kayakers, although freedom camping is allowed on most government-owned 'crown' land. While the archipelago may be abuzz during the day with bush planes, coastguard vessels, recreational fishing boats and the odd cruise ship in the main channel, by the evening even the fishermen have gone home.

It is hard not to be captivated by the mystical landscape of British Columbia's Broughton Archipelago. The clearest in the world, the water is a cold steely blue, giving the area a wild and mysterious quality. A natural sanctuary for birds, expect to see countless eagles, great blue herons, gulls, cormorants, oystercatchers and shearwaters as well as migratory sea birds galore. Cougars, North American black bears and sea lions, they are all out there.

Whether you spend a week or a month in the area, you will experience true wilderness. Nothing beats gliding under your own steam across the barely rippling surface of a beautiful two-way mirror, seeing starfish, anemones and sea slugs among the tidal life 15 metres below, as the morning sky changes colour around you.

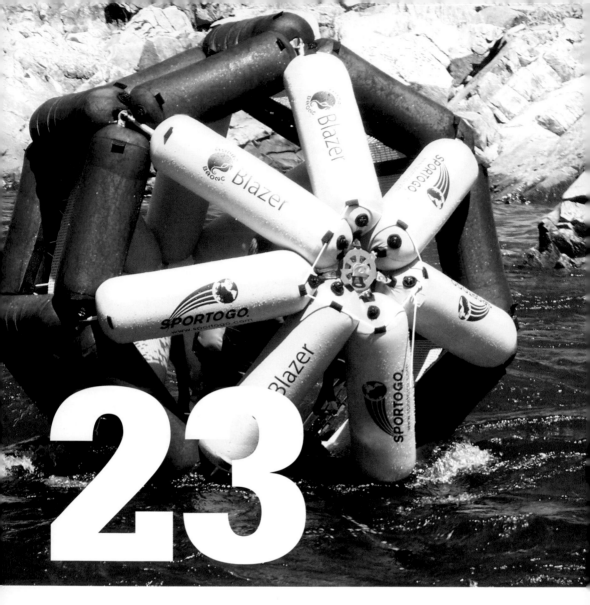

23

Joyride a Hydro Bronc in California

Location The American River, California, USA

Complexity Not a pushover

Cost ○○○○○

Lasting Sentiment Bronc'ers!

Achieve the unbelievable: walk on water. Step inside an inflatable Hydro Bronc and move as if running on a treadmill. Except instead of running up an imaginary hill, run up the face of a real wave. Run out from the beach into the ocean or down high-class rapids too dangerous for white-water rafts and kayaks. Descend safely over extreme drops and waterfalls. Or simply get some exercise with a leisurely morning jog across the surface of a lake.

Climb into what appears to be a giant inflatable hamster wheel floating on the water. Attach your safety harness to the two swivels and adjust the straps. This will ensure you remain centred in the Hydro Bronc even if you lose your footing. Stand up on the mesh track, which runs along the centre of the craft, and kick off from the bank! Once you have clasped the two webbing handholds, you are ready to run.

As you take a step forward, the Hydro Bronc moves forward. Take a step back and the Hydro Bronc moves back. When you start to run, the Hydro Bronc begins to revolve around you. Lean your upper body towards the direction you would like to go and the Hydro Bronc leans in that direction too. Try to avoid manhandling the craft or lifting the inflatable using the handholds. In fact, the less you think about it, the more instinctive the motion becomes. Soon you are navigating entirely subconsciously, steering the Hydro Bronc by adjusting your centre of gravity. Water rains from the revolving tubes as waves slosh in over your calves. You are totally soaked. Still, the desire to run faster is immense and the momentum quickly carries you away. When you look through the net,

Opposite and below © Sportogo Inc / sportogo.com

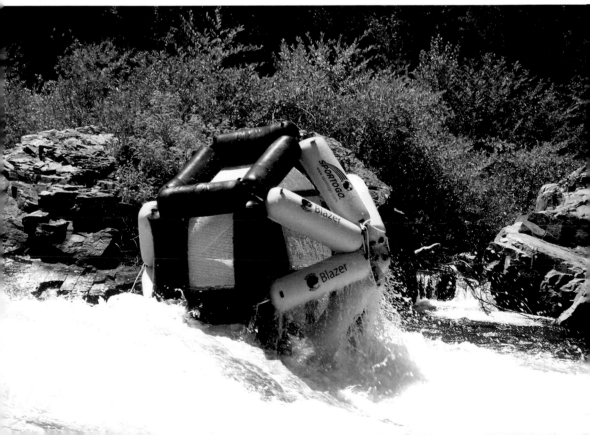

out through the gaps between the tubes, you are focused on the landscape coming up outside. The sensation of powering along using nothing but your own energy delivers an incredible rush. Running on a bed of air, at speed, down a river, makes you feel nothing short of superhuman.

Bizarrely classified by the United States Coast Guard as an inflatable surfboard, the Hydro Bronc consists of seven independent air chambers and is 100 per cent inflatable. If you lose air in one bladder for whatever reason, the performance of the craft will remain the same. Designed for ocean and white-water excursions, the Hydro Bronc was created in response to the need for an inflatable boat that doesn't flip during extreme white-water rafting. Ultramarathon runners looking for low-impact aerobic exercise have since adopted the Hydro Bronc as a training tool, and lighter-weight units are currently in development.

The versatility of the Hydro Bronc means it can be enjoyed over any kind of water. From running around the choppy Bosphorus in Turkey to bouncing down Class 5 white-water rapids through the North Fork tributary of the American River, there is no end to where you can take your Hydro Bronc. Choose your tube colours, receive your order and head for Sacramento, California for starters. 'Put in' at mile 3.3 and spin your way through the 28-foot-diameter diversion tunnel left over from the Auburn Dam. Next, tackle the more challenging Class 3–4 'Pump Station Rapids'. With strong reversals that might otherwise flip boats and hold swimmers, experience here the Hydro Bronc in its element.

A typical raft pump is all you need to get rolling. Water shoes to protect your feet against the net are recommended and a buoyancy vest is a legal requirement in most countries. While Class 6 rapids are considered on the International Scale of River Difficulty to be 'unraftable' (aka suicidal), Class 9 rapids have been safely run in the Hydro Bronc on stretches of the Zambezi River. If crashing down canyons is your goal, be sure to pack a bag of polypropylene rope for rescue purposes and strap a can of spare air to your waist. The canister is not for the bladders of the Hydro Bronc, but for you, just in case you find yourself temporarily immersed in white-water froth.

Take the Hydro Bronc for a walk on water. Strapped inside a big inflatable orb, joyride down white-water courses too dangerous for other craft. Just when you get into a good rhythm, you may be challenged, rebound off another rock and spin off in another direction. Using your upper and lower body at the same time, enjoy the physical exercise of channelling the inflatable in the direction you want to travel. Then at the end of play, open the valves, pop it in its bag and head home.

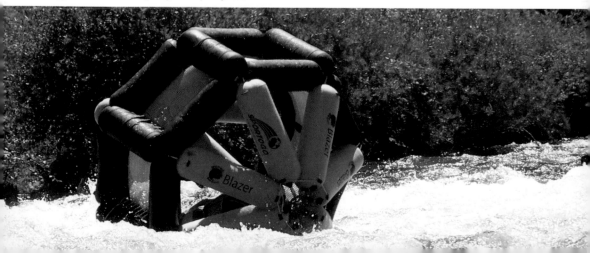

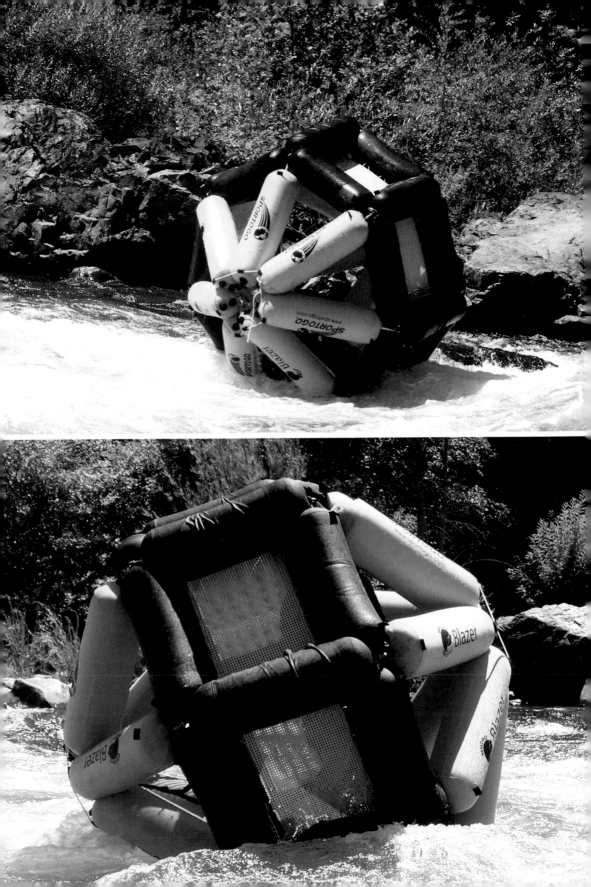

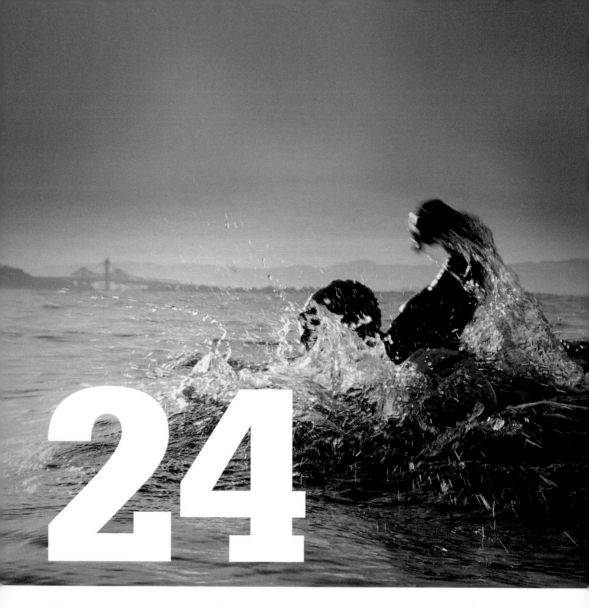

24

Swim from Alcatraz to San Francisco

Location Island of Alcatraz to San
Francisco, California, USA
Complexity Hardcore

Cost OOOOO
Lasting Sentiment 'I just escaped
from Alcatraz!'

Dream big and swim free. Escape from Alcatraz! Stranded in the middle of San Francisco Bay is an island steeped in history, isolated by rough, open water with strong, hazardous currents. This is the island of Alcatraz, often referred to as 'The Rock'. It was across these waters, on 11 June 1962, that Frank Morris and John and Clarence Anglin escaped from the island's penitentiary, paddling off in a raft made of standard-issue prison raincoats and contact cement. They may have survived, but nobody knows.

Take part in an open-water swim from this notorious starting place. When you slip into the frigid water your senses are fully awakened by the cold. Your wetsuit is like a second skin, but the Pacific Ocean is merciless. Soon your feet will be numb. With the Bay Bridge silhouetted in the distance by the rising sun, you know where you want to go and have a burning desire to get there. The water around you is a dark mercurial colour, glistening with early morning rays. Fog is starting to unwrap from the Golden Gate Bridge, hopefully to be drawn back out to sea. The clock is ticking. You start to swim.

The current is strong, trying to pull you off course, but you will have trained for this. Like a fish you swim into the rip and are offset in the right direction. The tide is slack, so there is a window of time before billions of gallons of water begin to flood in from the sea. You glimpse the support boat in your peripheral vision, before dipping your head in again and powering forwards with your legs. You draw your other arm back to see the safety kayaker, floating a respectful distance away. Their presence reassures you. You can concentrate on the swim.

Each stroke brings you closer to the shoreline. The shape on the horizon becomes larger, land ahead, as the sun begins to spill brilliant yellow light around you. The cold has slowed down your pace and your muscles feel a growing fatigue, but the achievement is now palpable. It spurs you on. Finally the Aquatic Park Pier draws in towards the Hyde Street Pier. You swim between the two, out of the current and into the Aquatic Park alcove with less than 500 metres to go until you reach the beach. The moment your feet touch the bottom successfully is a magical one. The relief is immense, the leaden feeling in your body inexplicably satisfying.

Opposite and below © Jonathan Drum / drum-productions.com

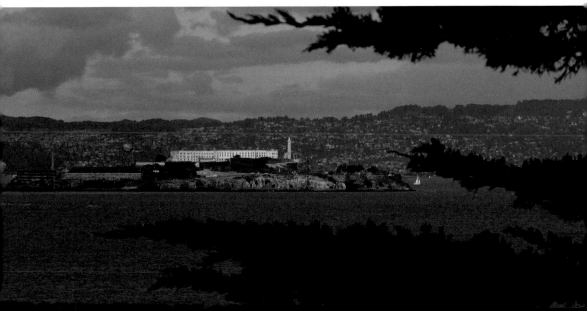

While there are several organised races that attract the toughest competitive swimmers in the world, it is possible to swim the one-and-a-half miles from Alcatraz to San Francisco as an individual or as part of a group on any given day of the year. The catch is that you need permission from the United States Coast Guard, who monitor commercial shipping and like to maintain radio contact with your support vessel throughout. Open-water swimming experience is preferable and ideally you should be able to swim a mile comfortably in a pool within 40 minutes. To avoid the red tape, contact Water World Swim, LLC, which has a blanket permit, offers access to a team of professional coaches and runs Alcatraz club swims every month.

You might get by with a generous smearing of lubricant around your armpits, neck, groin and kidneys, but a flexible 3mm wetsuit that fits like a glove will make a major difference to the core temperature of your body throughout the challenge. Bring your own wetsuit or rent one locally. Earplugs for swimming will help protect your middle ear from reacting to the cold, while a neoprene cap is highly recommended to keep your head warm.

Attracting swimmers of all shapes and ages, the beauty of the challenge is that the conditions are rarely ever the same. You may be able to see your destination throughout your journey, but beneath the water strong and variable forces will be at play. To reach land, you need to adjust your course to compensate for known currents as well as the state of the tide and its phase in the moon. Often you will swim in a huge arc.

Stretch beforehand. Eat a banana for potassium to help avoid cramp. Momentarily absorb the breathtaking view of the bay, the Golden Gate Bridge, the Bay Bridge, San Rafael Bridge and legendary islands, then take the plunge. Strum the notoriously treacherous stretch of open water with your feet. Swim for freedom and staggering up a beach will never again feel so good.

Opposite and below © Jonathan Drum / drum-productions.com

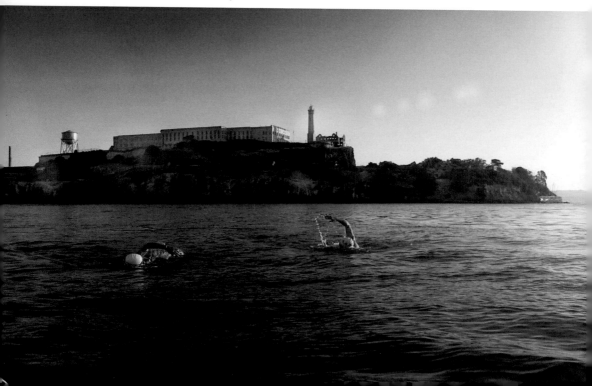

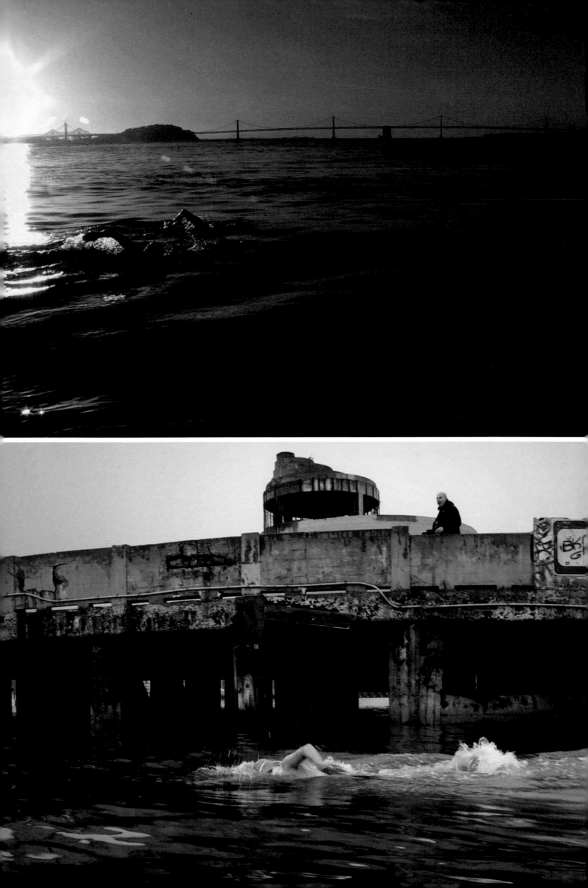

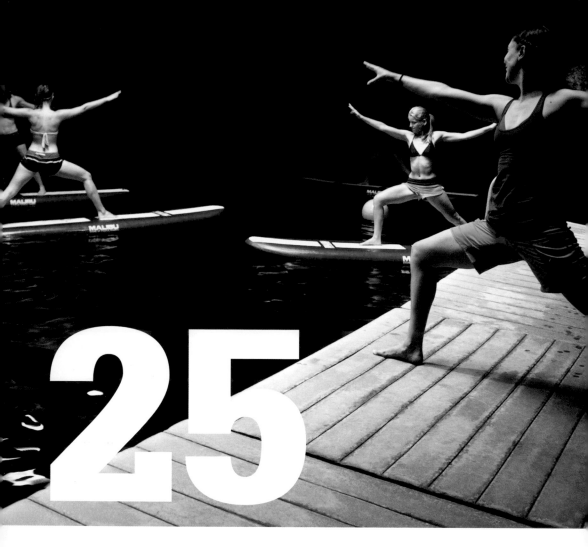

25

Try paddleboard yoga in a geothermal crater in Utah

Location Homestead Geothermal Crater, Midway, Utah, USA

Complexity Practice makes perfect

Cost ⚪⚪⚫⚫⚫

Lasting Sentiment Just what you didn't know you needed

Try something unique. Experience yoga while balancing on a paddleboard. Listen to the sounds of the water keeping you and your board afloat. Tap into the energy around you and let that energy resonate with your own. Enjoy falling in when your pose is out of alignment. Use this immediate feedback to improve your posture and take your yoga practice to a whole new level.

With its therapeutic mineral-rich waters, the Homestead Crater is the definitive setting for a paddleboard yoga lesson. A 50-foot tunnel drilled into the side of a hill takes you into the dome of a 10,000-year-old crater formed by water eroding rock over time. Warmth radiates from the rock as a cavern opens up before you with a perfectly still pool of water 60 feet deep. Wisps of steam emanate from the water's surface and drift up, rising slowly towards the sky. The water is a surprising colour, a beautifully clear Caribbean blue. The sound of your breath and an occasional metallic 'plink' as a droplet of condensation rejoins the water are the only sounds to break the silence.

Shafts of sunlight pour into the cathedral-like cave and illuminate an area of the rock wall. The atmosphere inside the cavern feels charged. There is an edge of excitement before the class begins, partly because of the uniqueness of the place and partly from the shared anticipation of falling off the paddleboard and into the water. You all know you will fall in. You just don't know when!

Starting the session on all fours, the first challenge is simple. Stand up and balance on the board. The instructor demonstrates from the pontoon, feet slightly apart. Take a moment to absorb where you are – standing on a paddleboard on a hot spring in an ancient geothermal crater enclosed in the

Opposite and below © Monique Beeley / parkcityyogaadventures.com

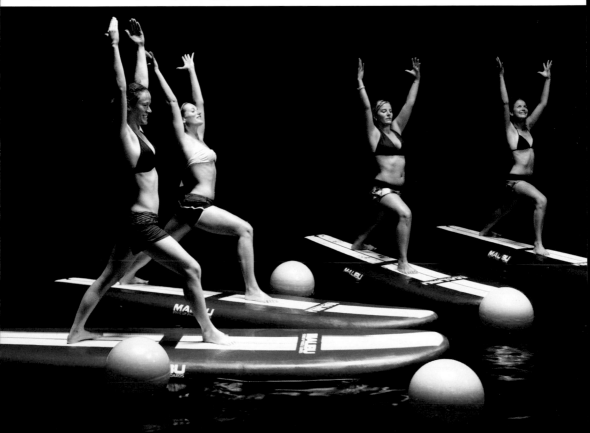

body of the earth. Then gently exhale. You are now ready to move on to Sun Salutations with poses such as the 'downward dog' and the appropriately named 'high mountain standing tall'!

The next positions are more difficult, with only two points of contact on the board. You may move tentatively, aware that you could splash into the pool at any time. There really is no room for random thought. When you raise one leg to do a side plank, instantly you topple into the water! When it happens for a second time you realise that your leg was beyond your centre of alignment. Thankfully, the water is lovely and warm, like bath water. You learn quickly and in a fun way.

Only in Midway, Utah, can you enjoy the complement of world-class skiing in the morning and a paddleboard yoga class in a geothermal crater in the late afternoon. With three local ski resorts – Park City Mountain Resort, Deer Valley Resort and Canyons Resort – less than an hour away, combine a ski trip with restorative sessions of paddleboard yoga. The drive from Main Street in Park City to the quaint town of Midway and the Homestead Crater lasts about 30 minutes, and what a drive! Leaving the scenery of the Timpanogos Mountain behind, the earth rises up into a mound concealing the Homestead Crater, steam rising mysteriously from its top.

Book yourself on to a class – part yoga, part swimming adventure – with Park City Yoga Adventures, the only company contracted to operate paddleboard yoga sessions in the crater. Not only will you hone your sense of balance through paddleboard yoga, you will boost your own physical awareness with exercises that are both mentally and physically challenging. Knowing you need to balance on water keeps you in the moment.

Each class is intimate, friendly and accommodates up to eight people. To date, the oldest person to try paddleboard yoga at the crater was in his 70s, the youngest just eight. Beginner classes are tailored to include stretching poses practised sitting down, but even the most experienced yogis may be challenged by yoga on a paddleboard.

The ultimate in après-ski activity, recuperate from time on the slopes by stretching in a natural spa environment that is as interesting and unique as it is safe and private. From the cold piste outdoors, to a hot spring in a cave, a paddleboard yoga class offers a delicious sensory contrast. Build up your core strength and flexibility. Engage your skin, muscles and bones in your stance and flow with nature both on and off the slopes.

Opposite © Cory Steffen / www.corysteffenphoto.com **Below** © Monique Beeley / parkcityyogaadventures.com

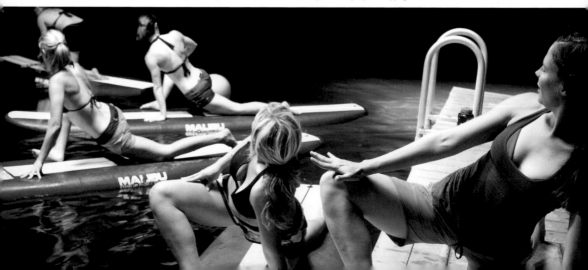

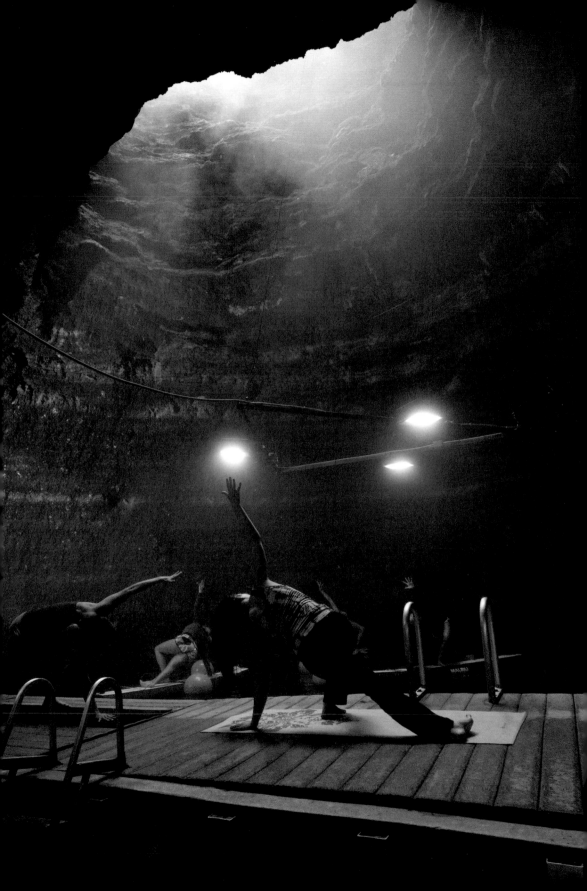

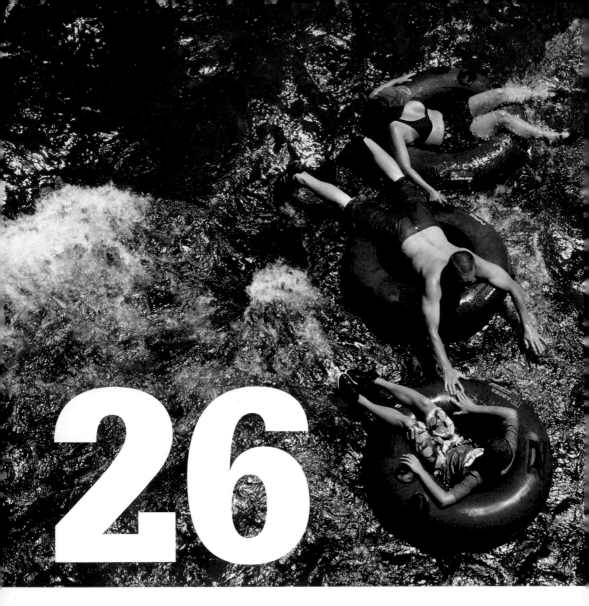

26

Inner tube the Colorado rapids

Location Pagosa Springs, Colorado, USA

Complexity Softcore

Cost ○○○○○

Lasting Sentiment Great fun in the sun

Run white-water rapids in a crazy, fun way. Allow yourself to be swept downstream sitting in a large doughnut inflatable. With next to no manoeuvrability, enjoy the anticipation of plunging over a big drop. Hang on tight as the water carries you over a ledge and use your feet to dodge a massive rock. When the flow winds down and the ride becomes a float, hop out. Catch the bus laid on for tubers and head upriver to rerun the fun.

Join the throng at the 'put-in' area and prepare to launch! With your bottom nestled comfortably in the hole in the middle, you and your tube are off. Using your arms as paddles, you try to steer the tube in the direction you would like to go, but your efforts will make very little difference. You will get spat down the narrow shoot regardless, through the gap and out between the boulders. Half out of control, half paddling wildly, expect to be spun around a bend, swirl under a road bridge and tank past the backyards of a nice residential neighbourhood. You know that you're floating through civilisation, but for the majority of the time you can hardly tell. The lush Weminuche Wilderness, part of the San Juan National Park, meets the banks on both sides. You are riding your way through a water park carved by nature over thousands of years.

Steering your tube as much as feasibly possible into the fastest rip, you choose to bomb down the last section of river. Your next run, you tell yourself, will be more leisurely. You'll stop along the way to swim and enjoy plenty of river sightseeing. Next, head for the hot springs conveniently located where tubers are encouraged to exit the river. Easing into the naturally warm water, revel in your self-styled spa combination – tube rental and a day pass for the deepest and largest hot springs in the world.

Opposite and below © Tobi Rohwer / pagosaoutside.com

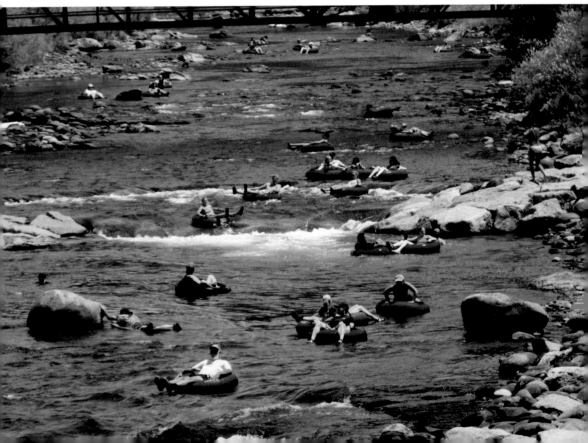

If you enjoy the great outdoors, Pagosa Springs in Colorado makes a good off-the-beaten-path destination in itself. Less of a resort community than other tubing hot spots, there are a variety of places to stay, from bookable campgrounds in the National Forest to vacation rentals, high-star hotels to historic cabins built in the 1900s. Nestled along the San Juan River, a tributary to the Colorado River, the town of Pagosa Springs has utterly embraced tubing. A mile and a half upstream is where the action begins. A special bus runs every 10 minutes to transport tubers back and forth. Expect to see boardshort- and bikini-clad swimmers with inner tubes waiting at pedestrian crossings as well as inner tubes stacked beside delis and outside restaurants at lunchtime.

When it comes to tube rental, one size should fit most. Buoyancy aids are recommended for those who are not comfortable swimmers and are a legal requirement for children under 12 years of age. It is likely that you will lose your flip-flops, your expensive sunglasses, your only set of car keys and your favourite jewellery during the course of your jaunt downriver. Invest in a retaining strap

Opposite and below © Tobi Rohwer / pagosaoutside.com

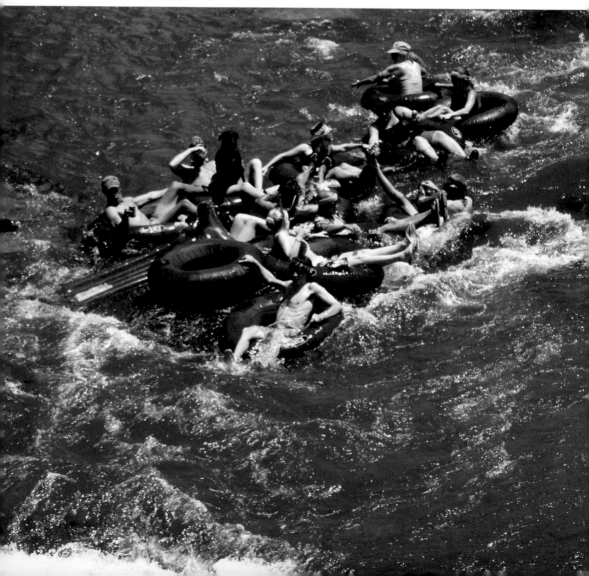

for your sunglasses and be sure to strip yourself of valuables and empty your pockets in advance. There is also no guarantee that once in the water you will stay on your tube the entire time. Water shoes are recommended in case you end up walking along the bank or clambering over rocks to retrieve your ride.

From 45 minutes to an hour, the duration of a single trip down the San Juan River will depend on the water level and the speed of the flow. Rip-roaring Class 2 and Class 3 white water usually makes for good rafting in May and June, leaving July and August as the prime tubing season. These months offer good cruising speeds and exciting runs with less chance of being flipped.

For an afternoon or a whole day of simple, silly fun, inner tubing is a great way to spend time with friends or family. Colorado's rivers may attract thousands of kayakers and rafting adventurers throughout the year, but for a more sublime summer experience, rock up and rent a tube. No need for a guide, no special knowledge required. It's just you, one giant doughnut inflatable and hours of frivolous fun.

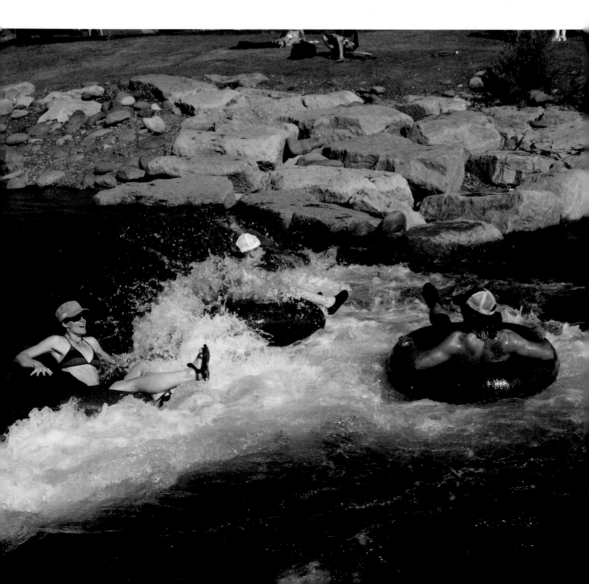

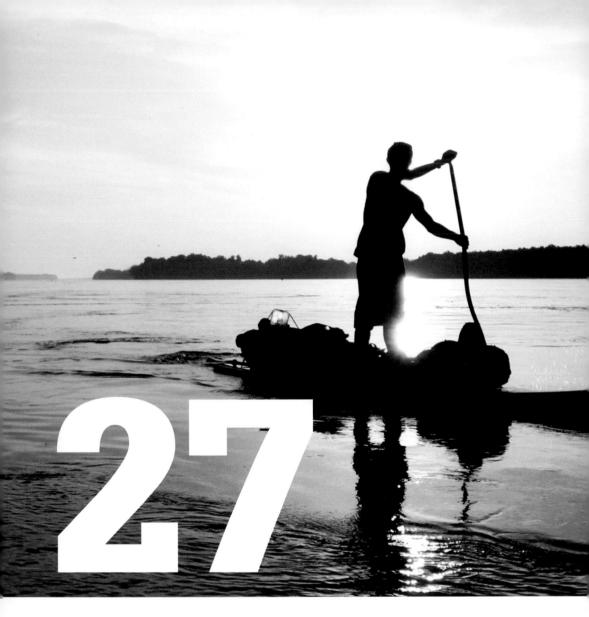

27

Stand-up paddleboard the Mississippi

Location The Mississippi River, Minnesota, USA

Complexity Minor organisational skills required

Cost ⬤⬤⬤◯◯

Lasting Sentiment Life in perspective

Live not by the clock but by the sun. Wake up in a hammock to the sound of fish jumping and from the warmth of the sun's first rays. When you decide it's time to move on, pack your bag on to your paddleboard, step on and paddle a stretch of river. Travel under your own steam across flat open water. Allow yourself to become absorbed by the exercise, each stroke of your paddle through the water.

Between the trees to your left and the trees to your right, an expanse of river reflects the early morning sky. Insects and birds chatter peacefully in the vegetation around you. Small crabs scuttle across the sand beneath your feet. From the moment you push off from the riverbank, the routine of normal life is left behind. The paddle becomes an extension of your arms as it cuts into the water with barely a sound.

Allow your body to adopt a new rhythm as every muscle from top to toe is gently stretched. Enjoy the blissful silence and the opportunity it offers for you to think. Rarely will you see the road or anyone else. You may turn a bend in the river to find a family of wild geese clucking and diving. As you paddle at the same pace, the geese might swim in front of you for quite some time. You may glimpse turtles occasionally. Possums, voles, river rats, beavers, otters and raccoons will otherwise populate your days.

Winding through a network of channels will prove a good test of your navigation skills. Paddle down a narrow stream between head-high reeds, then through a wide-open rice plain, bluffs rising in the distance. Glance over riverbanks and down through the water as you learn to read the direction of the flow by the angle of the reeds flexing in the current along the bottom.

The advantage of standing is that you can see fallen branches lurking under the surface ahead. When the river opens out into a lake the change of space is refreshing. Stand-up paddleboarding really is the closest thing to walking on water.

For a relatively non-technical paddle and the perfect mixture of wilderness and amenities, head for the spine of the USA, the iconic Mississippi River. From source to sea, the Mississippi stretches some 2404 miles, from Lake Itasca 150 miles from the Canadian border to Venice, Louisiana and

Opposite and below © Dave Cornthwaite / davecornthwaite.com

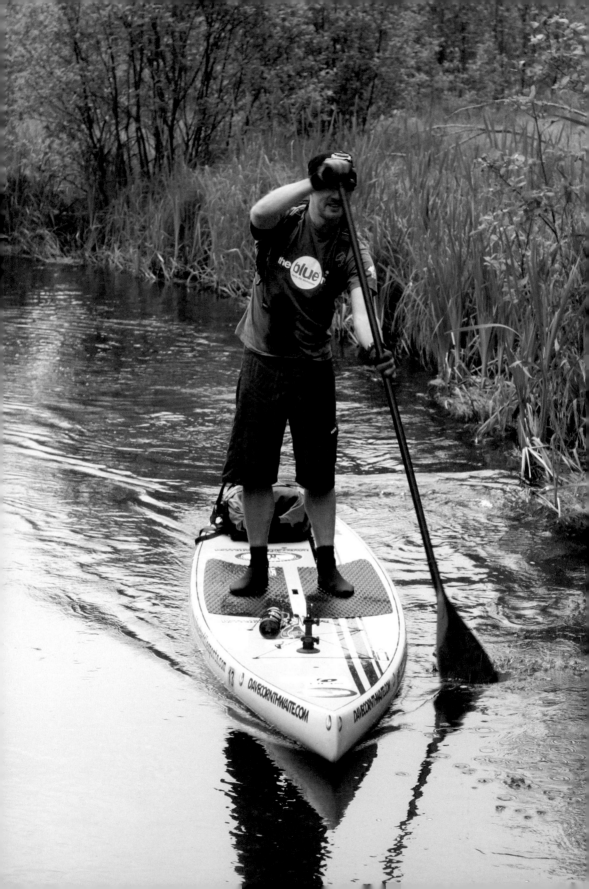

the Gulf of Mexico. Spend a long weekend or even a ten-day trip on the Upper Mississippi River between the cities of Bemidji and Grand Rapids in Minnesota. Local awareness of the river has kept this section pristine and resulted in the provision of designated campsites for paddlers. Enjoy wild camp areas with picnic benches and occasionally an outhouse with a toilet. Here the river is easily accessible for short or long paddle sessions and narrow enough to take in both banks and the wildlife living within. Pick up a U.S. Army Corps of Engineers river map at the Department of Natural Resources in Minneapolis. The campsites are clearly marked.

Built out of carbon or glass fibre reinforced around a foam core, most touring paddleboards have a higher volume than their surfing cousins. Once up to speed, they glide with less effort from the paddler. Rent or buy a board, new or second-hand. There are plenty of water sports shops in Bemidji. Look for a board with a recessed standing area to keep your feet dry and fixings for your own storage system. You are obliged by law to carry a personal flotation device and you may need to portage around the occasional dam. Otherwise you are at liberty to cruise and sling a hammock wherever you please. The best time to go is in June and July, when the water is highest. Simply go with the flow!

Whether you stand, kneel or sit, paddleboarding is a sport that people of any age and of any fitness level can enjoy. As you give yourself an all-over body workout, you may find the gentle repetition of paddling meditative, transcendental even. Use the surroundings to reflect on life, allowing the river to take you both physically and mentally from one place to another. Look down into an aquarium of life, up at birds of prey, and witness animals of all sizes scurrying about the banks. Strengthen your core and paddle into the bosom of nature without leaving a single footprint.

Opposite and below © Dave Cornthwaite / davecornthwaite.com

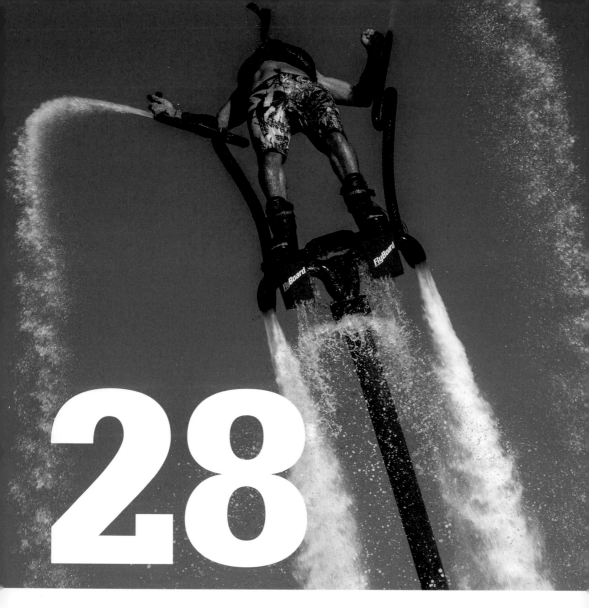

28

Master flyboarding in Miami

Location Miami South Beach, Florida, USA

Complexity As easy as learning to ride a bicycle

Cost ⭘⭘◦◦◦

Lasting Sentiment 'Am I a bird? Am I a plane…?'

Levitate off the water. Whizz around like a character from science fiction. Surf the air up to three storeys high with pipes strapped to your forearms and your feet fastened into boots on a space-age board. Dive into the water and surface dolphin-style. Flip in an arc backwards. Spin sideways. Twist. Feel super-human and enjoy a new kind of acrobatic movement, jet propelled.

Every Flyboard session starts in the water, bobbing in a buoyancy aid with the equipment strapped to you. When the device is switched on, water is suddenly picked up by the pump in the float that snakes behind you and is driven by a jet-ski motor through the 30-metre Kevlar hose beneath your feet. Water jets down at high pressure from underneath your footboard. Water pours at high speed from the hand-operated nozzles fastened to your arms. Then up from the depths, you rise like a creature from another planet. Standing statuesque above the water's surface, waterfalls rain from your arms and the board beneath you. You may laugh hysterically. Unsure of what happens next, do not make the mistake of moving too quickly as this will send you down, back into the water! When you rise again, this time balancing better on the cushion of water pressure, try rising higher and travelling forwards at the same time. You will feel like you have special powers!

Directional movement is achieved using your feet to tilt the footplate as you would a snowboard. Tilt the board too far and the distribution of water between the two jets changes and you will plunge back into the water. At first you may spend as much time sluicing through the water as you do hovering above it, but still having a blast, literally. When you start using the arm-directed jets as if

Opposite and below © François Rigaud / francoisrigaudphotography.com

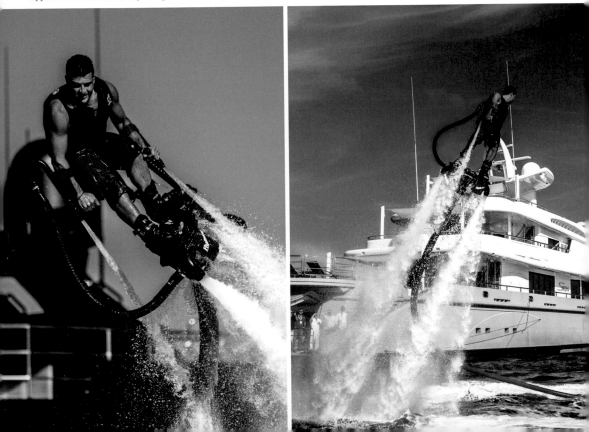

they are ski poles, your stability will greatly improve. You can rise higher, travelling through the air with great birdlike swoops. Beachgoers will stop to watch, hardly able to believe their eyes. Passers-by will do a double take. Only later, on film, will you realise how cool you really looked.

While it may not offer any fitness benefit, the Flyboard is one of the hottest water toys on the market. Even as a spectator sport, flyboarding has genuine wow-factor. Started by French jet-ski racer and World Champion Franky Zapata in 2010, the Flyboard is a hybrid of Franky's passions – jet-skiing, skiing, snowboarding and acrobatic diving. Within a year of its inception, the first flyboarding World Cup was staged in Qatar with a freestyle competition that attracted 50 competitors from 18 different countries around the world. There may be no such thing as a professional flyboarder yet, but the 'flyboarding family' – those that showcase the gear – can pull off some impressive synchronised somersaults.

Try-a-fly businesses have rapidly cropped up beside lakes, docklands and beach resorts, but there is no better place to give flyboarding a whirl than in the glittering turquoise waters around Miami. Popular with the rich and famous, Miami is about seeing and being seen. Fun, frivolous or extreme, Miami is the place where anything goes. This is your chance to be one better than the have-yachts and the mega-wealthy. For the least amount of expenditure, you will reign above the beach. Hovering on a Flyboard 10 metres up in the air, look down on million dollar waterside homes as they look up at you in awe! Boasting balmy temperatures all year round and plenty of water babes to cheer you on, sunshine in Miami is guaranteed. No wetsuit required.

Complete with safety equipment and a trained instructor, a taster session will get you rising from the depths in less than 30 minutes. Alternatively, Flyboard units are commercially available and retailers may now be found in nearly every country in the world.

Forget virtual reality, 3D glasses and high-definition TV. The future has arrived. A cross between a jet ski and a jet pack, the art of flyboarding is all about poise. Whether you choose to surf the air like a comic-book villain, shoot up to 30 metres in the air or serially dive, dolphin-like, under water, flyboarding gives you an unbelievable rush. Strap in, become a real-life action hero and you are guaranteed to attract an audience. Once you find your footing, only the sky is the limit.

Opposite and below © François Rigaud / francoisrigaudphotography.com

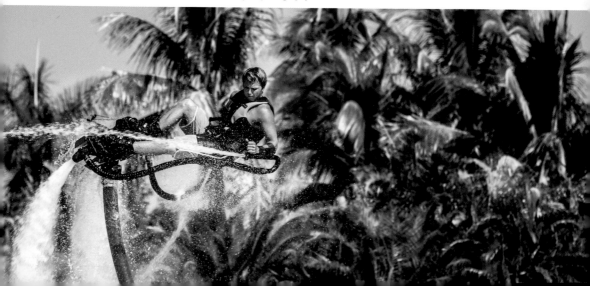

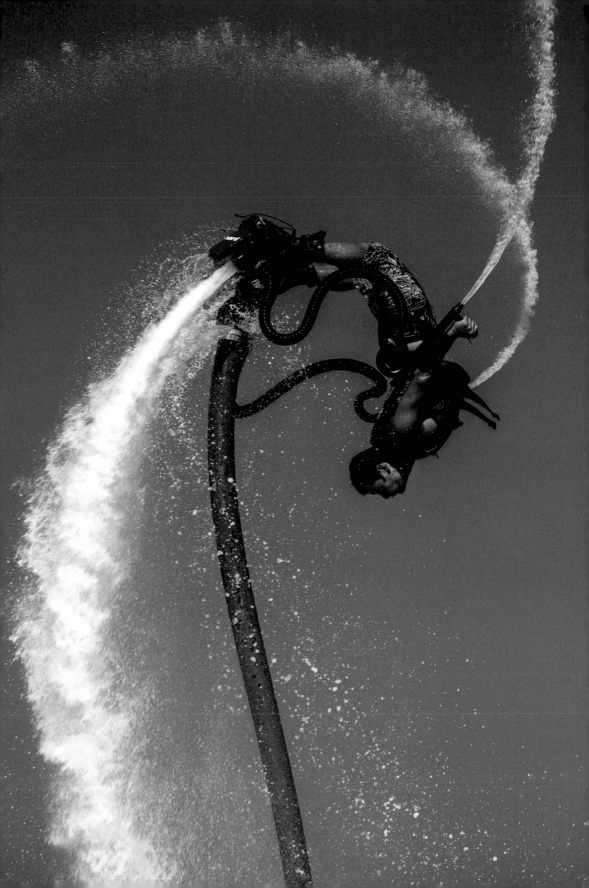

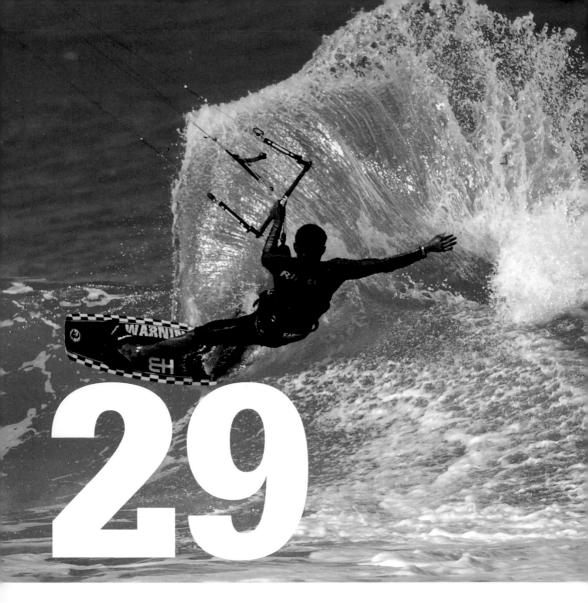

29

Kiteboard in the Dominican Republic

Location Cabarete, Dominican Republic

Complexity No longer just for daredevils

Cost ⬤⬤⬤⭕⭕

Lasting Sentiment 'Just one more length of the beach and then I'll go in...'

Combine the speed of water-skiing, the tricks of wakeboarding, the carving turns of surfing and the quiet freedom and autonomy of sailing. Strap on, buckle up and get ready to kiteboard! Tap into the free energy of the wind using only a backpack of kit. Get fully ripping in low winds. Achieve big jumps on flat water and soak up 360-degree visibility riding up or downwind. Once you can edge off a wave tip and become airborne, you will never look back.

If the kite is yin, you are yang. On the beach your instructor will teach you how to 'walk', how to control the kite, practising with shorter lines and a smaller training kite. Once up and 'running' on the water, steer the kite into the power zone and accelerate. The kite, attached by four lines running to the control bar in your hand, is hooked into your waist harness. On the board your feet are tucked comfortably under foot straps. Your concentration must be absolute since you need to make endless adjustments to how the kite rides the wind and move your body intuitively to compensate. Keeping one eye on the water rushing towards you, learn to read the waves and get truly in the zone. Become the kite and the board, harnessing the wind to skim the water and cut a wake across the bay.

From eight-year-olds to men and women in their 60s and even 70s, kiteboarding attracts people of all ages and body shapes. Good general fitness helps, but the main ingredients for success are a desire to succeed and tenacity. You must be willing to persevere. After 10 hours of tuition, expect to be up on the board. Heavier folk may require a larger kite and more wind in order to go faster and if you are not particularly sporty you may take longer to learn. But whatever your build or board skills,

Opposite and below © Eric Herstens

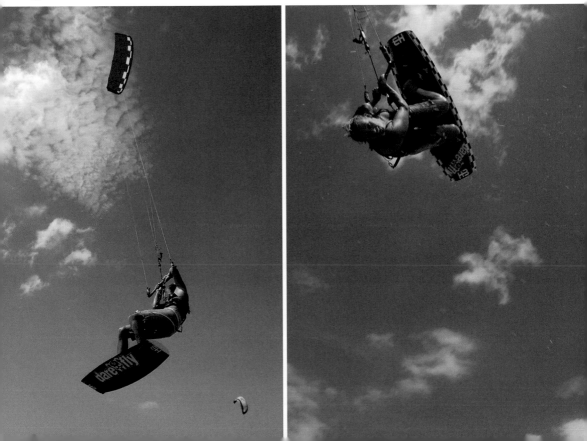

book yourself a block of lessons. When you move the kite quickly, the amount of power generated can be monumental. This creates a dangerous situation not only for you but also for other beach users – what kiteboarders call a 'kite-mare'! A beginner's course of one to one lessons will ensure you play safe, enjoy your time on the water and help you progress towards mastery faster.

Nestled between Cuba and Puerto Rico in the Caribbean, the Dominican Republic (DR) is considered one of the top kiteboarding destinations in the world. Previously a Mecca for windsurfers, the town of Cabarete on the DR's north coast now attracts kiteboarders in their droves. With palm trees draped along great stretches of white sandy beaches and boardshort weather all year round, it's not difficult to see why. Day in and day out, the trade winds flow across the Atlantic. The temperature differential between the thickly forested mountains and the sea results in more wind, creating a steady onshore breeze that picks up in the afternoon. These are heavenly kiteboarding conditions.

From budget hostels to high-end surf camps, modest apartments with one bedroom to penthouse condos and four-star hotels, the small town of Cabarete has it all. If you bring your own 'quiver' of kites – a selection of kites that vary in size for different wind speeds – you can store them in rentable lockers in many kiteboarding shops. Arrive in the early afternoon and, with the island's main airport a mere 25-minute drive away, you can be kiteboarding before sunset.

After a challenging day on the water, reward yourself with a massage at one of the spa hotels. Relax with the sand beneath your feet and enjoy a tasty supper of fresh kingfish or Caribbean lobster tail at one of the European-owned beach restaurants. Alternatively, eat local and mop up some Dominican culture with a plate of saucy 'jerk' chicken, grilled plantain, rice and pinto beans, washed down with a deliciously chilled beer.

Kiteboarding is a sport in which science meets art. Setting up the gear and running through the pre-flight checks to make sure the kite is attached correctly is an enjoyable social activity. Out on the water, you become Zen-like, single-minded with focus. Call it a moving meditation, call it an extreme sport, the action of the kite pulling you across the water can be simultaneously calming and exhilarating. The surge of speed combined with the feeling of power that you're attached to, that you're controlling, is the ultimate adrenalin rush. Kiteboarding is addictive and with the changing water, wind and wave conditions, no ride is ever the same.

Opposite and below © Eric Herstens

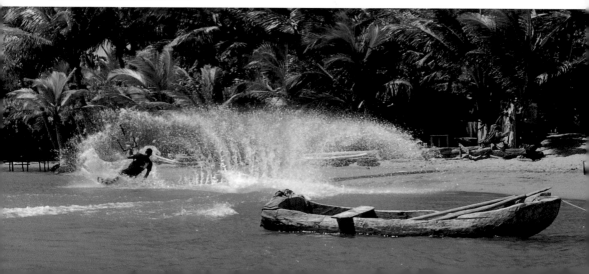

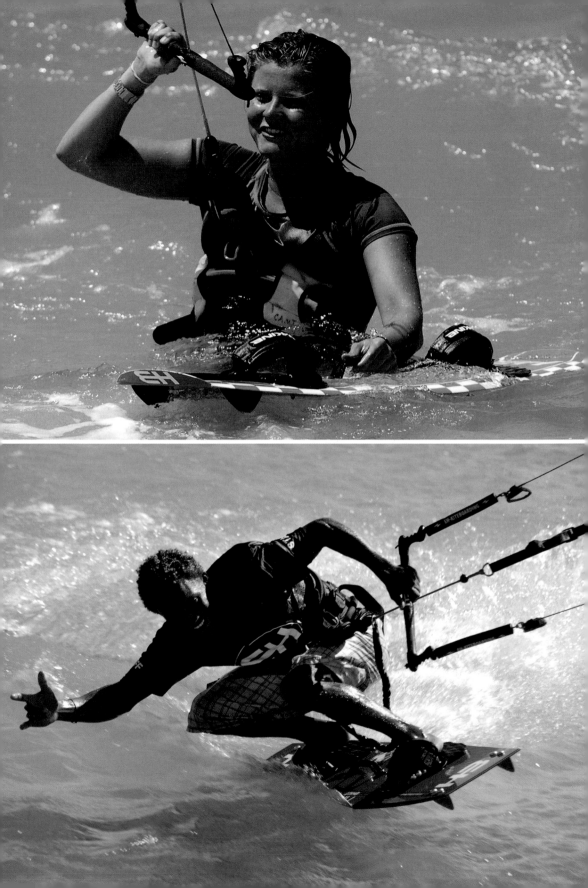

30

Fish for big game in Mexico

Location Sea of Cortez, Cabo San Lucas, Mexico

Complexity Luck and an experienced charter company will get you everywhere

Cost ⭕⭕⭕◯◯

Lasting Sentiment 'The fish was THIS big!'

Head for the marlin capital of the world. When the fish strikes and the line starts ripping out, enjoy the thrill of the catch. Get ready to wrestle the fish on board. Grip the rod and brace yourself against the fighting chair. Keep the tension on the line and slowly reel in the bounty. Blue marlin, black marlin, yellowfin tuna, skipjack tuna, dorado, wahoo or even a roosterfish, you never know what you might hook.

'We'll be on the fish in 20 minutes', the captain informs you as you sit back and watch the sun rise over the Sea of Cortez. When you reach the latest fishing hot spot, get involved helping to rig the lines. Out of the 'live well', pluck a caballito, also known as a 'goggle-eye' because of its big eyes. If you're not squeamish, carefully pin the wriggling fish on to the hook. You are now ready to throw the live bait, should you see a fish on the surface or get a bite on the lures.

The boat cruises around the fishing ground at 6–10 knots. The first mate checks all the reels, as the captain stands by the throttle ready to troll. Patience is everything. One of the rods bends and the reel starts screaming. The line is feeding out so fast that even the first mate gets excited. He directs you towards the fighting chair and hands you the rod locked and loaded. 'You need to tire him out,' the coaching begins. 'Pull up slowly and reel down, Señor!' The fish makes violent runs this way and that. You both wonder who is going to wear out first, you or the fish. It's man versus aquatic beast but you're determined to win. 'Nice slow movements', the mate says. 'Continue reeling down! Never allow the line to go slack.'

You try to imagine the size of the fish on the other end of the line. Then the fish leaps clean out of

Opposite and below © Ryan Donovan / redrumcabo.com

the water. It's a billfish, a blue marlin! The action causes a wave of excitement on board. Your arm muscles start to protest just as the first mate reaches over the back of the boat and, in one adept movement, grabs the fish by the bill. The fish is a wild-looking thing that spans the width of the boat. You lift up the bill, a half-metre-long spike protruding from its head and, with assistance from the mate and the captain, hold the fish up for a quick photograph. Returned to the blue, you watch your catch swim off to fight another day.

Right at the bottom of the Baja Peninsula, Cabo San Lucas is an angler's dream. To the east is the Sea of Cortez, to the west the Pacific Ocean, two very different and distinct bodies of water both teeming with fish. Between 8 and 40 kilometres offshore, you can catch a marlin 365 days of the year. Striped marlin average between 55 and 68kg and 2.4 to 3 metres long, while the blue marlins and black marlins can reach up to 450kg! The quota of how many fish you are allowed to harvest changes with the seasons, but most reputable sports fishing companies release the big beautiful billfish. On an average day, boats ice four to five fish, although if you manage to hook into a big school of tuna you may return to the dock with 10 to 15 fish.

To fish for big game with a fighting chair on board, it's worth chartering a 8.5–9-metre 'cruiser' with twin engines to get you around the fishing grounds faster. You need to buy a fishing licence, which costs a few dollars per person per day. Weekly and annual licences are available for not much more and your charter company will sell these to you. There should be a captain and first mate on board, which means no prior sports fishing experience is necessary. If you want, the crew can set the hook and pass the rod over when the fish is already on the line. With expert coaching, the crew will soon make an angler out of you!

Early morning and early afternoon are the best times of day to fish. When you hear the reel scream, you never know what you may have on the line. Your catch could be a 135kg yellowfin tuna, a 30kg dorado or a blue marlin heavier than your fishing party put together! The fish may get away or put up an incredible fight. Until you see the whites of its eyes, you don't know how it will end.

There is the satisfaction in bringing home a tasty fish, the photograph of you and your legendary catch, but it is the thrill of the unknown that will really get you hooked.

Opposite and below © Ryan Donovan / redrumcabo.com

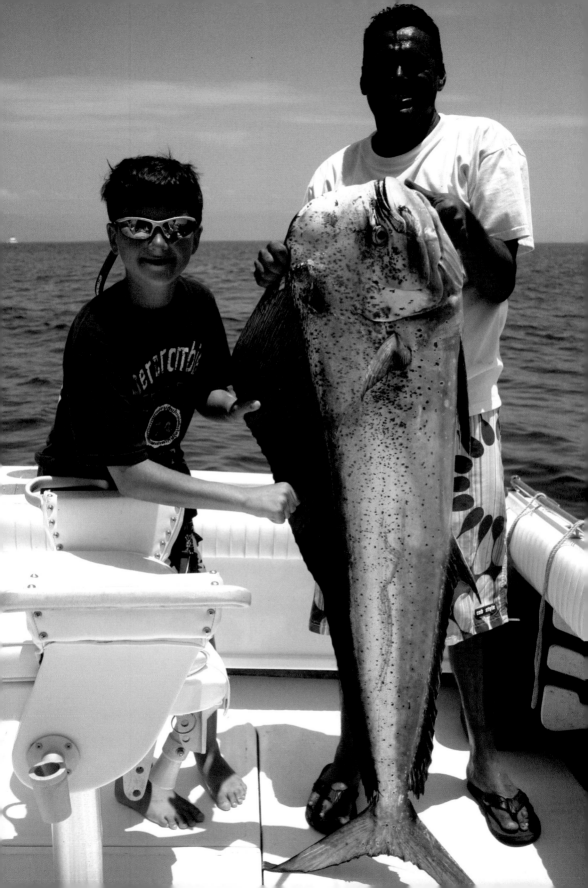

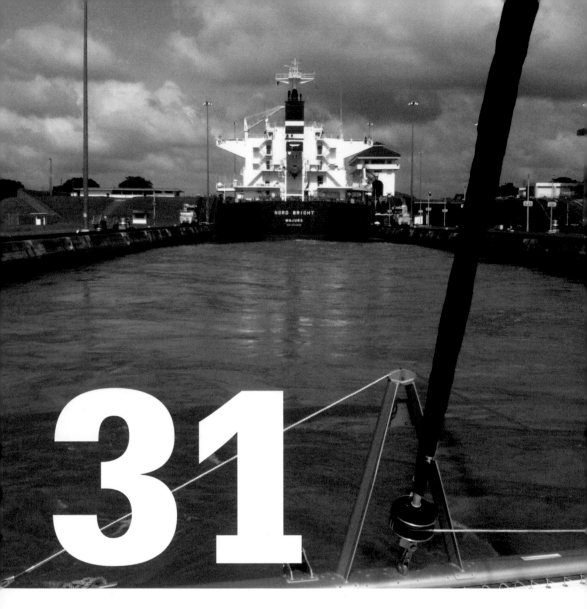

31

Transit the Panama Canal

Location Isthmus of Panama, Panama

Complexity Instruction will be provided

Cost ○○○○○

Lasting Sentiment One of the greatest feats of civil engineering

Witness first hand why the Panama Canal remains one of the greatest feats of civil engineering. Arrange to join a cruising yacht and transit the canal as a line-handler. Experience the excitement of going up and then going down on a large body of water, as the level of each lock is raised or lowered. Tucked in behind a cargo ship carrying up to 52,500 tonnes, prepare to feel very small as you travel through one of the most historic waterways in the world.

On the south side of the Bridge of the Americas, a whole archipelago of commercial freighters lies at anchor. Radiating an aura of orange light, each one is waiting to enter the mouth of the canal. Operated 24 hours per day, every day of the year, the timing and transit of each ship is carefully scheduled. Tomorrow your vessel will follow one ship only in and out of the lock chambers.

Your captain is informed over the ship's radio that your pilot is about to board. A tugboat comes alongside and skilfully drops off a friendly Panamanian with a briefcase. This means that your lock companion is already underway and being towed towards the Miraflores Lock, the first lock of the journey. The tanker is a 'Panamax', the largest size of vessel built to be able to pass through the locks. The word 'massive' doesn't do it justice! Watch in awe as the tanker is towed in to the first chamber with barely any clearance on either side.

Two 24-metre concrete walls loom on either side, blackened by more than a century of ships passing by. Stationed at the front or the back of the boat, your job is to catch the line thrown by one of the canal authority workers.

Opposite and below © Deborah Shadovitz

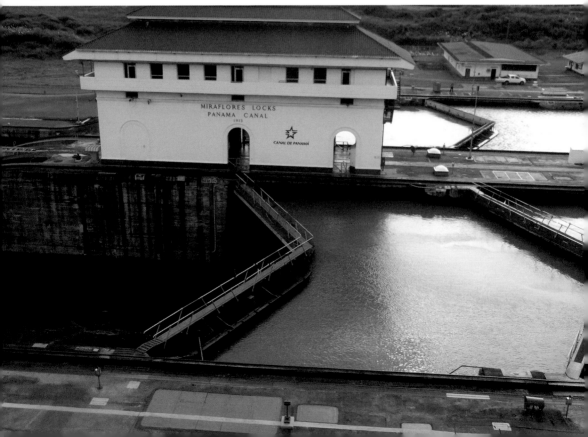

Bells go off. Then the two sets of gates, each 2 metres thick and 19 metres wide, begin to close. This is it – stand by to take up the slack in the mooring line as the water rises. With no turbulence under the boat whatsoever, the boat rises in a matter of minutes. Electric locomotives known as 'mules' grind into action to pull the tanker forwards into the next chamber. The gates close and both boats rise up to another level. At the end of the second flight, the walls suddenly disappear, revealing the scenery on either side and after a short stretch of open lake you reach another lock.

The Pedro Miguel Lock brings the boat up the third and final stage. Next you pass under the Centennial bridge and enter the Culebra Cut, one of the greatest earth-moving accomplishments of mankind. You pass single-file through the Cut, a 12.5-kilometre slice in the mountain. Gatun Lake on the other side, with its myriad inlets and uninhabited islands, seems a world away from the industrial traffic passing through it. Regretfully there isn't time to meander and explore. Descending the final set of locks at Gatun, you start to look down at the sparkling Caribbean Sea.

Private boats are taken through the canal as 'handline' transits, where all mooring lines are managed by hand. Each boat is required to have a minimum of four line-handlers on board, so

Opposite and below © Deborah Shadovitz

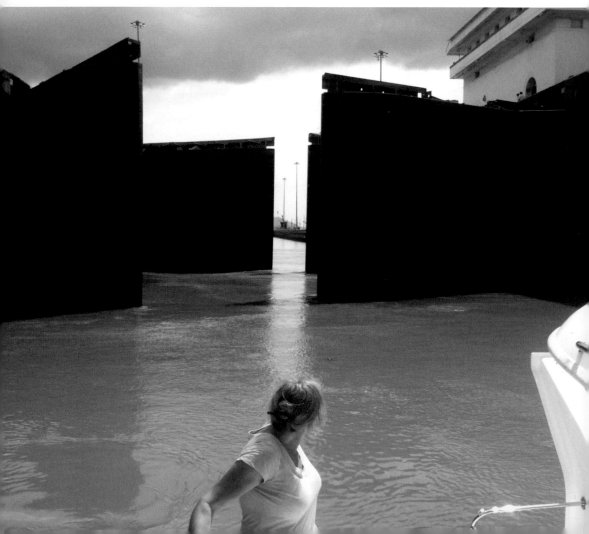

smaller craft may require additional crew. In order to secure an invitation, subscribe to sailing forums and make your plan known. Leave a note on the noticeboard of the Balboa Yacht Club or Shelter Bay Yacht Club in Colon or join one of several crew-finder websites. When asking around in person be aware that brokers are in the business of hiring out locals. March is the peak season to head from the Atlantic Ocean to the Pacific Ocean, but prepare to wait anything from an hour to a week for a ride.

We think of a canal as a connecting ditch or passageway, but the Panama Canal is actually a man-made lake, which happens to have an exit carved out to the Pacific and Atlantic Oceans. Commissioned in 1914, the Panama Canal halved the transit time for marine shipping, forever changing the global economy.

In the shadow of a 300-metre tanker, with a strange view of the sky outlined by the looming lock walls, you may gain a renewed appreciation of scale and a different perspective of the foreign commodities you consume. As naturally beautiful as it is man-made, as fast operating as it seems slow in real time, discover for yourself why the Panama Canal is considered one of the seven engineering wonders of the modern world.

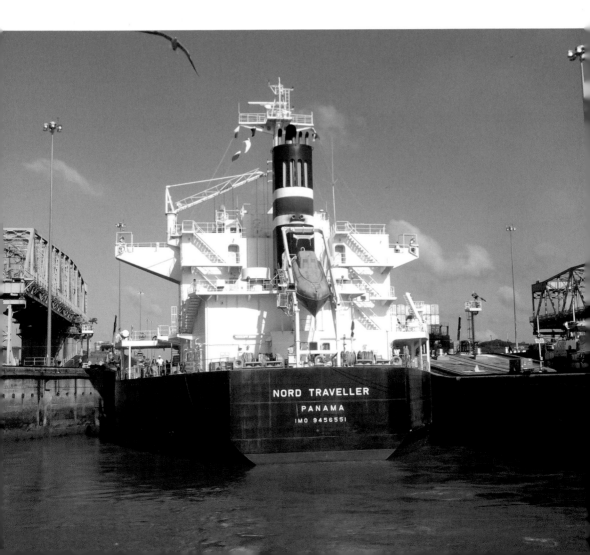

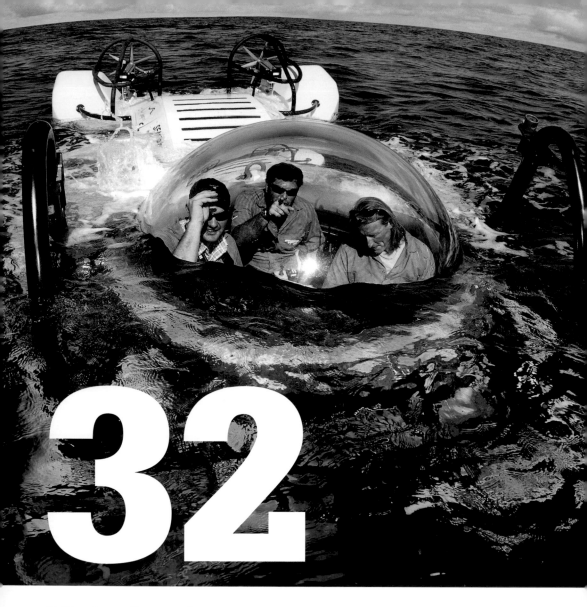

32

Visit the deep sea in a recreational submarine in Costa Rica

Location Cocos Island, Costa Rica
Complexity No swimming certificate required, just a healthy sense of wonder

Cost ○○○○○
Lasting Sentiment 0.05 leagues under the sea

Experience space travel. Not up into outer space, but down through the medium of water into inner space. Visit the 'deep sea' in a three-person recreational submarine. Travel beneath the surface of the ocean to a place beyond the reach of ordinary light. Here, illuminated by the submarine's bank of red lights, observe weird, beautiful creatures, many of which have yet to be identified. Come face to face with wild animals in their own habitat; animals few people have seen or will ever see.

Kitted out in a sterile blue cotton overall you feel like an aquanaut on a mission. The overall is sterile to avoid contaminating the small cabin, blue to minimise reflections on the windscreen and cotton with no sharp edges to prevent scratches on the glass. Wearing the outfit seems to heighten the anticipation as the submarine bobs on the surface, preparing for your expedition into the unknown.

Even in broad daylight on a summer's day, the incredible blue of the Pacific Ocean quickly darkens. From pale blue to ultramarine, violet to black and every hue in between, you will see more shades of blue than you can think of names for. Schools of sizeable tuna swim past, as if you and the submarine were not there. Further down, a cookiecutter shark is identified before a huge stingray swoops close to the window. Somehow you don't expect to see bottlenose dolphins at 100 metres below the surface, but they're here and en route to the Galapagos Islands. A minke whale is the last of the pelagic, warm-water mammals you may encounter before the animals become vastly unfamiliar.

Dark shadows flicker around the periphery of the submarine's column of light, as other invertebrates cruise in and out. You will be astounded to see such breathtaking colouration. A giant octopus, a type of tubeworm and a fish with jagged teeth and transparent scales, some of these creatures are gnarly and terrifying looking – like something out of Greek mythology or a horror film – but you may be too enrapt to feel afraid. Delicate-looking polyp membranes filter small particles from the water. Giant spider crabs creep along the coral wall as a sailfish with a bill several feet long circles the submarine. Sitting in temperature-controlled comfort, breathing normal compressed air, the experience is surreal.

Opposite © Shmulik Blum / underseahunter.com **Below** © Avi Klapfer / underseahunter.com

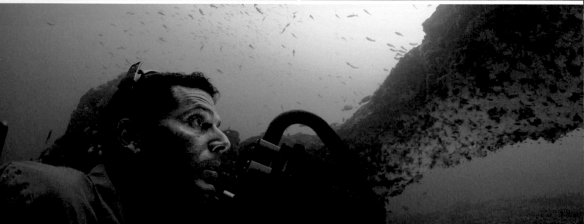

Launching from the uninhabited Cocos Island, 550km west of the Costa Rican coastline, a private submarine voyage does not come cheap. With 36 hours of travelling involved to reach the mother ship, it is not easy to get to either. There are currently no other outfits offering recreational deep-sea dives in a submarine or in a submarine also equipped for scientific charter. As part of a high-end package that involves a week's liveaboard and multiple other dives, the experience is a must for keen divers, adventurous individuals or those with a curiosity about what lurks within the deep.

Operated and maintained according to strict guidelines dictated by the American Bureau of Shipping, the submarine is always under the command of two people – a pilot and a licensed captain. The pilot operates a small control vessel, which remains on the surface. The control vessel is fitted with an advanced tracking system and the ability to communicate with the submarine in real time. The two vessels are not tethered and so all communication is acoustic, passed through the water as radio waves. With a 'down' time of around three hours, this helps maximise the dive experience as the surface controller can guide the submarine to highlights from routes taken before. Back at the surface, the submarine is docked inside the mothership. When the lid seal is released, all you have to do is step out.

More people have been to the moon than down to the deep ocean. Sitting in a transparent bubble, travelling through water without getting wet is an outrageous sensory experience. Then there is the wildlife. What you see through a flat mask while scuba diving is barely an iota of the life hosted by the ocean. At a depth of 300 metres colour can no longer be defined by what the human eye sees when all the wavelengths of the visible spectrum are present, but by what the fish see. And what fish there are to see!

For this experience you don't need a swimming certificate, just a healthy sense of wonder. With more than 95 per cent of the underwater world remaining unexplored, book that front-row seat now. Push one of man's final frontiers and go to the depths of Planet Ocean. Venture deep inside the world's most impressive aquarium and enjoy the 360 degree view.

Opposite top left and right © Shmulik Blum / underseahunter.com **Opposite bottom** © Avi Klapfer / underseahunter.com
Below © Shmulik Blum / underseahunter.com

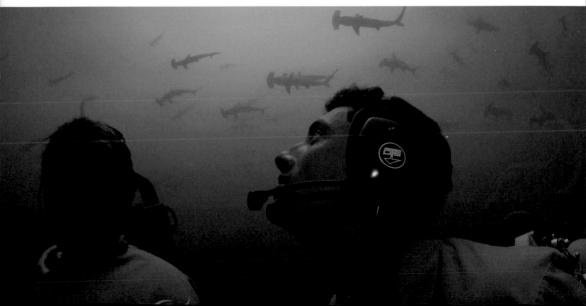

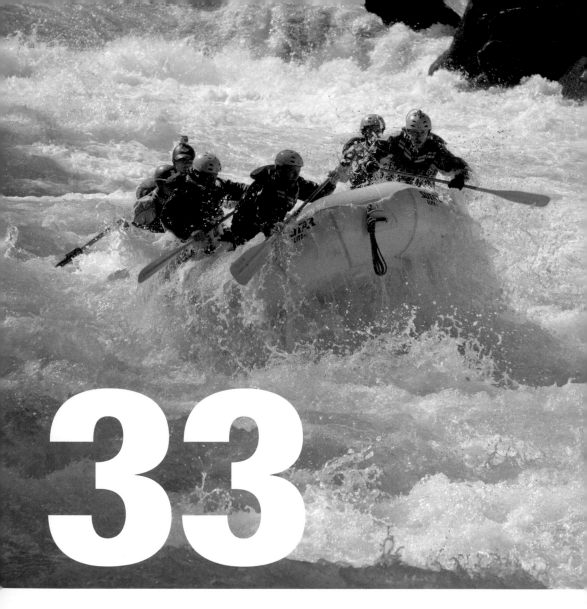

33

White-water raft the Futaleufú River in Chile

Location Futaleufú River, Chile
Complexity Adventurous spirit more
important than physical fitness

Cost ❍❍❍❍❍
Lasting Sentiment Rapid exhilaration!

Paddle as if your life depends on it. Raft the length of South America's Futaleufú River, flowing through Chilean Patagonia beneath the snow-capped crowns of the Andes and through dense evergreen wilderness. Course down highly revered Class 4 and Class 5 white water. Feel the exhilarating rush, as fear turns to elation and back to fear again as you approach the next descent. Run deep turquoise glacial waters and tackle some of the wildest white-water rapids in the world.

'Left forward!' 'Right back!' The commands start flying as fast as the spray. Like pistons in an engine, you and your fellow raft mates thrust your paddles into the spume. You have entered the upper canyon of the Futaleufú and the sheer vertical rock walls mean the only way out is downstream. When you paddle as hard and fast as you can, all you can think about is each stroke. The names of the rapids, 'Infierno', 'Purgatorio', 'Danza de Los Ángeles', that earlier filled you with dread are momentarily eclipsed by the urgency of the moment. You try to rip the paddle through the next patch of churning white water, but to your horror, the river has dropped out from underneath the boat. The bow of the raft begins to plunge down. Your pulse racing, you lever hard against your toes tucked into the foot cups on the floor. You are determined to stay in the raft.

The 'Terminador' on day three of the four-day rafting experience is the stretch of river wildly anticipated by your group. From the quiet pool at the top of the rapid, your guide briefs you on the features you see ahead. All six of you listen in, the atmosphere on board tense with apprehension. You are in this together. Pulled by the flow, the rollercoaster starts again and you're back fighting to navigate

Opposite and below © Carr Clifton / carrclifton.com

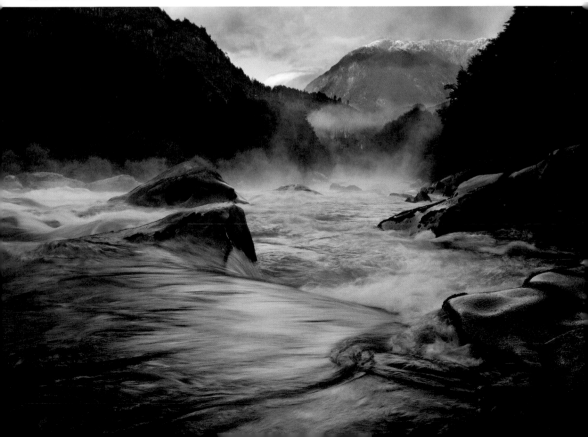

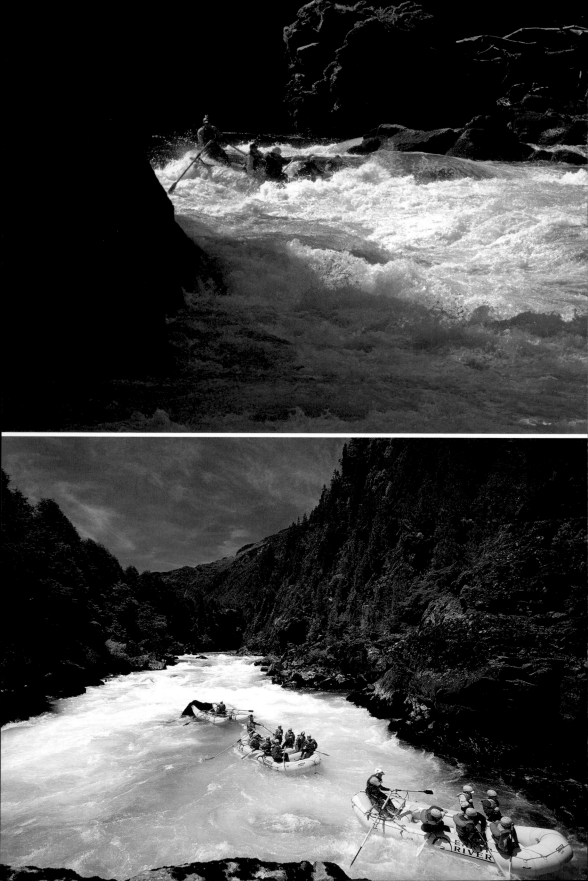

through the froth. The watery landmarks, so easy to see from higher ground, are quickly obliterated by spray. Fortunately your guide knows exactly where you are. The raft careers on. Water barrels along the sides of the rubber and sluices into the boat but by now you no longer wait for the call. When the boat starts to tip sideways, you know to throw your body up to the high side to help rebalance the raft. The bubbles of the hot tub soothe your body as you later recount the flood of relief you felt afterwards.

Connect in Santiago, the capital of Chile, to fly down to Puerto Montt. The town of Futaleufú is an hour or so further via twin-engine prop plane. Passing beautiful lakes and wild rivers, waterfalls and hanging glaciers, the journey to the head of the river is an exceptionally magical one. As the meltwater drains off the glaciers it filters through a series of lakes, leaving any silt behind. The result is unusually translucent water. At a depth of 6 metres, you can see the bottom of the Futaleufú River. The valley also has its own microclimate with the mountains acting as a windbreak, so the water is relatively warm. Any sudden immersion won't come as an icy shock. The best time to go is still in the southern hemisphere summer, between December and March.

From sheer canyon walls to granite cliffs, snow-crested mountain scenery to dense forest lining the banks, the changing topography makes the Futaleufú River feel like a series of rivers rather than just one. A trail runs alongside most of the 80km length of the river. So if you don't fancy the final slalom through the rapids named after endangered animals – 'Pudo' (a native deer), 'Tiburon' (a shark) or 'Wiña' (a small wild cat) – rest up and portage by horseback or mountain bike. Fly fish off the side of one of the 'cataraft' safety vessels. Spend an afternoon hiking, canyoning, rock climbing or ziplining 90 metres across the river.

For an adventure from start to finish, choose a multi-day trip stopping off at exclusive, privately owned wilderness camps located along the river. Maximise your experience by spending a day learning how to paddle using your shoulders as the driving force. Boost your confidence by mastering how to self-rescue and work as a team through the flip drill. When you run out of river and arrive at the final take-out point, together you will feel a great sense of collective accomplishment – especially when you look back at the churning teal-coloured waters of the Futaleufú.

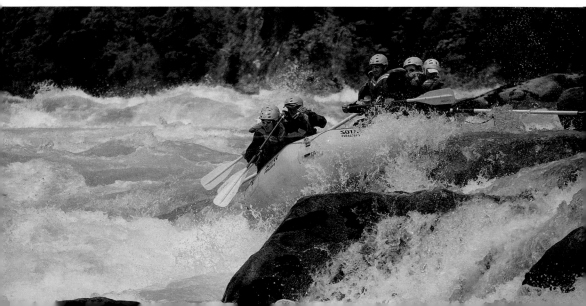

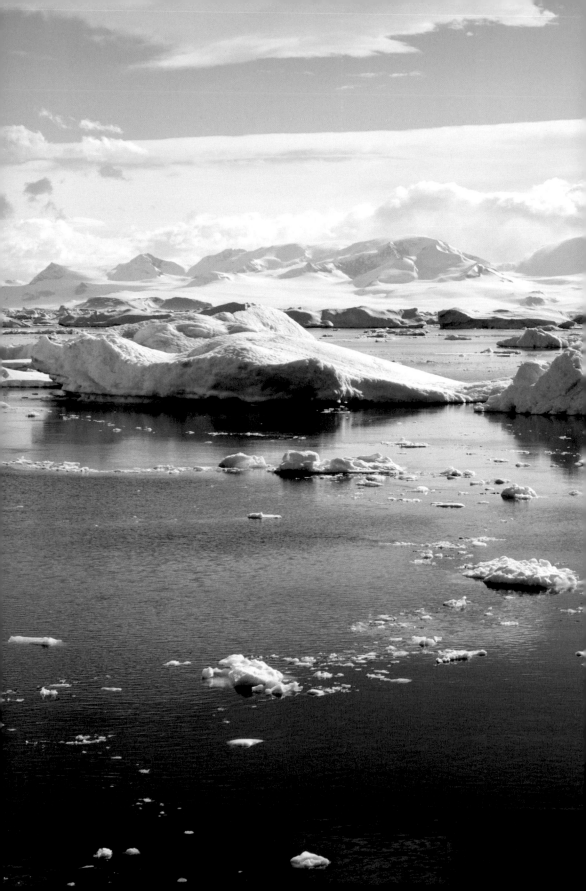

Antarctica

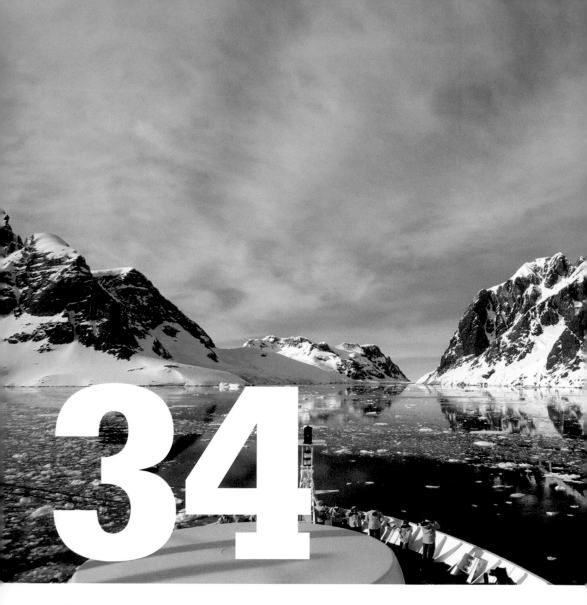

34

Go on a cruise to Antarctica

Location From Ushuaia, Argentina
to Antarctica
Complexity Cruisy!

Cost ○○○○○
Lasting Sentiment Mysterious and vast

Visit a world completely removed from your own. Arrive on the Antarctic Peninsula by boat as all the great explorers have done. Witness an incredible untamed beauty. Mountains draped in thick blankets of snow and gigantic icebergs carved by nature. Encounter wild birds, seals, whales and thousands of penguins living on a land that is colder, wilder and windier than any you may have ever experienced.

Leaving the port of Ushuaia in Argentina, a cruise to Antarctica takes you down the Beagle Channel and out into open water. The Drake Passage between South America and the Antarctic Peninsula can be a glassy lake. When the waves do pick up, you will likely find most of the passengers on deck captivated by the birds – petrels and Antarctic terns swooping and diving for fish drawn to the surface by the chop. The sense of anticipation on board is palpable. Nobody knows the exact destination of the ship. Whether or not the ship stops at each landing site depends on the weather and the itinerary is only divulged in the expedition leader's briefing the night before.

Antarctica never disappoints. You will be stunned by the vastness of the landscape, by the great monoliths of floating ice and by the light. Stepping out of the rigid-inflatable boat (RIB) and on to stone and sand, you get the real sense that you are on an expedition. It feels an achievement in itself simply to reach the frozen continent.

Make your way towards the penguin rookery and a gentoo penguin chick will waddle towards you excitedly. Watch amused as two chinstrap penguins slide down the snow on their bellies and collide before your feet. One penguin steals a rock from an unsuspecting neighbour; you may never tire of watching the penguins interact. When they dive into the sea and shoot about under the water, they truly come into their own.

Back on the ship, head out into the bay. Enjoy the privilege of observing a leopard seal, crabeater seals and the cat-like Weddell seal in their natural habitat, lolling around sleepily on a loose sheet of ice. A hushed awe settles over the passengers on board the RIB as you potter around the edge of massive arching icebergs a glossy translucent blue. You listen to the ice crackling and popping under

Opposite © Steve Chong **Below** © Piotr

stress. When the noise gets louder, it sounds like every strand of ice is splintering. Finally a mass of icy rubble cascades like a landslide into the sea. Thankfully you are a safe distance away.

Later you may get the opportunity to kayak among the 'growlers', the chunks of breakaway ice. If you come face to face with a humpback whale, stop paddling and drift about in your own world, a world consisting of two 5-metre kayaks, two people and an eye – a whale eye. Being examined by one of the largest creatures on earth is a special moment you will never forget.

For the ultimate white Christmas, visit Antarctica in season between November and February, during the southern hemisphere's summer. Book a cruise-south-fly-north package with Quark to save time and avoid the return trip across the Drake Passage. Jet back from King George Island with its view of the Russian Antarctic base in the distance.

Many companies issue an advisory packing list. You are expected to bring waterproof trousers and base layers, but for wear on deck and during landings you will be kitted out with a special polar jacket and boots. Note that smaller ships with fewer passengers offer a community feel and more time to explore on the continent itself.

From snowshoeing to cross-country skiing and mountaineering, the adventure options vary from one ship to another and with the weather. For one unforgettable night only, leave your cosy cabin on board and camp ashore under the stars. Take the 'Polar Plunge' – hurriedly disrobe, then run or jump into the 1°C water before scurrying out open-mouthed, trying to scream, but unable to do so!

Cruise to a magical land of glittering ice and majestic peaks, where the summer sun neither rises nor sets. A land with meteorological extremes, from screaming winds and deep oceanic swells to an open sky and sun that makes a perfect mirror of a glassy sea. Icebergs drift. Curious penguins rush to meet you. Whales surface metres away. With no native population, Antarctica really is like no other place on earth. Before you even leave, you will want to return.

Opposite and below © Quark Expeditions / quarkexpeditions.com

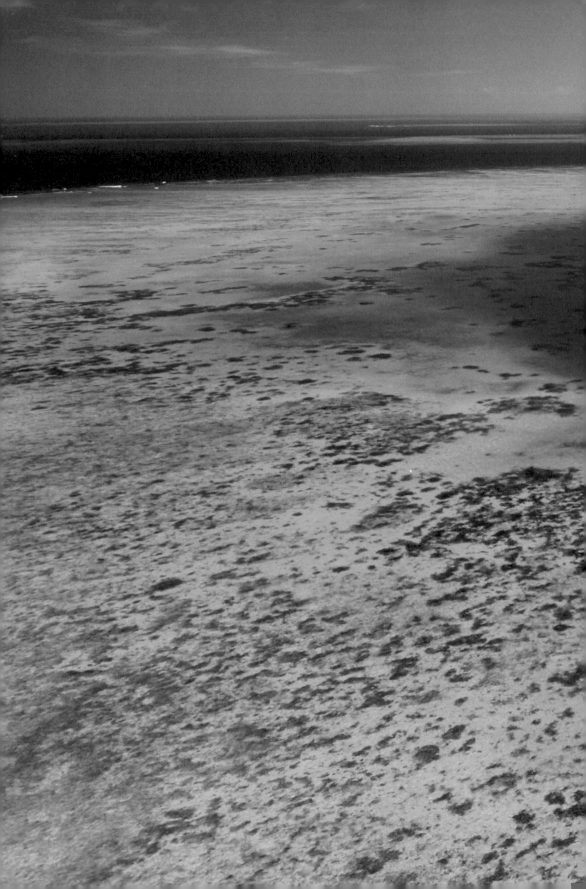

Australasia

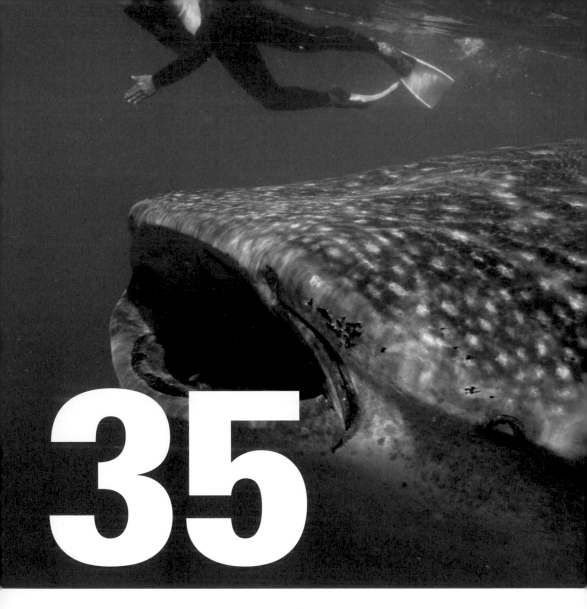

35

Swim with whale sharks in Australia

Location Ningaloo Reef, Exmouth, Australia
Complexity 'Just get in the water, mate!'

Cost ○○○○○
Lasting Sentiment 'Strewth!'

Encounter a fish in the wild that is far longer than you are tall, with a weight more than double that of an elephant and a girth as wide as a London bus. Swim with a whale shark, the largest living non-mammalian invertebrate. Gape into the creature's open mouth as he vacuum-filters microscopic zooplankton from the water. Observe the incredible power in each sweep of his tail, but be more than just a spectator. Get in the water with whale sharks to help a team of marine biologists collect important scientific data.

Mystery still surrounds the whale sharks, since all known congregations in the world are groups of juvenile males, no females. You are briefed the night before on the research tasks you will be given. For note-taking, an underwater slate is used. Your job may be to check the animal for scars, bite marks and propeller wounds. Or you may be entrusted to photograph the whale shark's flanks, its spots and stripes. These markings are unique to each fish in the same way that fingerprints are unique to each human.

The Cessna aircraft takes off to head out to Ningaloo Reef, which fringes the mainland of Western Australia. Your research vessel motors out through a natural channel, where the water from the lagoon drains into the eastern Indian Ocean. Up ahead, the spotter plane scours an area nicknamed the 'megafauna superhighway'. Here the seabed rises up from thousands of metres to less than a hundred metres, drawing leviathan sea creatures up from the deep. Everyone onboard peers into the blue, waiting.

Humpback whales, blue whales, sperm whales, dolphins, marlin and sailfish – suddenly the water erupts with life. Someone catches sight of a huge dark shadow cruising beneath the surface. Trepidation and excitement mount.

Once in the water, your world becomes just you and the whale shark. Expect to be awestruck by the sheer presence of this massive fish. Find the animal's eye and you will be fascinated to see that he too has an iris, which swivels in your direction. Watch the animal looking at you – the experience is unreal. The whale shark doesn't mind you being in his vicinity at all. Swimming slowly round you, he may even be playful.

Underneath the whale shark's belly, you will discover an amazingly diverse community of other

Opposite © Ben Fitzpatrick / oceanwise.com.au **Below** © Silke Stuckenbrock / silkephoto.com.au

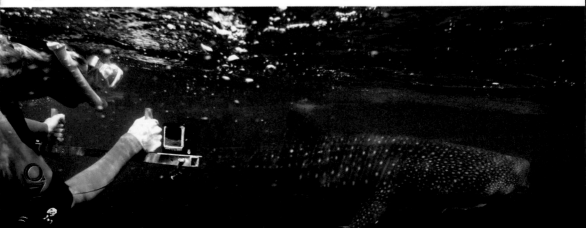

creatures, a collective often referred to as the fish's 'associated biodiversity'. One baby trevally, 12 sizeable tuna, a marlin, a manta ray and a cobia may all be free-riding. To record the whale shark's particulars, such as its sex, dive down until the animal passes over the top of you like an aircraft. Like a living, breathing submarine, the whale shark moves at a fair pace with seemingly little effort at all. You have to swim hard to keep up. Then suddenly the whale shark is gone, the 'fish assemblage' et al simply vanishing into the abyss.

Leading the way in eco-tourism, Australia was the first country in the world where whale sharks were given complete protection by the Federal Government. Interaction guidelines are dictated in specific legislation. Far from heavy agriculture and with no plastics or other pollution being piped into the water, Ningaloo Reef is one of the most pristine coral reefs in the world. To learn about what you see and for a more involved experience, be an active tourist. Join the scientists at Oceanwise Expeditions and sign up to assist in monitoring the whale sharks. Survey the megafauna and witness first-hand the impact of climate change on the ancient living Porites coral.

From Perth, fly up to Learmonth Airport located 36km from the Exmouth Peninsula. Here the reef runs parallel to the shoreline, where the whale sharks are readily accessible. With the help of aerial reconnaissance, the whale sharks can usually be found feeding along the deep outer reef front approximately 26 minutes offshore by boat. Research studies are run during the winter months when the whale sharks congregate at the reef. So the best time to go is between March and August. While the water may be a pleasant temperature, a 'shorty' or full 'wetty' (wetsuit) is still needed to insulate you from any wind chill.

When you follow the whale shark's subtle movements, you begin to understand the amazingly docile nature of the creature, despite its mammoth size. Whale sharks are vulnerable to extinction because of the demand for shark-fin soup and the tuna fish that swim alongside them. Help support scientific research to better our knowledge of these animals. Become a scientist for the day and, in return, spend time with a benign and beautiful sea giant – the biggest-known fish in the world.

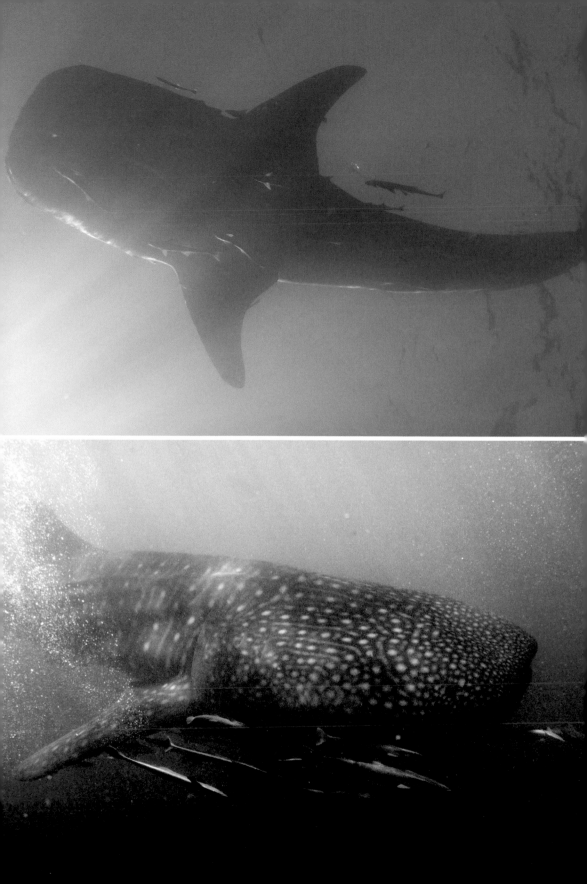

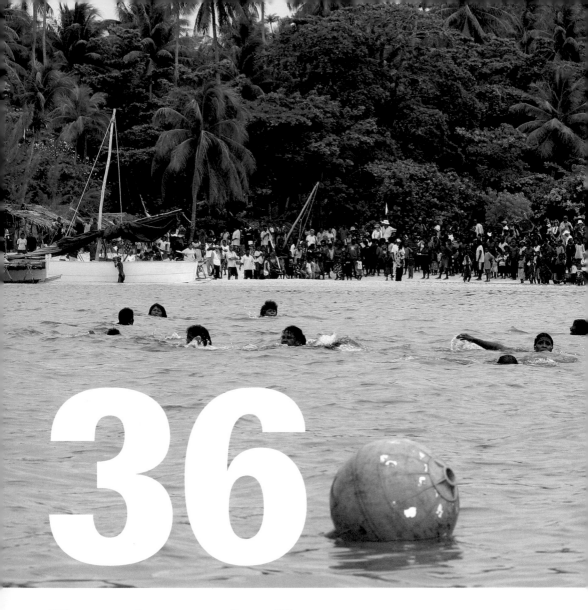

36

Experience the Panapompom Canoe Regatta

Location Louisiade Archipelago, Papua
New Guinea
Complexity Is in the getting there

Cost O O O O O
Lasting Sentiment Give and you
shall receive

Watch a series of races on the water, perhaps as thrilling yet as rudimentary as the first Olympic games in Ancient Greece. Participate by racing with local people, on board a dugout sailing canoe and again when they crew on your modern yacht, since the invitation is reciprocal. With prizes that benefit the local community and a day of fun for everyone, call it sustainable tourism and enjoy this unique festival.

The annual Panapompom Canoe Regatta is worth the expedition to get there. Part of the Louisiade Archipelago south-east of mainland Papua New Guinea, the island of Panapompom is a paradise of palm trees and pearly white beaches. Low-lying and with lush tropical foliage, the only way to reach the island is by boat. Charter your own or crew on a yacht out of Cairns, Australia and enjoy three-and-a-half days of superb sailing across the Coral Sea. Rather than being a contrived festival put on for 'dim-dims' (the local name for white tourists), the regatta offers local men and women, boys and girls, the opportunity to compete to win useful prizes. A tarpaulin or rope to make a sail, several packets of copper nails or a roll of twine might be donated as prizes by the dim-dims. In fact, because there is no local currency, from the moment you arrive everything is negotiated as a fair trade: a chicken, some eggs and pineapples for pens, t-shirts and first aid.

The day of the regatta dawns with blazing blue skies and brilliant white sunshine. Row ashore early in order to get a good vantage point from which to watch the opening festivities. Amid a flurry of excitement, the ceremony starts with traditional dancing right on the beach. 'This is the storytelling of a dugong hunt,' a local elder explains in English. Dressed in their usual everyday

Opposite and below © Clare Pengelly

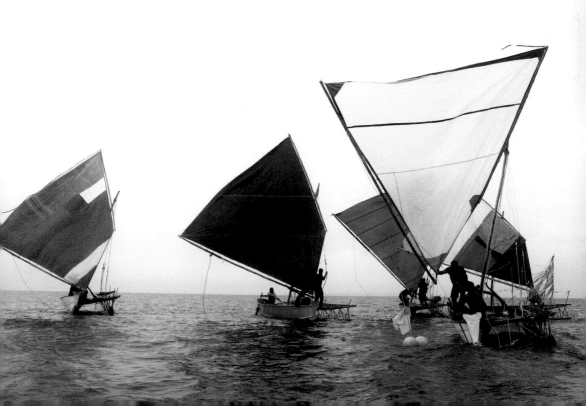

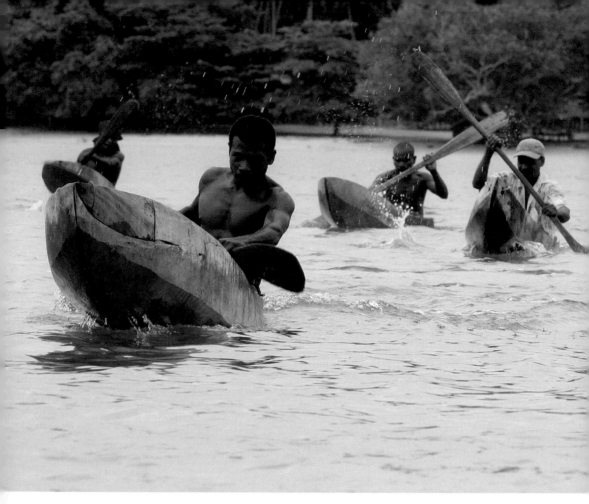

Opposite and above © Clare Pengelly

skirts made of grass, the story is acted out by the residents of Panapompom to the beat of a drum. Two small children hide while the rest of the children, armed with spears, pretend to hunt for them. The crowd of several hundred locals and some 50 cruising yachtsmen and women shout, 'ooh' and 'aah' as the story unfolds. Finally the children are caught and killed in a mock slaughter to which the audience gives thunderous applause.

When the gong goes for the first swimming race, the competitors sprint into the water in their grass skirts. Round a copper marker ball, arms splash as the swimmers drive hard through the water to get back to the beach first. The competition is fierce, the action exciting to watch.

There are races for dugout canoes with outriggers, followed by races for canoes with no outriggers. Each race is hotly contested in a titan match of muscle and whirring paddles. The speed at which the boats without outriggers are propelled is amazing. Pencil-like and called a 'gepo', each boat is carved from a single malauwi tree. Finally it's time for the event highlight and for you to hop aboard your designated 'lakatoi' sailing canoe.

You cross the line with the breeze pressing hard into the seams of your boat's colourful patchwork

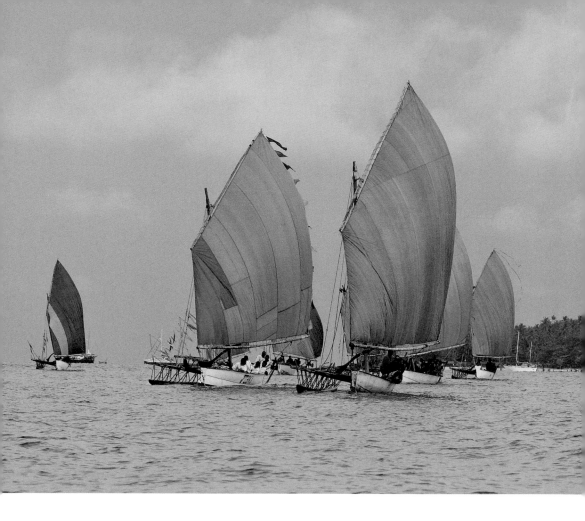

sail. All 20 boats quickly start to convene on the rounding mark. The scene is one of high drama. There is plenty of jovial shouting and red smiles from those chewing betel nut. In order for a lakatoi to change direction, the boat must first stop. You will watch in dismay as each sail is fully depowered, the ends of the material are untied and crew members run with them to the other end of the boat. Meanwhile the helmsman runs in the other direction with the paddle rudder. This all happens fast and in strong wind! With the sail clipped in its new place, the rudder installed and the mast re-tensioned, the sailing canoe accelerates. The front of the boat has now become the back and vice versa. For first-time crew members, the art is in managing to successfully keep out of the way!

There is something quite unique about the Panapompom Canoe Regatta with its triathlon of swimming, paddling and sailing races. The relationship between tourists and locals boosts the welfare and prosperity of the local community and the regatta is great fun for all involved. With a prize-giving, a 'singsing' (singsong) and a 'mu-mu' (a feast cooked in a traditional pit-fire), enjoy all the liveliness you would expect from a Pacific Island celebration. Thanks to the clever concept, there is none of the artifice that tourism usually creates.

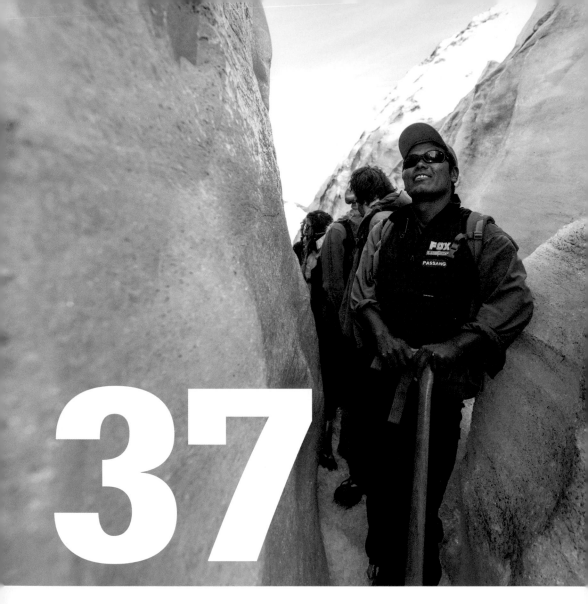

37

Heli-hike a glacier in New Zealand

Location Fox Glacier, New Zealand
Complexity Moderate level of fitness required

Cost ⦿⦿⦿⦾⦾
Lasting Sentiment Frozen in time

Gain an aerial perspective of one of the world's finest glaciers. Fly up a frozen waterfall and over giant ice pinnacles. Marvel at the dirty whites and breathtaking powdery blues. A helicopter ride enables you to explore special hard-to-reach parts of the glacier. When you land on the highest plateau, hike under nature's newest sculptures, through glistening arches and into spectacular ice caves. Go on a water adventure of the frozen kind!

Enjoy the thrill of being in a helicopter cruising over a World Heritage site. Passing over jaw-dropping valleys and concealed crevasses, you are reminded that the ice is in slow, constant motion. When the helicopter banks over the glacier, adjust your sunglasses for the glare and prepare to rise up over the cascade of Victoria Falls and set down on Victoria Flats.

Decked out with sturdy leather boots, you step out on to the brilliant white landscape. The view is spectacular, the glacier around you a textured snowy-white. Take a moment to regain a sense of scale – the helicopter will look comparatively small. The atmosphere within your group is charged from the privilege of being in such an exceptionally beautiful place. You are ready to explore.

Your guide demonstrates how to strap the specially designed ice crampons to your boots. You will be glad of the crampons as the metal teeth give you traction on the ice. Gingerly at first, then more confidently, you trek through massive rifts of ice, the sun cutting dramatic shadows into the undulating surfaces. Follow your guide down channels a half-metre wide that are starting to pool with meltwater. Peer into spectacular caves with large icicles dangling overhead and walk through gullies with sheer vertical walls leading out into great chasms of cool blues. One overhang drips

Opposite and below © Fox Glacier Guiding / foxguides.co.nz

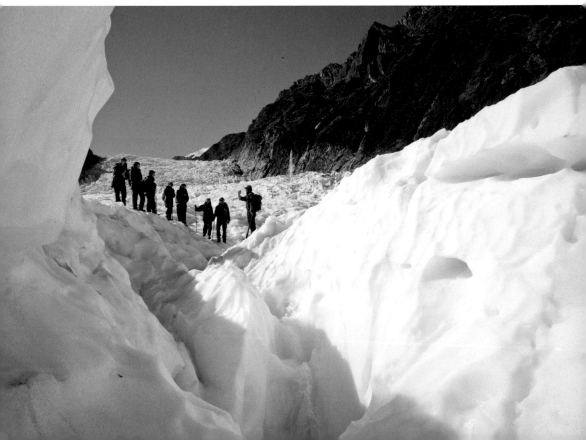

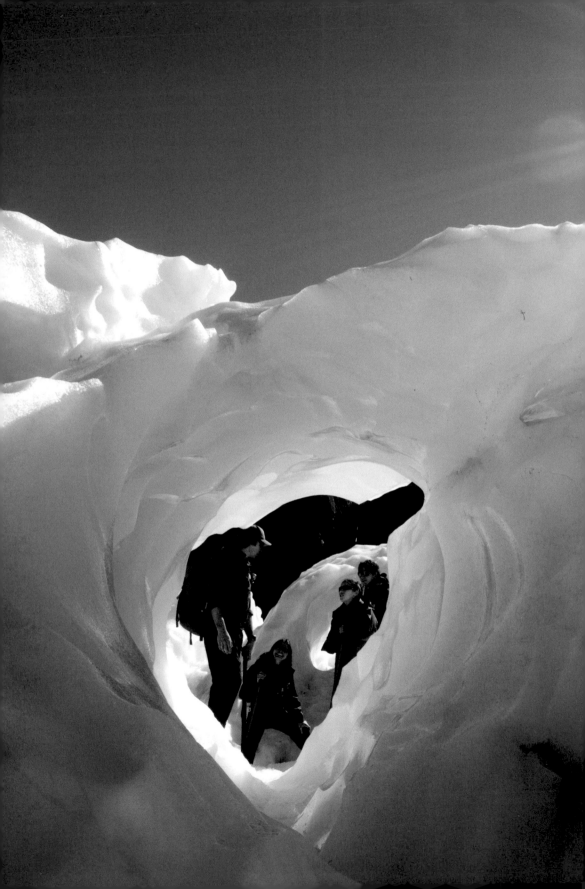

clean water like a running tap. Odourless, colourless and tasteless, the water is as pure as it should be. Be sure to fill your drink bottle and sip the deliciously cold glacier water.

As you walk, you will learn about the glacier from your guide. About the extreme forces that create compression arches and how the moving ice grinds against the rock to create rock flour, which gives glacial lakes their incredible milky turquoise colour. The temperature varies quite readily and with the katabatic winds (wind that blows down a slope) starting to draught down the mountain you will be glad of the extra layers you were advised to wear. Back up in the air and looking down from the helicopter, watch the icy wonderland below as it darkens into dramatic shades.

Anyone with a moderate level of fitness and agility can hike Fox Glacier. Situated on the west coast of New Zealand's South Island, Fox Glacier is one of only four glaciers in the world that culminate in lush rainforest several hundred metres above sea level. A short walk from the main state highway, it is by far the most accessible of the four. Regular coach services connect Fox Glacier Township with Wanaka and Queenstown in the south, while Hokitika is the nearest domestic airport in the north.

The combination of the unique opportunity to fly over the ice flow and the excitement of a walk in a remote region takes your visit to the next level. Rather than being an extreme adventure in its own right, the ride by helicopter acts as a safe shuttle. Ice axes, boots, crampons, hiking poles – all the necessary equipment is provided.

In the autumn, long periods of blue sky alternate with rain that washes the glacier clean, restoring the ice to a brilliant white. In the winter, the ice is harder and drier. Each season brings it own beauty. While the higher melt ratio in the summer means the ice shines, the features change more readily and pools form from the run-off. Whichever season you choose, expect to be on the ice for about two-and-a-half hours, weather permitting.

Follow the ice steps cut by your guide as you explore together the amazing formations only seen at higher levels. Trek down ice passageways, listening to the rasp of your crampons gripping the ice. Bask in the cool soothing blues. With the ice flow in perpetual flux, a flight over Fox Glacier is a true voyage of exploration. As the Greek philosopher Heraclitus is reported to have said, 'everything changes and nothing remains still'. The ices features today may not be the same tomorrow.

Opposite and below © Fox Glacier Guiding / foxguides.co.nz

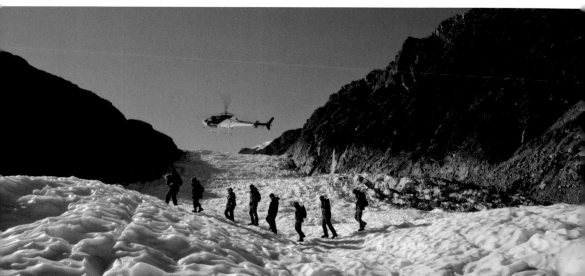

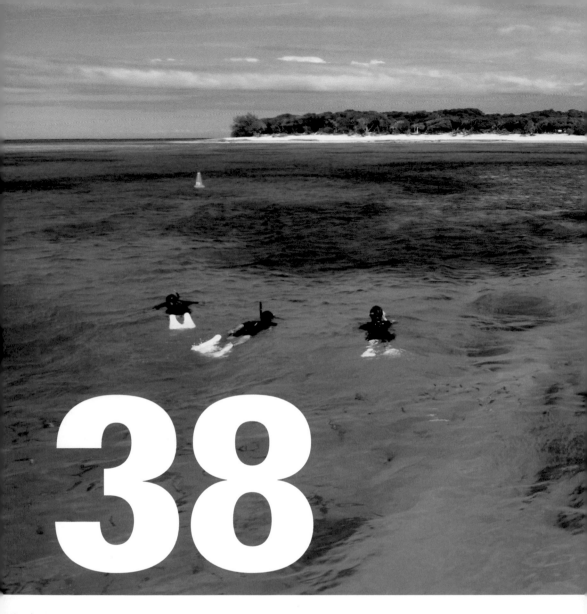

38

Snorkel the Great Barrier Reef

Location Lady Musgrave Island,
Australia
Complexity Book and go!

Cost ○○○○○
Lasting Sentiment Snorkelling that
takes your breath away

Enter another world. Slip on fins, mask and a snorkel and watch manta rays and large turtles in their natural habitat. Swim in pristine, clear blue waters. Gaze down at starfish, sea urchins, clams and corals of myriad vibrant colours. As the waves break on the outside of the reef, enjoy the calm inside the lagoon. Like swimming in a giant aquarium, snorkel the Great Barrier Reef where it is most protected, both environmentally and physically.

From the village of Seventeen Seventy in Queensland, cruise out to Lady Musgrave Island in the Coral Sea. A World Heritage Area managed by the Environmental Protection Agency, the boat ride is a wildlife-watching bonanza. You will gasp in surprise when a huge humpback whale breaches so close that you can smell his fishy breath. Black with a white patterned underbelly, it is astonishing to see the whole animal launch clean out of the water. To ensure the safety of the animal, your boat will drift with the engine switched off for a few minutes until the migrating whale has passed.

A pod of dolphins some 10 to 20 in number may be your next treat. The younger ones do somersaults, all females travelling together. A fast-swimming bronze whaler shark may graze the surface, its dorsal fin causing much excitement on board, or a turtle 1.5 metres in diameter flapping its way past.

Once at the floating pontoon, you gear up for snorkelling. Even 300 metres from the sandy cay, the water clarity is incredible. A protected Green Zone, the lagoon has never been fished and so is abundant with large and rare marine life. Through your mask you see a marvellous underwater garden teeming with life. Home to some 1300 varieties of tropical fish and 350 species of both hard and soft corals, you could watch the marine activity for hours.

Opposite © Terry Wright / blackdiamondimages.zenfolio.com **Below** © Lady Musgrave Cruises / lmcruises.com.au

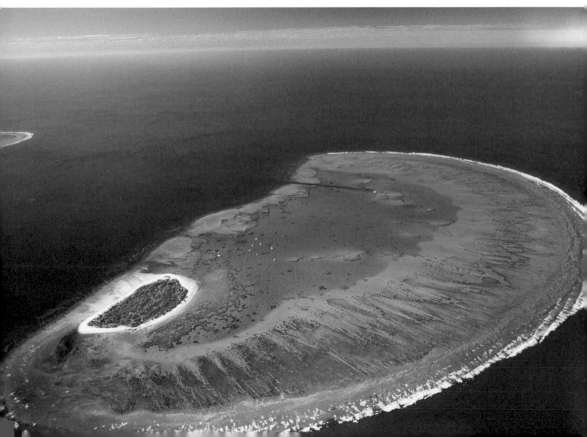

Later, in the comfort of the semi-submersible, venture outside the lagoon to the area where the manta rays are known to circulate. On the other side of the window, 15 to 20 manta rays swoop and dive, giant fish gliding through the water with their mouths open and wings trailing. A school of sizeable bonito may also idle by. None of the creatures shy away.

With 400 hectares of reef to explore inside the lagoon alone, book one of only 40 camping permits available per night. This is your genuine castaway experience, as you must bring with you everything you need to survive. Uninhabited and outside the light cone of coastal cities, the stargazing is spectacular. Fall asleep to the sound of nothing but wilderness, ready to sightsee the Great Barrier Reef another day.

To visit Lady Musgrave Island, first head to the village of Seventeen Seventy, named after the year in which Captain James Cook first landed in Queensland. Fly into Bundaberg or Gladstone or drive up from Brisbane to the cruise departure point at Round Hill Head. Lady Musgrave Cruises is the sole operator permitted on the island, so day trips include the option of a guided island walk, a tour in a glass-bottomed boat and/or in a semi-submersible.

Overnight campers must arrive equipped for self-sufficiency, with enough food and drinking water. There are composting toilets and solar-powered freshwater showers, but otherwise the island is populated solely by forests of the native Pisonia tree. You can snorkel here at any time of the year without the need for a 'stinger suit' to shield you from the venomous Irukandji jellyfish and other box jellyfish. However, to avoid getting marooned on the island, steer clear of the cyclone season, from December to April. Also note that the island is closed to campers in February and March to provide a haven for nesting seabirds and to protect the turtle hatchlings.

In rustic Robinson Crusoe-style, stay on the untouched island of Lady Musgrave, the only coral island with a navigable lagoon in the Great Barrier Reef chain. With glittering turquoise water and no current or swell, swim in the lagoon until you tire. Wake early to explore more of the exotic aquarium – your own 400-hectare swimming pool. Bring a dinghy, if you have one, to venture further afield and discover for yourself why the Great Barrier Reef is one of the seven natural wonders of the world.

Opposite top © Andras Deak / andrasdeak.com **Opposite bottom** © Lady Musgrave Cruises / lmcruises.com.au
Below © Annie Lindsay / highlanddrover.com

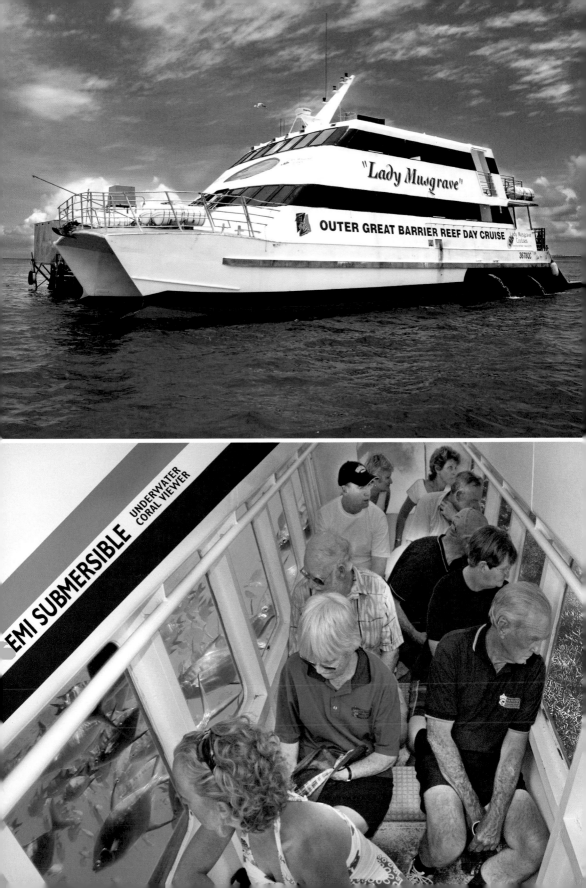

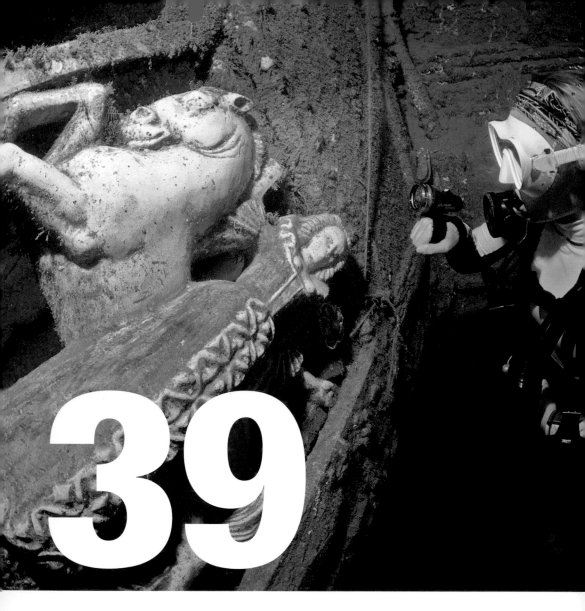

39

Wreck dive the SS *President Coolidge* in Vanuatu

Location The SS *President Coolidge*, Espiritu Santo, Vanuatu
Complexity For learner-divers and pros alike

Cost ○○○○○
Lasting Sentiment The greatness of the ship makes you feel small

Dive one of the largest accessible shipwrecks in the world. Delve inside the fascinating interior of a luxury liner turned military troop carrier. Explore the many cabins, cargo holds and function rooms, including the barber's shop and doctor's office. With all the fittings, fixings and paraphernalia well-preserved, imagine the workings of life on board and then the moment on Monday 26 October, 1942 when the call is given to abandon ship.

An underwater mine strikes near the engine room of the SS *President Coolidge* and another near the stern. The captain, in an effort to avoid losing the ship, runs the vessel aground near the harbour's mouth. Over the course of the next 90 minutes, all bar two of the 5342 men on board make it safely to shore. Not believing the ship would sink, the troops leave all their belongings – and thus a fascinating playground for divers – behind.

Dive your way along the deserted promenade deck towards the ship's gun turrets and you will find the entrance via the open bulkhead door. Inside a long eerie tunnel, windows of light show where the portholes once looked out to sea. Duck down into cargo holds number one and two to explore a treasure trove of car parts – frames of army jeeps, stacks of tyres and trucks with a colourful coat of reef plants. In the barber's shop, the traditional barber's chair is still bolted to the floor; in the Captain's bathroom, a bath with claw feet is filled with years of seabed slime. A couple of beautiful angelfish may swim casually by, or a large fat-lipped grouper. They remind you of the here and now.

With the ship lying on her port side, you have to turn your head to picture the original scene. Chinks of light seep through, but by now a flashlight is needed to illuminate the details and to

Opposite and below © Matt Krumins / mattkrumins.com

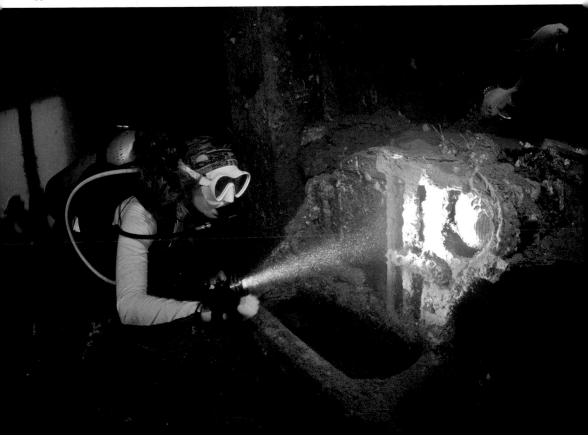

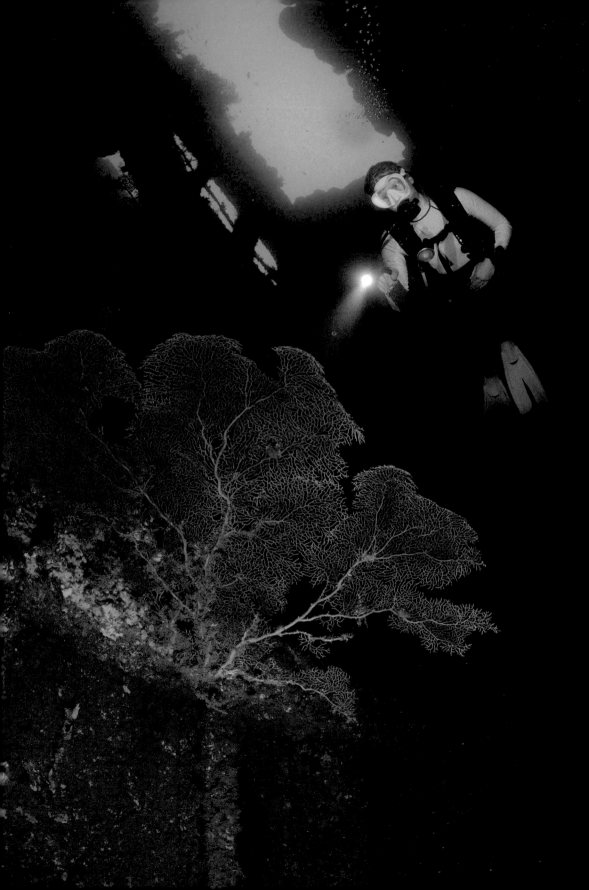

navigate safely. A pattern of white, blue and orange ceramic tiles make up the mosaic in the lobby fountain. From here, stairs lead up to the top deck and the first-class dining room where the large iconic ceramic is located. The ceramic used to be above the fireplace in the first-class saloon, but it fell off during an earthquake. Part of the identity of the ship, the ceramic features the figure of a lady in front of a rearing unicorn, the colours white, red and yellow still amazingly vivid. Only the accommodation sections deep within the deck appear full of silt.

The wreck of the SS *President Coolidge* sank in 50 metres of water off the beach of Espiritu Santo, the largest island of the South Pacific island chain of Vanuatu. This is very convenient – unlike the RMS *Titanic* which, lying some 600 kilometres south-east of Newfoundland and at a depth of nearly 4000 metres, is fairly inaccessible. Stretching a colossal 187.5 metres from bow to stern and lying in 20–60 metres of water, the SS *President Coolidge* caters for every level of diving competency. While it depends on the depth, usually only 5 to 10 per cent of the ship can be explored per dive. There is so much to see. A package of 10 dives is therefore recommended in order to have a good look inside.

The SS *President Coolidge* is a protected heritage site. Each dive must be booked through one of the dive shops on the island, as only they are licensed to ensure that soldiers' helmets, rifles and all removable objects remain in their rightful place. The local dive instructors are also your best guides on how to move safely and time-efficiently through the ship. For a 45-metre dive, discover the engine room filled with huge turbine engines, where the brass telegraphs remain stuck on full reverse and a wall of analogue dials form the electrical panel. Finally, the stern area – where cargo holds six and seven contain ambulances, the ship's spare propeller and rounds of ammunition – is a quick deep-water dive suitable for competent technical divers only.

Fascinating for beginners and experienced divers alike, the SS *President Coolidge* is not the usual rotten corpse of a ship with massive holes from collapsed bulkheads. A 20th-century cruise liner, the superstructure of the SS *President Coolidge* is completely intact. Only the wooden interior doors have disappeared. From the bridge deck to the swimming pool in the stern, the amount of paraphernalia the vessel contains is astounding and great fun to interact with. Suit up and swim out. All you need is a guide, a dive buddy and a full tank.

Opposite and below © Matt Krumins / mattkrumins.com

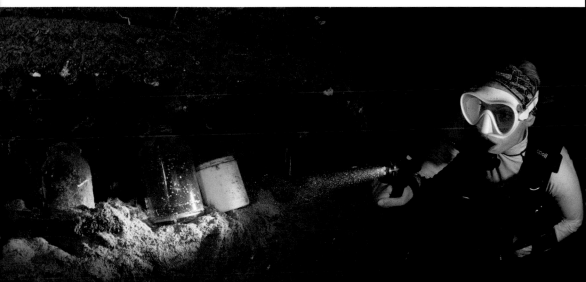

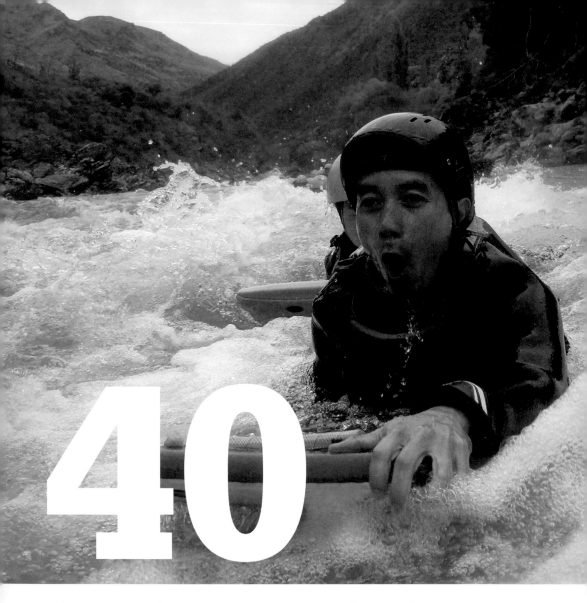

40

Riverboard in New Zealand

Location Kawarau River, South Island, New Zealand

Complexity Concentration required

Cost ○○○○○

Lasting Sentiment An immersive ride

Tap into the raw power of Mother Nature. Jump into a seething river with a riverboard. Point your board and kick with your fins to steer a line down the channel. Navigate your way through a series of Class 3 rapids and whirlpools a gorgeous turquoise colour. Feel the water surge beneath your body, look up at every wave and enjoy an intense, adrenalin-pumping rush, immersed in a white-water river without either boat or crew.

Also called white-water sledging in New Zealand, hydrospeed in continental Europe and white-water swimming by others, riverboarding involves getting wet and going fast. For safety reasons, bigger-volume rivers – the deeper the better – make great riverboarding destinations and mountainous New Zealand is full of them. For a challenging but enjoyable introductory experience, head to the Roaring Meg section of the Kawarau Gorge, on the Kawarau River. Here the rapids are formed by the narrowing gorge and the restricted passage of the water, rather than by water pouring over buried rocks. With numerous features to look forward to, this 7km ribbon will keep your mind buzzing for the entire 45-minute ride.

Five-mm thick wetsuit and helmet – check. Buoyancy aid and short bodyboarding fins – check. Your riverboard is a flat closed-cell foam board with handholds, which resembles a modified bodyboard. Now you are ready to leap in. First your guide demonstrates how to roll your body to get back on your board if you come off. He shows you how to angle the board to direct your way through the rapids and the best kicking technique to use. How to read the water and understand what the

Opposite and below © Serious Fun River Surfing / riversurfing.co.nz

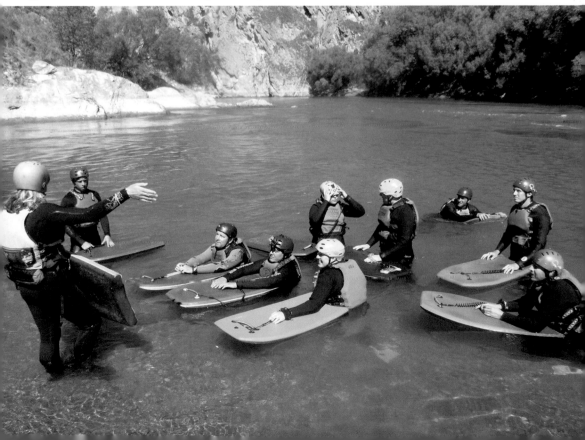

hydraulics are doing up ahead is something you expect to learn with experience, but he gives you a few tips on what to look out for in the meantime. With some trepidation you finally take the plunge.

The first stretch of the river zigzags down to a scarily narrow rift barely a metre wide. The river widens. You will probably bomb straight down the middle of the first rapid, then the second, with a few waves bobbing you merrily up and down. Then you reach the pronounced 'S' bend, known as 'The Elbow'. You watch the water pile into the rocky bank and ricochet into the opposite cliff as you get drawn nearer. Pushed one way then the other, your traverse is quick and a brief float section afterwards allows you time to steel yourself for the next section.

Your guide shouts the name of the rapids: 'The Vacuum Cleaner and the Man-eater'. The water swirls. Currents ripple the surface. You may get caught in a whirlpool, which spins you round momentarily, disorientating you as the water attempts to pull you under. You are released. The river straightens out and the exhilarating ride continues.

Take a domestic flight down from Auckland or fly direct to Queenstown, considered the adventure capital of the world. You'll find the Kawarau Gorge 40km out of town. The highway snakes along the river, past the famous Pinot wine-growing region of Gibbston Valley, so expect stunning views

Opposite and below © Serious Fun River Surfing / riversurfing.co.nz

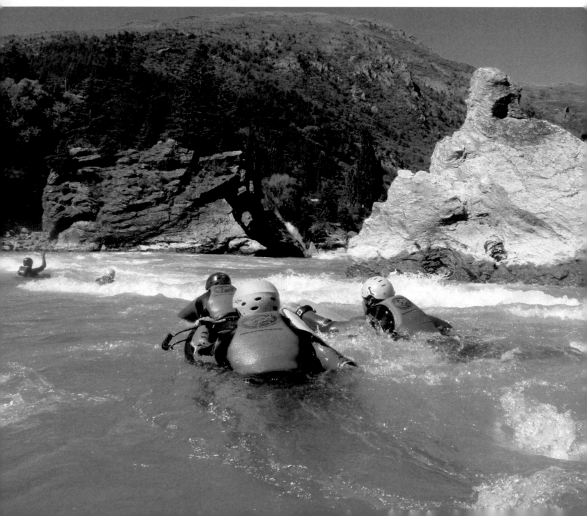

of rugged alpine hillsides. In early summer the Kawarau River starts to drain Lake Wakatipu of meltwater with a cool, swift flow all the way to Lake Dunstan. Terrific currents can flatten out the rapids, but then again the fast, powerful flow can kick up some enormous rolling stationary waves perfect for surfing. For an enjoyable first experience, wait for warmer water temperatures and a lower flow rate from January.

Unless you are an experienced riverboarder and know the Kawarau River, a guide is essential. Your guide will know the best and safest route. They say that bad surfers make good riverboarders, as they are used to being jostled by waves. You don't need to be a strong swimmer, just comfortable with being in the water and getting splashed in the face!

While your first run through the rapids will quickly familiarise you with the technique of riverboarding, by the second you will probably feel bolder. Try riding a 'squirt', a seam line where two currents meet each other, or carving back and forwards on a static river wave. As the river tumbles and roars through a succession of rapids and swirling eddies, you will flow with the river's every twist and turn. Physically demanding and thoroughly exhilarating, riverboarding is the most intimate experience you can have with a white-water river.

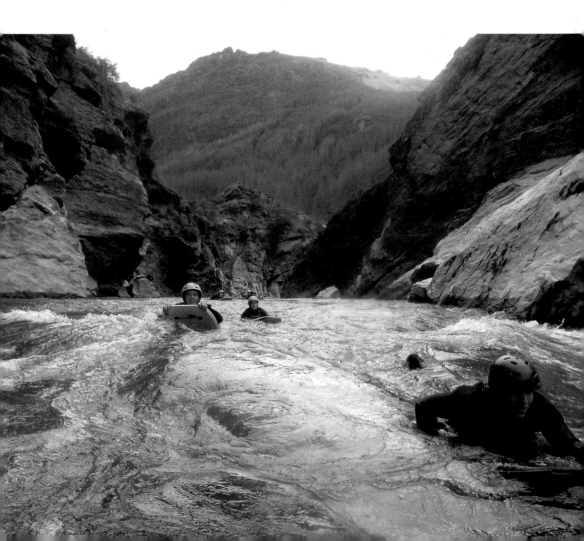

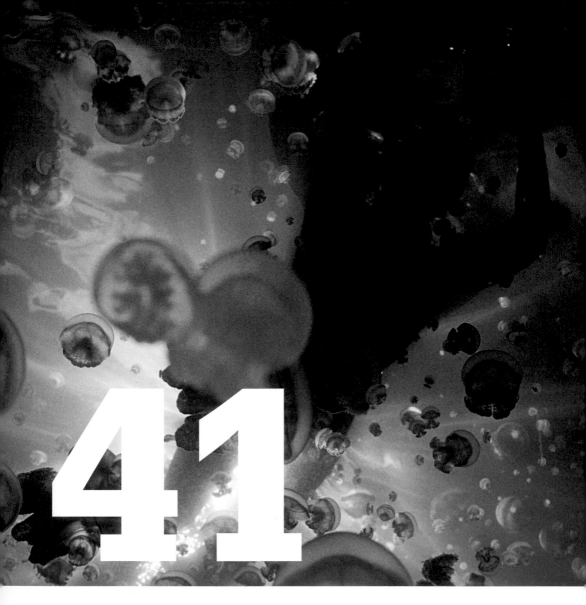

41

Swim with jellyfish in Micronesia

Location Republic of Palau, Micronesia **Cost** ○○○○○

Complexity Not for jelly-phobes **Lasting Sentiment** Creepy but beautiful

Imagine your body being touched all over by soft wet jelly. Override the inclination to flinch, as you remind yourself that the Mastigias jellyfish does not have a sting powerful enough to harm people. Snorkel further into the lake and allow your body to become enveloped by the beautiful, pulsing, peach-coloured globules. Observe these fascinating creatures as they propel themselves slowly through the water while you float like a 'golden jellyfish' in its natural salt-water habitat.

For 400 metres, you hike up and over the mountainous ridge through cool underbrush. Having arrived at the wooden dock on the north-west corner, Jellyfish Lake suddenly opens out before you. The view is of exotic green water bordered by dense rainforest on all sides. As a National Park, the lake has an ancient, untouched beauty. Initially you only see a few jellyfish scattered in the nearby water but, once in the lake, you peer down through your mask and in the sun-kissed green find exactly what you came for.

Several golden jellyfish gently pulse up towards you. When you venture deeper into the lake, swimming further out, the water becomes thick with life. All around you, jellyfish are travelling in slow motion in different directions. Jellyfish parts brush your body all over, amass around your face and under your mask. For a moment the sensation may be claustrophobic. You may feel alarmingly outnumbered but, with so many jellyfish in the water, wriggling away is laughable. You quickly become absorbed watching the delicate translucent membranes pull together like a drawstring, watching closely as the jellyfish suck in and expel water as a means of propulsion. Using slow, gentle kicks with your fins, try to glide serenely on the surface above the animals as brisk movements could snag or unintentionally tear them.

Towards the eastern rim of the lake, the jellyfish population becomes denser still. A smack of jellyfish congregates beside the shadow cast by the mangrove trees lining the shore. The jellyfish need sunlight in order to survive and so they stay in the sunlit waters. Clustered around the roots of the mangrove trees, discover sea squirts, sponges and mussels. Anemones too, the jellyfish's only predator. Being mid-morning, most of the jellyfish will have made their migration across the lake

Opposite and below © Navot Bornovski / fishnfins.com

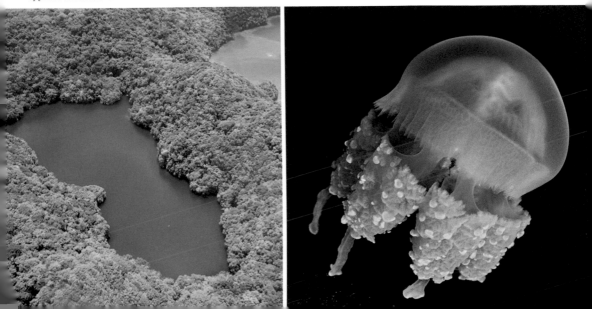

and so are now starting to turn back. Watch them slowly starting to reverse their route, back to the western basin to idle overnight.

Jellyfish Lake or Ongeim'l Tketau (meaning 'Fifth Lake' in Palauan) is situated on Eil Malk, the southern peninsula of Mecherchar Island in Palau. This is the main island of the largely uninhabited Rock Island archipelago in the Pacific Ocean, and the lake is a 30–40 minute trip by speedboat from the former Palauan capital Koror. Before visiting the lake, you must purchase a Rock Island permit from a tour operator. This is a park fee to aid conservation, and is valid for ten days. From your arrival point in the neighbouring lagoon, the trail to Jellyfish Lake is a relatively steep succession of rocky steps. Rope handrails lead the way, so you needn't be particularly fit. Rent a buoyancy aid if you are not a confident swimmer, or request to go in the early morning or mid-afternoon when the jellyfish in their migration pattern are likely to be closest to the dock.

Curiously, Jellyfish Lake is naturally stratified. There is an oxygenated upper layer and an anoxic (toxic) lower layer, which restricts plant and animal life to the top 12 metres. Scuba diving is banned partly for this reason. The air bubbles exhaled by divers can also become trapped in the tissue pockets of the jellyfish, pinning them to the surface. Just like jellyfish everywhere, the golden jellyfish have stinging cells called nematocysts. However, their sting is undetectable except on sensitive tissue such as the lips. Those prone to allergies are advised to wear protective clothing just in case. While it is possible to snorkel the lake at any time of the year, there is less chance of rain and fewer windy days between November and May.

Ensconced in the world of your own mask, being surrounded by soft, peaceful creatures going about their daily existence, can be a very meditative experience. The first golden jellyfish to touch you may cause you some alarm. Once reassured that you won't be stung, you find yourself diving down to glide through clouds of jellyfish, each one a universe of lazily spinning jelly planets.

Opposite and below © Navot Bornovski / fishnfins.com

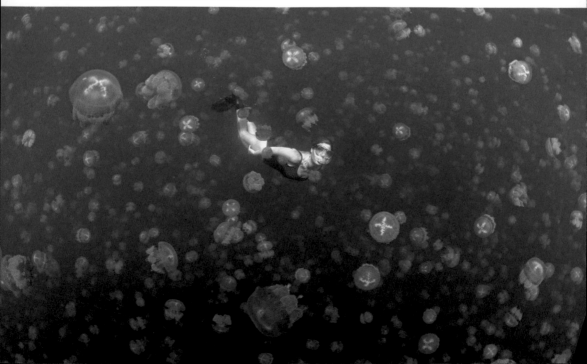

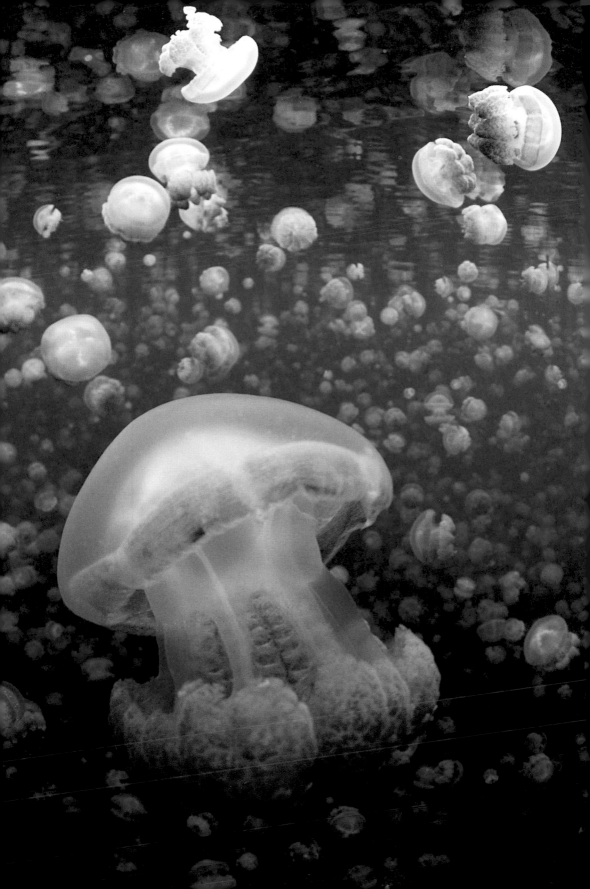

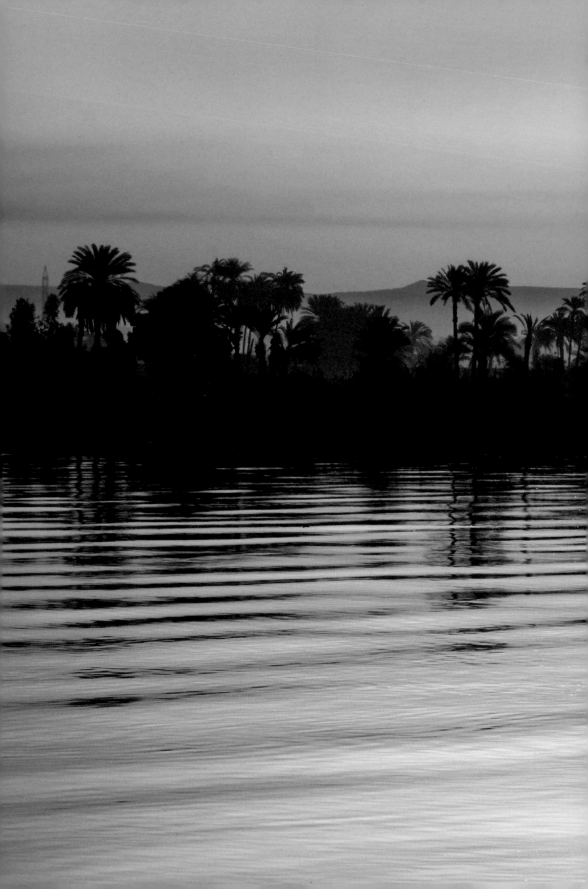

Asia

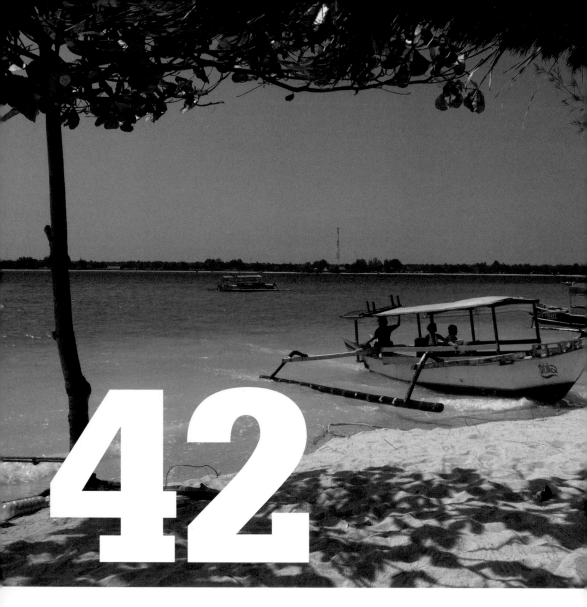

42

Island hop to Gili Meno

Location Gili Meno, Indonesia
Complexity Hang on and try to keep your bag dry!

Cost ○○○○○○

Lasting Sentiment Relax, island-style

Feel the allure of total escapism. Visit a forgotten island of vivid tropical plants, indigenous parrots and wildly photogenic beaches. Set in the middle of three tiny islets in Indonesia, travel to Gili Meno, turtle capital of the world. One of few places that remain slightly out of reach, enlist a local fisherman to get you across the channel. Take a local boat round the island to dive. Snorkel anywhere off the beach and enjoy all the pleasures of a secluded island retreat.

The castaway adventure begins with the fun of getting there. The island of Gili Meno is only 2km long and 1km wide, so there is no room for an airport. Hemmed in by a thriving reef, it is not possible to arrive or depart by seaplane either.

You have two transport options by boat. Catch the high-speed ferry from Padang Bai on the east coast of Bali directly to the largest of the three islands, the neighbouring island of Gili Trawangan, known as 'Gili T'. From here you need to hire a local fisherman and his 'jukung' to sail you across the channel from Gili T to Gili Meno. A jukung may be only slightly deeper than a canoe, with an outrigger to balance and two bamboo poles to spread the makeshift sail, but rest assured, you will likely make it, even if the vessel seems to be tied together with string!

Alternatively, cruise on down to Benoa Harbour in your rental car or scooter. If time is on your side, drive your scooter on to the slow ferry and sail off to the adjacent island of Lombok. After cruising through the town of Mataram, pick up the coastal road and ride up from Lembar to Bangsal, the jumping-off point for the Gili Isles. With the surf breaking on the beach on one side and the mountains on the other, the 70km drive is heavenly.

A small wooden ferry goes to Gili Meno via the island of Gili Air. Pack yourself in among the locals with their chickens and produce and resign yourself to wait. The captain will only leave when a minimum number of people are in the boat. You can see the island of Gili Air 1km away. It isn't far! A note of warning – take care not to interact with touts or 'helpers', who are likely to try to mislead you and coerce money out of you for non-existent services. For a speedier departure, you and your fellow passengers may be genuinely encouraged to buy up the remaining tickets. Finally, after a

Opposite © Stuart McDonald **Below left** © Rosino **Below right** © Christian Anderson

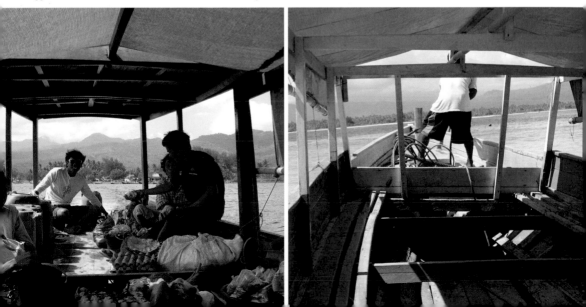

quick stop at Gili Air, your boat cuts through a small channel in the reef to drop you right on the beach of Gili Meno. There is no formal harbour.

'No cars or motorbikes, no worries' is the local mantra on Gili Meno. Motorcycles are prohibited so be sure to drop your scooter off on Lombok. There are three ways to get around Gili Meno: by foot, bicycle or by 'cidomo', a carriage drawn by horses, but for now you may simply want to doze, happy to kick back in a hammock on the beach after all your efforts to arrive.

Negotiate with a fisherman and take a ride out through the reef belt to the north-west of the island. For divers and snorkellers, a tour of the Gili Meno 'Wall' is a must. With good visibility all year round, expect to see hawksbill and leatherback sea turtles. Schools of batfish and blue-spotted stingrays can also be seen freely swimming by. At night, moray eels defend their crevices. Baby cuttlefish cruise. Crustaceans crawl over the reef, while the so-called 'Spanish Dancers', the rare and unusual nudibranch, writhe around, their bodies resembling the swirl of a Flamenco dancer's skirt.

For the driest weather and deserted beaches, visit in January, February, October or November. Book yourself a charming hut on the main beach, or a thatched bungalow set back from the main path. The electricity may go out for the whole morning, but with gorgeous virgin sand beneath your feet, balmy 33°C-water sluicing between your toes and the option to snorkel on the reef just a four-minute walk away, you will hardly notice the inconvenience.

Soak up that remote island feel of peaceful evenings under starry skies. Take a dip in the pristine waters and watch the locals collect sea urchins as the tide rolls out. When it's time to leave the island, carry your bag overhead and walk out to where the fisherman is waiting for you at the very fringe of the reef.

Opposite © Prof. Michael 'Mikaku' Doliveck / balifloatingleaf.com **Below** © Andrew Cosgreave

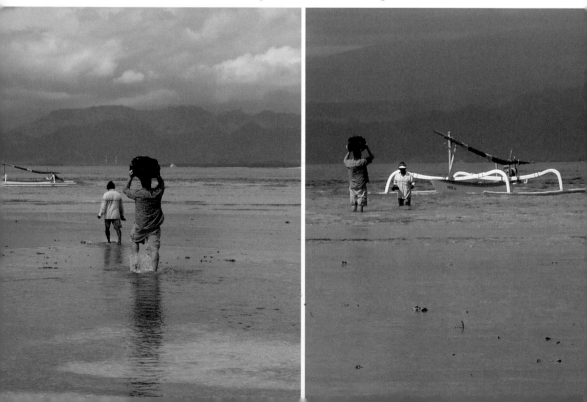

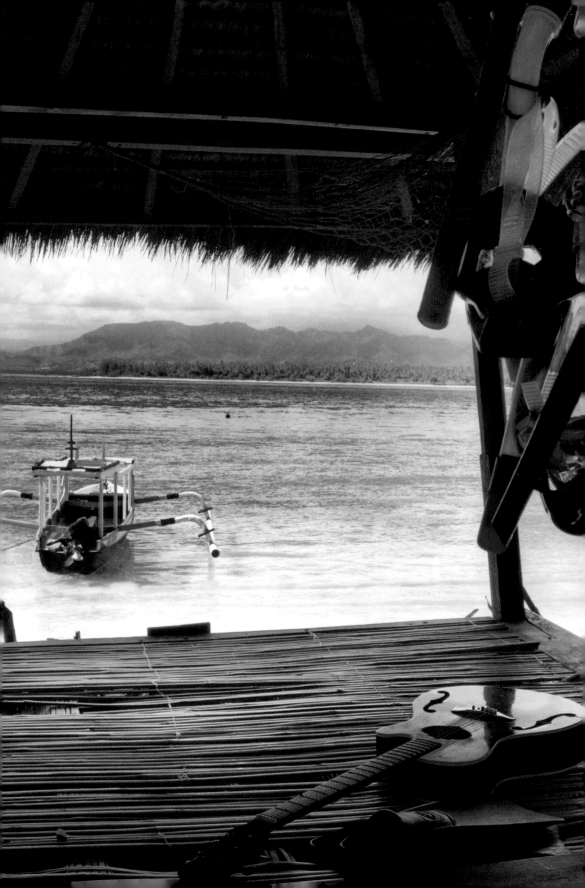

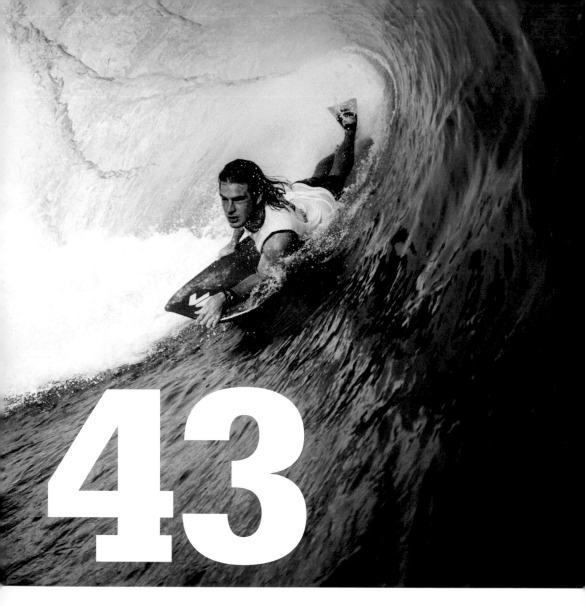

43

Bodyboard a tube in Indonesia

Location Mentawai to Sumba
Islands, Indonesia
Complexity Timing is everything

Cost ○○○○○
Lasting Sentiment Supernatural

Ride a wave that a surfer cannot ride. Use your short fins to power up to the speed of the swell and scoop into the wave early. Adjust your weight on the board to trim along the wave face and carve a line through the side of the barrel. As the wave tubes over you, time stands still. The thundering body of water is momentarily silent. Focus on the end of the tunnel and, if you're lucky, pull out before the wave comes crashing down!

All the energy you can see when water breaks on a shoreline is returned out to sea as the rip current pulls back. Use this power to take you out past the reef, duck-diving the board as you go. If you kick fast with your fins, you can catch nearly every wave, taking off late sometimes and dropping in before it breaks. Ride the slow waves that draw back on themselves with not much grunt behind them and the small waves too. With no fall-off factor, you will love bodyboarding and learn fast.

When the wind shifts offshore, blowing from the land directly out to sea, conditions conspire to create tubes. If your first tube is not quite open enough and the wave closes out, you may get tossed like a rag doll in fizzing white water. The power of the water is awesome, but do not be discouraged. If you see a monster forming, shake the water from your ears and simply refocus. Poised with your board, the wave picks you up and up. The wave is alarmingly steep. Kick fast and hard and descend down into the pocket of the wave. Commit to the inside of the tube and a great translucent wall of water will begin to curve up and over you. Subconsciously you will fine-tune your position on the board to maintain speed. The rush is intense. The water, backlit by the sun, is like rippled glass: an incredible crystal blue. You are in the hollow cocoon of a wave and not a drop of water is out of place.

Opposite and below © Aidan Salmon / balibodyboarding.com

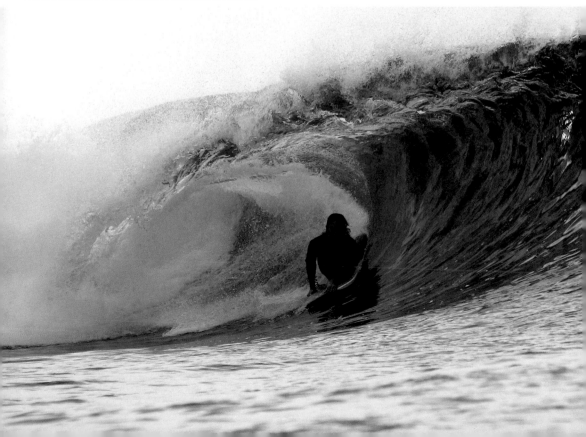

A flash of fear may bring you back into the moment, as water begins to rain down beside you. The noise may be deafening. When you see your exit, the light at the end of the tunnel, try to make a sweet line towards it but whether you make it out in time only nature can decide.

For perfect 'hollow' conditions and a variety of surf spots ranging from sandy bottom beach breaks to the finest reef breaks in the world, head to Indonesia. Enjoy predictable trade winds, swells with a consistently long period and year-round warm water lapping beautiful beaches. Whether you are a complete beginner looking to catch your first ride or an experienced ripper, hunting barrels and massive launch ramps, the islands from Mentawai to Sumba will provide you with some of the best rides of your life. Visit during the southern hemisphere winter, in particular June, July and August. During this period, big low-pressure systems form over Antarctica creating swell, which rolls the length of the Indian Ocean to arrive on Indonesian shores.

Part of the beauty of bodyboarding is that very little equipment is needed in order to have hours of fun. A bodyboard is easy to carry and transport and even high-end boards for advanced riders are relatively low-cost. Renting or buying the right board size for your height and weight will make a big difference to your ability to catch waves and control your board while riding. The stiffer the board, the better in big waves, clean surf and warmer waters. However, a more flexible board will help you 'boost' some top manoeuvres – turns, spins, rolls and airs. To get the optimum board, contact a specialist bodyboarding shop for advice.

Gift yourself some excellent 'tube' time. Paddle out into the ocean and hook into a potentially perfect wave. With less of the showmanship associated with surfing, catch wave after wave indiscriminately with your bodyboard. Enjoy an enormous amount of fun, while learning all the time about the characteristics of waves, how to manoeuvre your body and your board. Take in the visceral feeling as you become wrapped momentarily in a perfect tube of water. Observe how events seem to unfold in slow motion and ultimately give in to the addiction of riding the ocean.

Opposite and below © Aidan Salmon / balibodyboarding.com

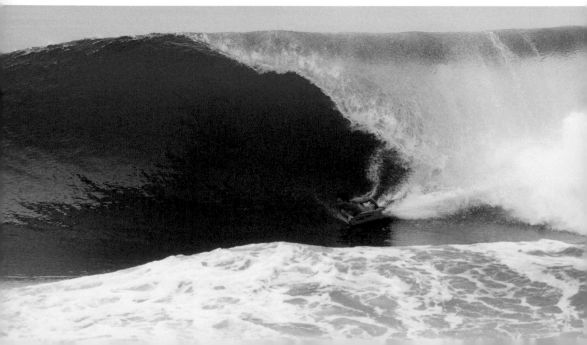

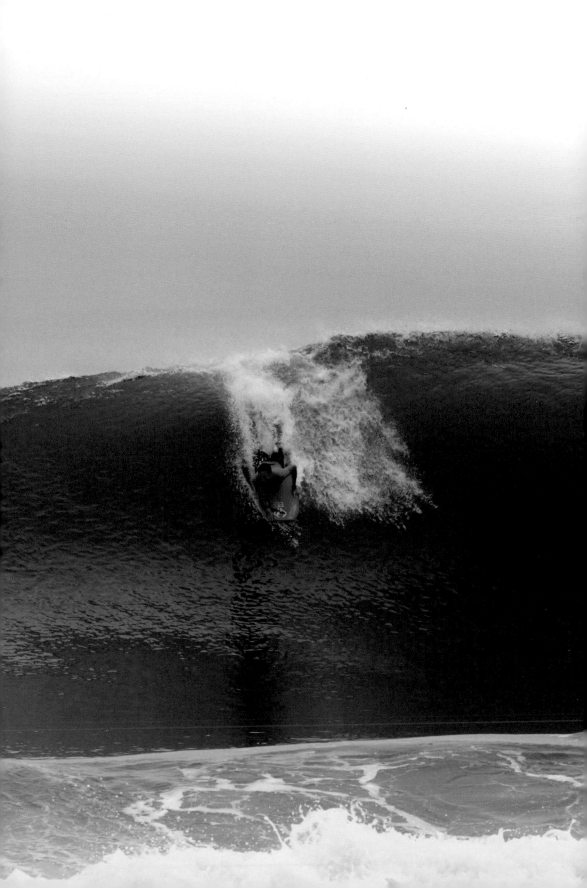

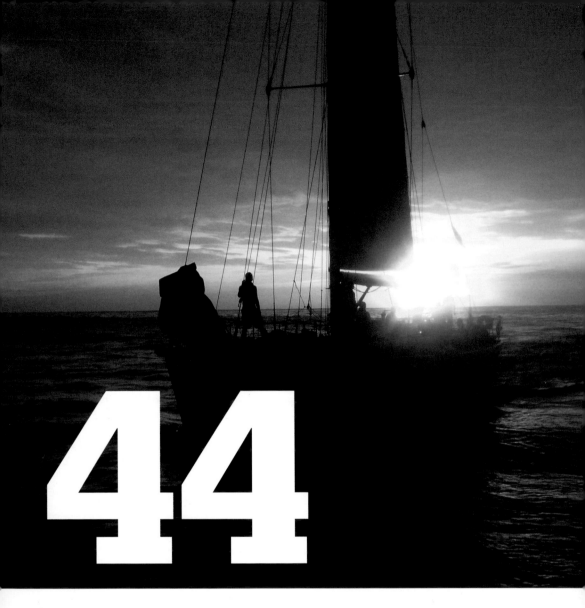

44

Sail a leg of the Clipper Race

Location Pacific Ocean, China to West Coast, USA
Complexity Everything is possible with teamwork

Cost OOOOO
Lasting Sentiment A once-in-a-lifetime experience

Race, not just sail, across a whole ocean. Complete the training and become a deckhand or even a watch leader on board one of the boats in the Clipper Round the World Race. When it's your turn to helm, feel the power of driving 31 tonnes of steel through open ocean. Grip the wheel to retain control. Look up at the sails you helped hoist and allow yourself a very different feeling of confidence.

It's your watch. Time to dress quickly and head on deck for the crew change. Ensconced in waterproofs, you must clip your lifejacket harness to the deck before stepping out. The sky is black, but you can see iridescent white water cresting on the waves. The waves are loud and rumbling. You take your position next to the port primary winch, ready to trim the headsail when required. It's a clear night and so the Milky Way is startlingly visible, pinpricks of light banded together in a cosmic cloud. The great sweep of stars every night never fails to amaze you and your watch mates. You may look forward to arriving, to passing under San Francisco's Golden Gate Bridge and making one of sailing's most iconic landfalls, but not nearly as much as you wish the journey would never end.

Minutes later the breeze picks up. The boat starts to slew down the waves. The helmsman is agitated. It's time to reduce canvas, put a reef in the mainsail and downsize the headsail. By this stage in the race, you know exactly what to do. You and two crewmates are given the nod to head for the bow, clipping on as you go. One clip of your harness is always attached to the boat. One hand is always holding on to the boat.

Opposite and below © Jess Mason

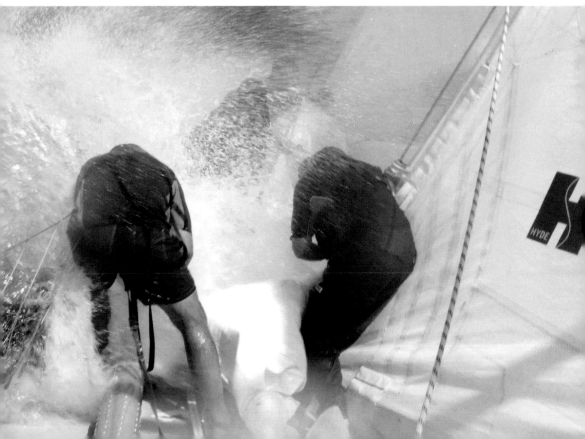

Now the wind is absolutely howling. Even between the three of you, it's a real struggle to fight the headsail down. Water is cascading over the deck, soaking the outside of your foul-weather gear. You shake the spray from your face. You're having the time of your life. When the fabric is pinned under your knees and the sail is neatly lashed to the deck, the relief is palpable. Now it's time to gybe, to take the wind on the other side of the sails. The action keeps rolling and you love it. You want to help maintain and better your position in the race.

If you are itching for a life change or curious to push yourself under pressure, the Clipper Round the World Race is the perfect platform. Prior sailing experience is not necessary. In fact, 40 per cent of the crew on each boat have usually not sailed before, let alone together. Safety is paramount and three to four weeks of sail training is included and obligatory. The training teaches you to how to operate a winch and how to move around the boat safely. You learn the difference between sails for upwind and sails for downwind conditions and what has to be done in order to manoeuvre the boat through a tack or a gybe. Alongside your fellow crew members, men and women aged from 18 to 78, you will experience a steep learning curve.

The Clipper Round the World Race is the only way an amateur can race across the Pacific Ocean, the largest body of water in the world. In terms of value for money there is nothing else like it. The waves can be some of the biggest on the planet, but the sailing is only half the challenge. The other half is becoming part of a team and living with a group of people who are initially strangers. You have at least one ambition in common – winning the race.

Between adjusting the sails, steering the boat and making repairs, there are always jobs to be done. The camaraderie, the shared sunrises and sunsets, the laughs and trials you face together are likely to foster everlasting friendships. When the speedometer hits 30 knots or the boat surfs down a huge Pacific roller before crashing into the pillow of water in the trough ahead – these are some of the exhilarating moments you can look back on for the rest of your life.

You may be successful in other areas of your life, but when the seas are rough and you need to go up front to douse the largest sail in the boat's sail inventory, how will you cope? Take a break or set aside some thirty days of holiday, because there is only one way to find out.

Opposite and below © Clipper Ventures / clipperroundtheworld.com

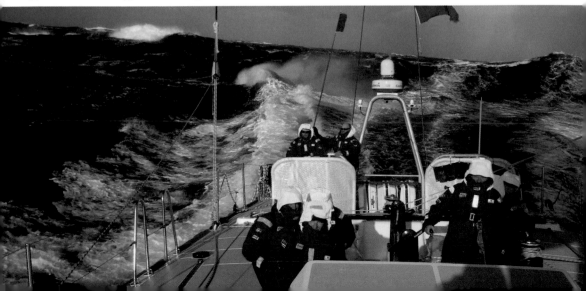

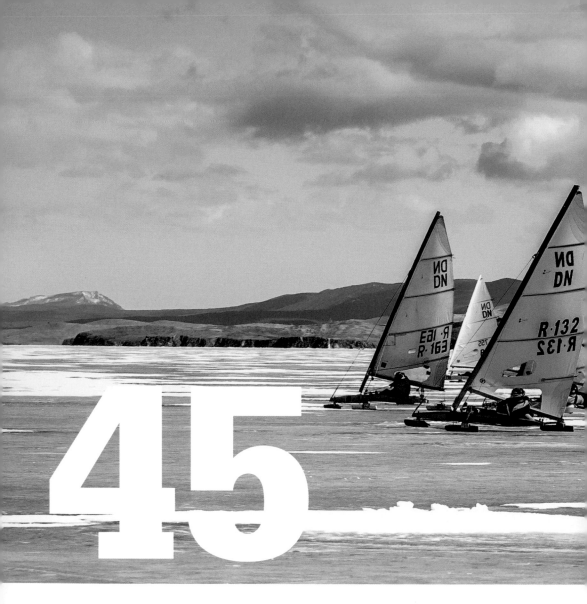

45

Go iceboating in Siberia

Location Lake Baikal, Siberia, Russia **Cost** ⭘⭘⭘⭘⭘

Complexity Not for the fearful **Lasting Sentiment** On the verge of out of control!

Find out why they call it motorcycle racing without brakes. Hop in to a moving iceboat. Under an intense sky and brilliant white winter sun, tear across a vast plateau of glistening ice. With nothing but mountains in the distance, feel the whole world open up around you. Dressed in a snowmobile suit, wearing a racing motorcycle helmet and goggles, your body acts as ballast as your arms steer the boat. When the windward skate starts to lift off the ice and fly through the air, reach between 95 and 240 kilometres per hour. Bubbling over with fear, adrenalin and excitement, you will not want to stop. Continue hurtling over the frozen terrain, which stretches as far as the eye can see.

You slide your craft over to the line, where the other racers are standing in garb like adventure pilots from another era. Taking up position on the left, exactly where the race committee determined you should be based on your experience, you crouch down on the ice like a runner in the Olympics. Everybody has shoes with spikes so they can run as fast as they can. 'Ready on the left?' the race director yells. 'Ready on the right?' The flag is dropped. The race start is official. You're off and running, pushing your boat with the mainsheet already in your hand. When the boat starts to accelerate faster than you can run, you drop into the cockpit, lie back and sheet the sail in hard. The boat takes off at a breakneck speed. Your flight over frozen water has begun.

Juggling the tiller in one hand, the mainsheet in the other and the boom on your shoulder, your mind is working overtime. With no suspension between you and the three skates, you can only hope the ice sheet ahead is immaculate. Time to tack, you ease the mainsheet a touch, pick up the boom

Opposite and below © Gretchen Dorian / gretchendorian.com

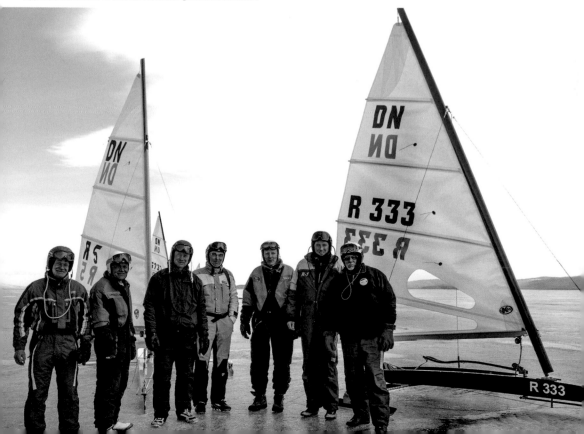

and shift it to your other shoulder. The sail flits across, filling in one flick on its other side. It's a highly risky manoeuvre, but you've practised on more forgiving older boats with wooden rather than carbon masts. Your pulse is racing, your body tense. You must fight to maintain the speed. Tweak the sail. Adjust the angle of the skates. Shift the boat's angle to the wind. Like a fly in the wind, you whiz around the racetrack switching between port and starboard tack. You pass another iceboat and are thrilled to whizz across the finish line within the 10-minute cut-off time.

Stepping out of your craft, stand still for a moment. Let your heartbeat wind down. Take in the beauty of your craft, man-made and finely tuned, contrasting against the raw and majestic backdrop of nature.

For the ultimate iceboating experience, your destination has to be Lake Baikal in Siberia, situated north of the border with Mongolia. In the spring, temperatures are above freezing, the breeze is consistent and with 1-metre-thick ice there's no danger of falling through. Unlike in Europe and North America, where iceboating often involves driving cross-country for better surfaces, here the ice is always sailable.

Opposite and below © Gretchen Dorian / gretchendorian.com

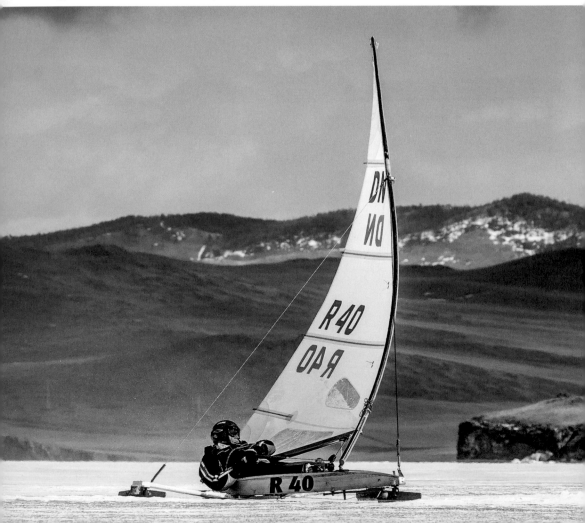

Thanks to the Russian Ministry of Youth Affairs, Sport and Tourism, the getting there, staying there and sailing there is still a proper adventure – but not a troublesome one. To participate in this event, you need your own boat. You can buy a custom-built carbon racing-machine or build one cheaply yourself, although if you want to race, the boat needs to abide by strict design rules. Raced globally, the DN is a one-man iceboat, whose design was commissioned in the 1930s by the publication *Detroit News*. Many are still made out of wood. You also need to be a member of the International DN Ice Yacht Racing Association, which you can join for a nominal annual fee. Upon registration, a sail number will be assigned to you according to which country you are from. Next, ship your boat to Moscow. Take it to the train depot of the Trans-Siberian Express and a specially organised trailer will transport your equipment to Irkutsk.

While the Baikal Ice Sailing Week is a regatta with prizes, it is open to all levels. Even if you have no chance of winning, go and have a blast on the ice. Dangerously exhilarating, indulge your thirst for speed. In the company of the world's best iceboaters, careen across the finest-quality ice, a mirror-like surface of marvellous blue.

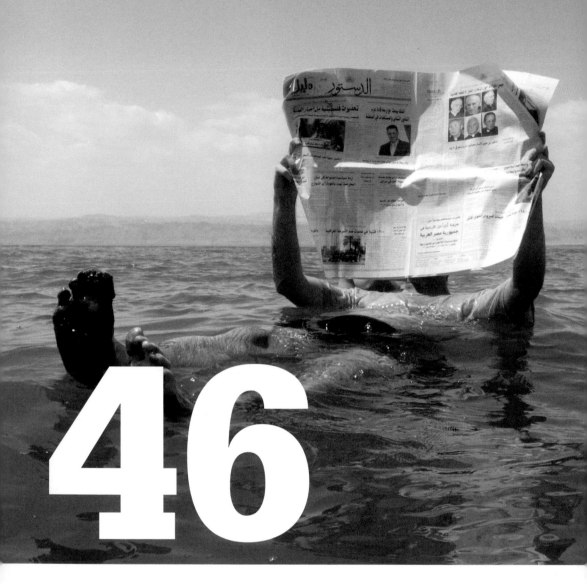

46

Float in the Dead Sea

Location Jordan
Complexity None! Bob along

Cost ⦿⦿○○○
Lasting Sentiment Mud and a dip are technically gross, but hilarious in almost equal measures

Follow in the footsteps of Cleopatra and head for a dip in the healing waters of the Dead Sea. Wade into the warm water and surrender your body to the world's saltiest lake. Revel in the unique floating sensation. Soak up the minerals. Take a newspaper in with you or simply unwind and bob your way to a golden tan.

With the backdrop of the mountains of Palestine visible on a clear day, the soft turquoise waters look inviting. Wavelets lap the shoreline like on any other beach, but they leave a curious rim of white. In certain places, salt deposits have amassed into rocky stalagmites – great clusters of crystallised fingers, beautiful and jagged like exposed coral. The scene is otherworldly. Eager for your Dead Sea floating experience, don a pair of water shoes to protect your feet and step in. The water feels like water and is wet to the touch, but in a bizarre gravity-defying way you need to push down with your feet just to stand.

Nine times more buoyant than the ocean, there is no such thing as swimming in the Dead Sea. You may try, but your feet and shoulders will continuously rise to the surface. Your body will bob in a comical manner that prohibits any kind of stroke. Floating on your front is also devilishly hard since you need to keep your bum down to prevent your head from pitching into the water. Eventually you will give in to the buoyancy and just float without any effort whatsoever. The feeling is sublime, as if you are floating on an airbed – but without the airbed!

Next it's time to get muddy. Urns full of mud are collected by the major hotels for the convenience of paying guests, but for the do-it-yourself approach, scoop handfuls from the sea's bottom. Lather

Opposite © Ranveig Thattai **Below** © Mark A. Wilson

yourself in the thick black paste, sparing a moment's thought for those of us who pay good money for the stuff elsewhere in the world. To benefit from the 'internationally recognised healing properties', leave the mud on for the recommended 20 minutes before rinsing it off in the sea. Known to successfully treat conditions such as psoriasis, arthritis, poor circulation, rheumatism and muscle aches, look forward to an improvement in the health and beauty of your skin.

With more than 30 per cent salinity, avoid ingesting any seawater. Do not put your face under the surface if you can help it, at least not without eye protection. Wear an old bathing suit, as the salt may discolour the material, and rinse it thoroughly after use. You are advised not to shave at least two days before you plan to dip and be prepared for any open cuts or sores to teach you the real meaning of putting salt in an open wound!

Accessible from Palestine as well as Israel, the Dead Sea is actually a land-locked lake, best visited from the eastern seaboard and the politically peaceful country of Jordan. Sitting on the beach with a cocktail in hand or on your hotel balcony, watch the sun set in the west, the oranges darkening into peachy reds and finally Arabian blues. At night it is possible to see Palestine twinkling on the opposite bank, often masked during the day by a combination of heat haze and air saturated with evaporating brine.

While there is a high and a low season, the Dead Sea with its dry climate is the perfect destination for a luxury spa vacation any time of year. April to June and October through November are the most popular months, but the temperature in winter is comfortable and there is rarely a rainy day. Locals descend from Jordan's capital city, Amman, at weekends, so you may find the weekdays more tranquil. For a five-star treat, luxuriate at the hands of a professional and book yourself in for a series of spa treatments: a facial, a body scrub and a mud wrap. Dip in the sea from the privacy of one of the world-class hotels, whose beaches are often better maintained than the public beaches, and enjoy the free towels, showers and sunbeds.

The Dead Sea experience is as steeped in religious heritage as it is salty. To reach the top of Everest you may need to become a proficient mountaineer. To enjoy the lowest place on land, some 418 metres below sea level, you need nothing more than a swimsuit. If a dip followed by a mud bath worked for Cleopatra to enhance her beauty and renew her skin, it will probably work for you too!

Opposite top © Noga Kadman **Opposite bottom** © Hanna Azar **Below** © Dieter Manske

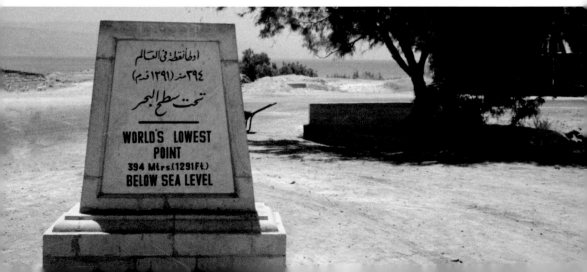

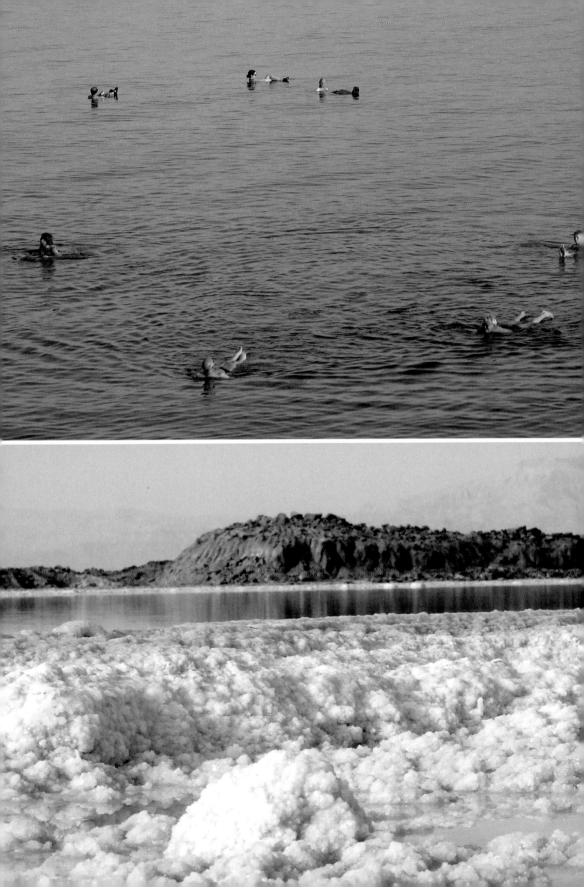

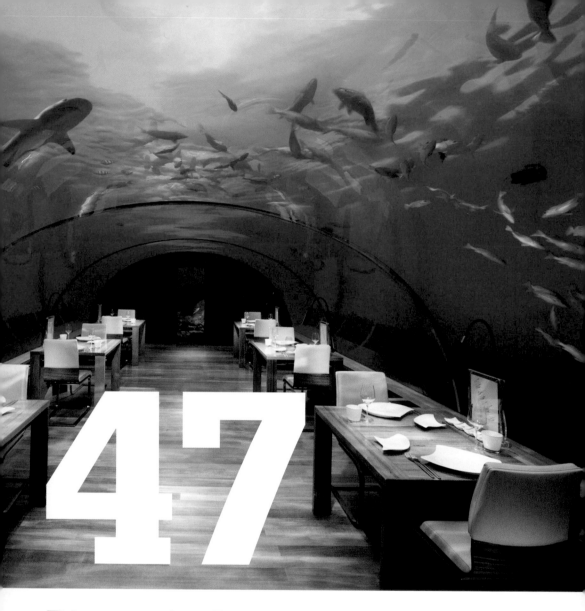

47

Dine in the Ithaa Undersea Restaurant in the Maldives

Location Rangali Island, the Maldives

Complexity Adventure made simple

Cost ●●●○○

Lasting Sentiment Eat and drink in the bosom of another world

Dine in a room with a view. Not looking out to sea, but up and around at one of the most vibrant reef environments in the world. Take a seat in a truly unique restaurant located 3 metres below the waves of the Indian Ocean. Enjoy a sumptuous lunch for two and spend quality time together under water, watching a breathtaking array of aquatic life.

Once inside, the first impression is always the incredible ambience. The blue colour tones of the water surrounding the restaurant are strikingly beautiful, the intensity of natural light below the surface surprising. You've arrived for lunch and so rays of midday sun are filtering down through the water, ribbons of light dancing across the tables. The waiter shows you a collection of designer sunglasses you may use in case you've forgotten yours. A sunglass-cleaning service is also on offer so that you don't miss a thing. Ideal, you may think, having spotted a large turtle nibbling away at the coral reef as you are led towards your seat. With tables to accommodate a total of just 14 people, a booking at the restaurant is much sought-after. When a huge black-tip reef shark cruises past the window with its mouth open, you understand why.

Over plates such as Maldivian lobster carpaccio and reef fish tartare, you and your partner will gaze in wonderment at the tropical fish going about their lives. You never quite know what will glide past the window next. The space is not at all claustrophobic. In fact, like an infinity pool, the room seems to stretch out indefinitely into the sea. Between courses, you realise that some fish are attracted to certain colours in your clothing. The marine life can see in as much as you can see out. You are fine dining in a human aquarium with a 270-degree panoramic view!

Opposite and below © Conrad Maldives Rangali Island / conradhotels3.hilton.com

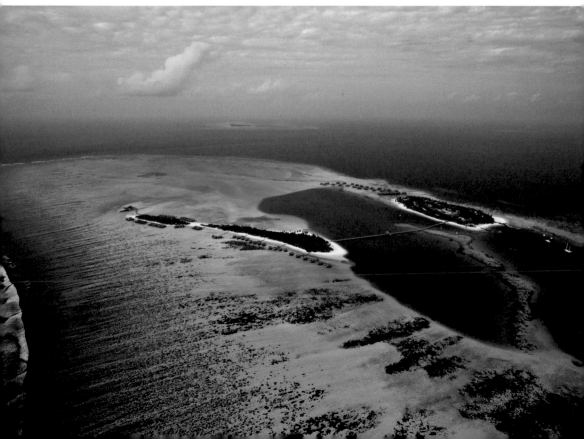

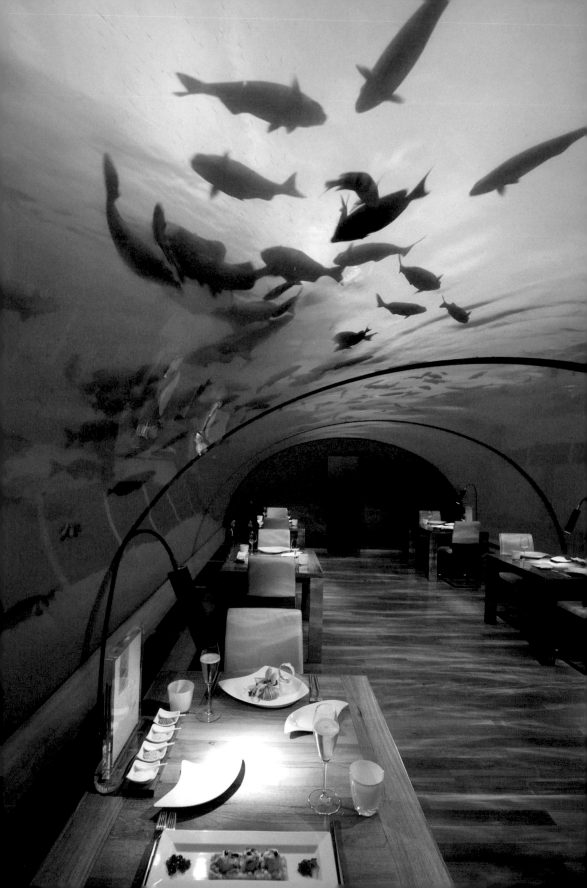

A school of hammerhead sharks often circle, their heads a distinctive anvil shape. You may spot a moray eel as well as a barracuda with its row of tiny teeth. The show of aquatic life will far surpass your expectations. Evening guests, the waitress informs you, are almost guaranteed to see a stingray swoop past, or a giant trevally. Once in a while, a manta ray with a wingspan bigger than your table may even make a star appearance. Make a note to come back!

'Ithaa', pronounced 'eet-ha', means 'mother-of-pearl' in Dhivehi, the language of the Maldives. Owned by Hilton's luxury hotel brand Conrad, the Ithaa Undersea Restaurant is part of the Rangali Island Resort which occupies two private islands, Rangali and Rangalifinolhu. A 500-metre footbridge joins the two islands and the restaurant is located just off Rangalifinolhu Island. The restaurant cost 5 million dollars to build and consists of three 12.5mm-thick clear acrylic arches. Sitting 1 metre below sea level during low tide and almost 2 metres below at high tide, you can never quite see the restaurant clearly from the surface. Waves lap at a modest pier beside a thatched pavilion. From here a spiral staircase leads you down to the floor of Neptune's kingdom 5 metres below.

Non-hotel guests are welcome and if you happen to visit the Maldives by private yacht, you'll be delighted to hear that you can anchor in the lagoon. A lighter, four-course set menu is offered at lunchtime rather than the seven-course taster menu served in the evenings. This allows plenty of time before sunset to catch a seaplane or boat back to another island. The merely curious, meanwhile, may visit for 11a.m. cocktails. Expect to see fish galore – red snapper, blue-striped snapper, angelfish, rainbowfish, as well as the orange and white stripy clown fish that tend to hover among the anemones.

The Ithaa Undersea Restaurant is a gem waiting to be discovered and is perfect for those who do not dive or snorkel or who would like to enjoy a novel underwater experience. The architecture of the Undersea Restaurant has an estimated lifespan of only 20 years. So don't miss out! Treat your taste buds to a meal of contemporary French cuisine with an Asian twist and enjoy the colour, clarity and beauty of the Indian Ocean – without even getting your feet wet.

Opposite and below © Conrad Maldives Rangali Island / conradhotels3.hilton.com

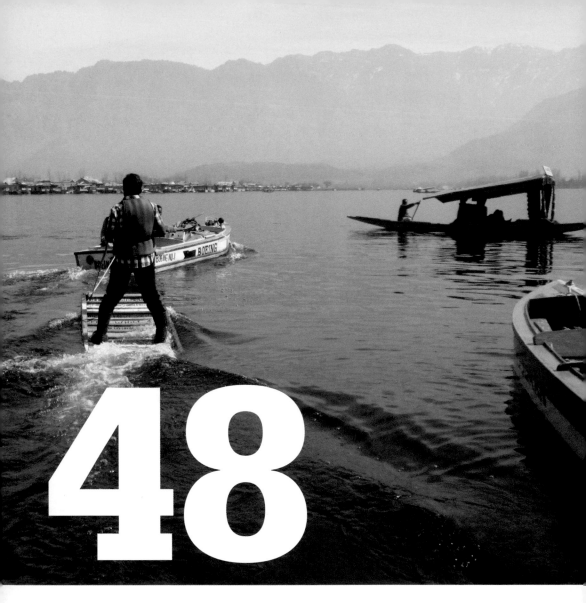

48

Waterski Indian-style in Kashmir

Location Dal Lake, Srinagar, Kashmir, India
Complexity Easier than standing on top of a table

Cost ○○○○○
Lasting Sentiment Timeless comedy value

Waterski without getting wet. Go for a spin around Kashmir's Dal Lake, Nagin Lake or Manasbal Lake in whatever you happen to be wearing, be it a sari with jewellery and handbag or jeans and a sweater. Stand up comfortably. Take in the view of the Himalayas. Cruise at a relaxed pace around the perimeter of the lake without worrying about your balance. With the platform beneath your feet being towed by the motorboat, all you have to do is hold on to the reins of the board and enjoy moving across the water.

More water-skating than waterskiing, negotiate a price for you and your friends to each partake in this novelty ride. As instructed, step off the 'ghat' (jetty) and on to the wooden platform just as the boat is ready to depart. This avoids getting anything more than a light wash of water over your boots, trainers or bare toes. You plant your feet and hold on tightly to the loop of rope attached to the front corners of the board. The colourfully painted wood is ribbed with strips, so there is no danger of your feet slipping. As the motorboat tows you away, lean back. You have to laugh! There is something undeniably comical about being towed behind a motorboat while standing on a painted wooden raft half the size of a door.

Once settled into the rhythm, you may feel more daring. If so, you are ready to try the 'Look, no hands' manoeuvre! Lifting the rope loop up and over your head, bring the rein down to the middle of your back. Ta-dah! Easy. You wave to the tourists lounging in a wooden 'shikara', a traditional Dal Lake boat. You are cruising along hands-free, posing for photographs.

Not exactly an adrenalin-fuelled ride, your tour of Dal Lake is definitely silly, memorable and fun.

Opposite © Rudolph.A.furtado **Below** © Midhun Menon

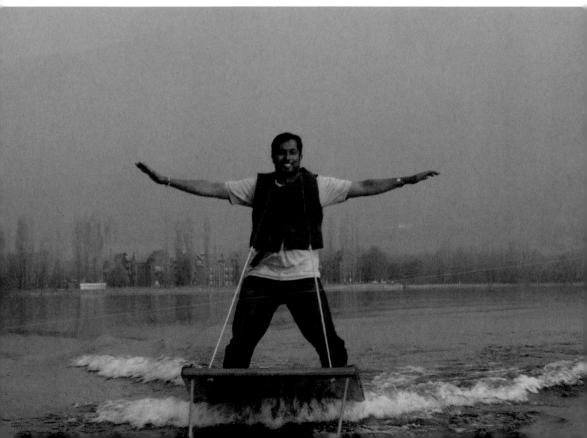

As you near the jetty, get ready to step up off the board. Release the rein and you will be off the water without a single splash above the knees!

While watching waterskiers make a tour of Dal Lake makes for a thoroughly entertaining afternoon in its own right, nothing beats actually having a go. Rates depend on the duration of your ride or the diameter of the circle in which you are towed. Many of the houseboat hotels will book a time slot for you. No upper or lower body strength is required and if you can't swim, don't worry. A car inner tube, like a rubber ring, will be inflated around your waist or slipped over your head. Alternatively, many enterprises now offer modern buoyancy aids. Really keen waterskiers may rent a privately owned 'bathing boat'. Situated in the largest expanse of the Dal, known as the 'Boddal', and similarly in the centre of the adjoining Nagin Lake, these launch platforms hire out motorboats, all the necessary equipment and trained instructors. If you rent your own base station, you can lap the lakes as many times as you want!

'If there is a paradise on earth, it is this', reads the inscription on the pavilion of the Shalimar Bagh gardens, built between 1569 and 1627 in Srinagar, the summer capital of Kashmir. Made famous by the Shammi Kapoor Bollywood movies, many of which were filmed in, on or by the lakes of Srinagar, there is no better place to try waterskiing than in 'paradise on earth'. After nearly 20 years, the UK Foreign & Commonwealth Office has lifted its guidelines advising tourists against travel to Kashmir. Dal Lake, one of India's most beautiful sites in the Kashmir Valley, is now open again to visitors.

Fly into Srinagar from any number of domestic airports including Mumbai and New Delhi. Stay in one of the colonial-style houseboats reminiscent of a bygone era. Revel in the affordable luxury and feast on the delicious local food. While Kashmir is an all-season destination, the months between March and October are the best time to visit. Enjoy the blossoms of spring, the cooler higher-altitude weather in the summer or the gold and red hues of autumn.

The benefits of swapping skis for a wooden raft are numerous. You should be able to avoid falling in and getting wet, so there's no need for a wetsuit in the cooler months. You can enjoy the view rather than concentrating on trying to balance and you can stand up straight rather than having to squat. Conventional waterskiing came first, then barefoot skiing and wakeboarding, but the entertainment value of waterskiing in Dal Lake is absolutely timeless.

Opposite © Midhun Menon **Below** © Hemant Bidichandani

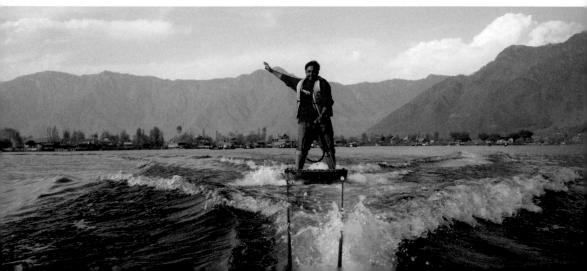

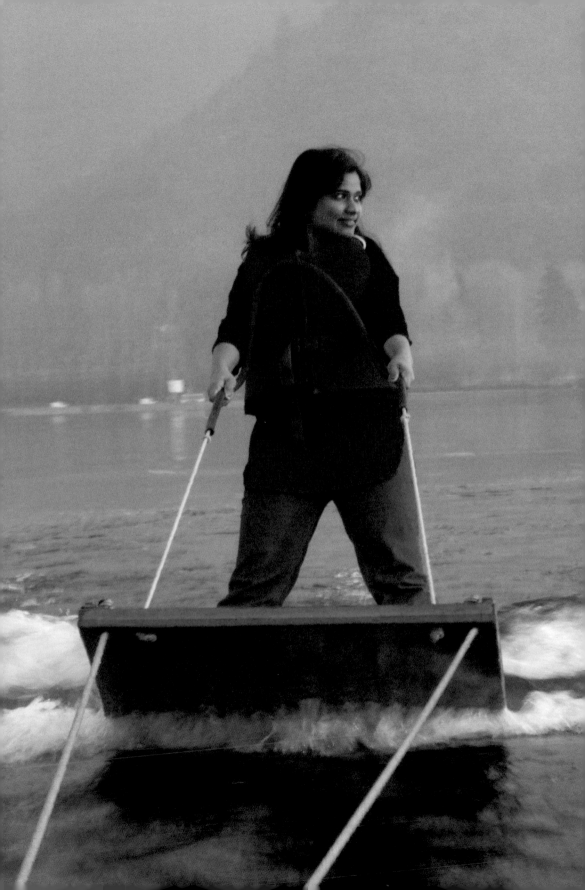

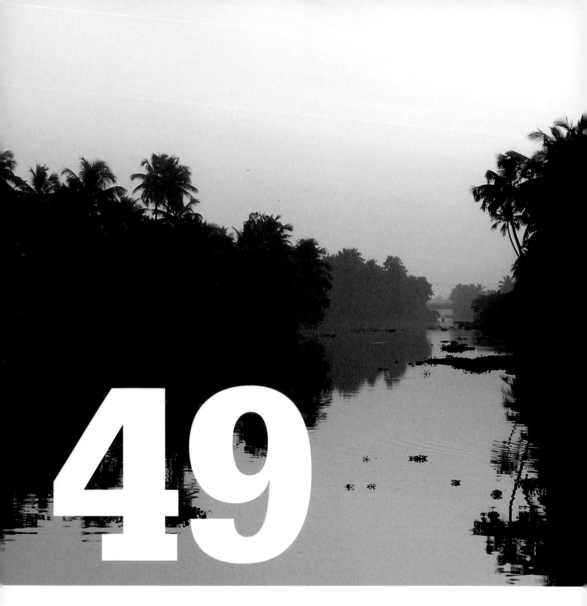

49

Cruise on a houseboat in Kerala

Location Kumarakom Backwater, Kerala, India

Complexity The ability to unwind is a must

Cost ⬤⬤○○○

Lasting Sentiment Venice of the East

See India's true loveliness. Take in the lush palm-fringed landscape from the lap of post-colonial luxury, on board a traditional wicker houseboat. Explore the labyrinth of canals, both natural and man-made. With everything you need on the boat, sit back and relax. Discover forgotten waterways and trails of never-ending coconut trees. Tuck into mouth-watering spreads of southern Indian cuisine with hotel-grade waiter service, followed by a peaceful evening on Vembanad Lake.

Moored along the waterfront of the city of Alappuzha (Alleppey), step aboard your 'kettuvallam', a traditional houseboat. You will be delighted by the character and design of your craft. Some 21 metres in length and 4.5 metres wide in the middle, the wooden hull, you learn, was once used as a cargo ship at the time when tea, rubber and spices were shipped from the hill stations to the sea. The frames are joined using coconut fibre. The roof is an intricate cocoon of bamboo poles woven with palm leaves and coated in cashew nut oil. Despite the boat's rustic appearance, air-conditioning and modern hygienic toilets are at your disposal. For now, settle into the cushions set up on the bow and look forward to seeing the view.

Within minutes of your departure, the bustle of Indian life recedes. Tall palm trees create a canopy of lush tropical greens and a great sense of calm. A slender workboat slides silently past, its hold piled high with green coconuts. The vessel is punted fore and aft by men with long bamboo sticks. The first man may nod, the other stare. Down another verdant corridor the boat glides. The inboard diesel engine purrs unobtrusively as solar panels keep the cooling fan turning overhead. The water is an impenetrable shade of fertile green, in which shrimp and freshwater fish – tilapia, perch, catfish and eel – aim to hide from the heron and egrets. A kingfisher flutters past as you are offered a perfect chilled beer of the same name.

Wafting from the onboard kitchen, the aromas of lunch draw you inside. Prepare to salivate; Kerala cuisine is renowned for its vegetarian dishes and very rich use of spices. Soon the table is laden with freshly prepared local dishes. The ripe pineapple cooked with mustard seed, turmeric and curry leaves is to die for.

Opposite © Cordelia Ditton **Below** © Leif Petersen

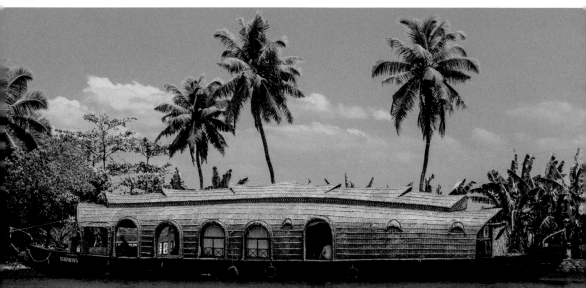

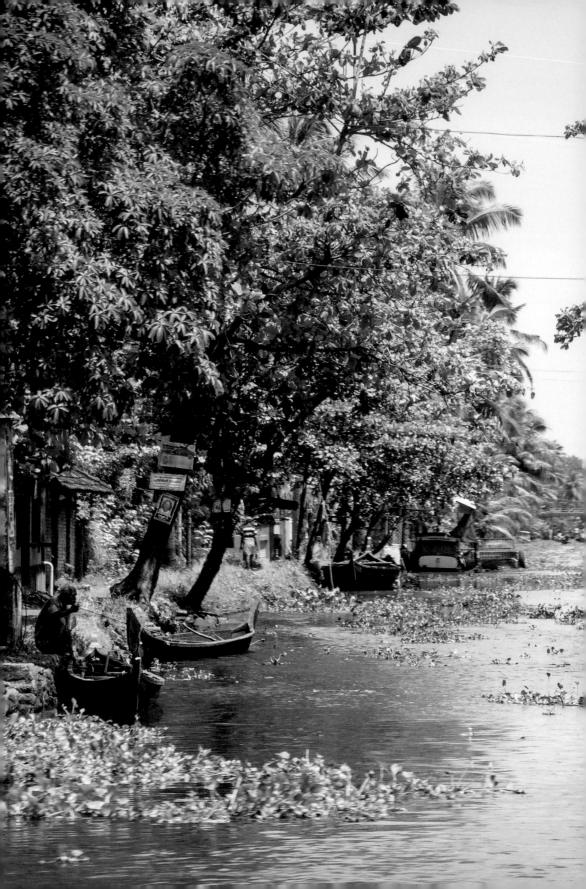

Past rice paddies, your boat will potter on. You take in the impressive network of fields reclaimed from the sea. This is a place where life revolves around the water. Finally, your kettuvallam emerges into the shallow but 2000sq km Vembanad Lake. Out in the middle you are a self-contained island. Blissfully anchored away from civilisation, the scene is atmospheric with blushes of colour. Watch the sun go down and linger until the stars come out. Listening to the sound of wavelets licking the hull is the perfect way to end the day.

Start your trip off well by travelling in style. Fly into Kochi (Cochin) and ask for a chauffeur-driven air-conditioned car to the departure point of your houseboat. Book your cruise through a reputable travel agent or through the concierge of one of the five-star hotels in Kottayam. This should assure you quality service and a houseboat in excellent condition.

With two bedrooms on average per boat, consider hiring the houseboat in its entirety. Avoid air-conditioning in favour of hearing the beautiful song of the night birds and the lapping of the waves against the hull. The cabins should all have mosquito nets and fans. For the most authentic experience and to sleep in serenity, insist on anchoring in the Vembanad Lake overnight and request that the boat continue moving during meal times where possible. One or two nights are usually enough and you may need to purchase your own alcohol if the boat is not licensed.

Kerala weather is classified into three seasons: winter, summer and monsoon. The slightly cooler winter season from October to February is the best time to go.

Known as the 'Venice of the East', meander through the backwaters of Kerala in luxury. With a personal chef and waiting staff to cater to your gastronomic desires, get away from the throng. As the boat wanders through the maze of Kerala's secluded backwaters, spot the diverse wildlife. Observe the jungle of different greens and wave at the children who learn to swim before they can walk. If you like flavoursome food, the dining alone will make the trip worthwhile.

Opposite and below © Leif Petersen

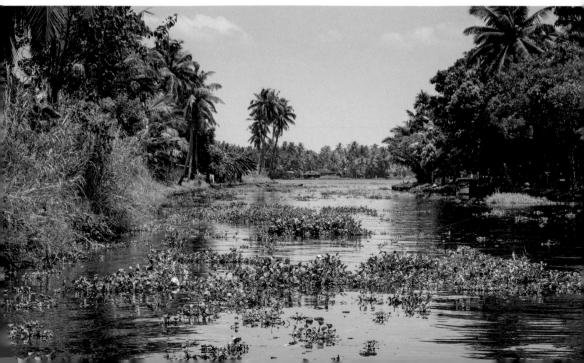

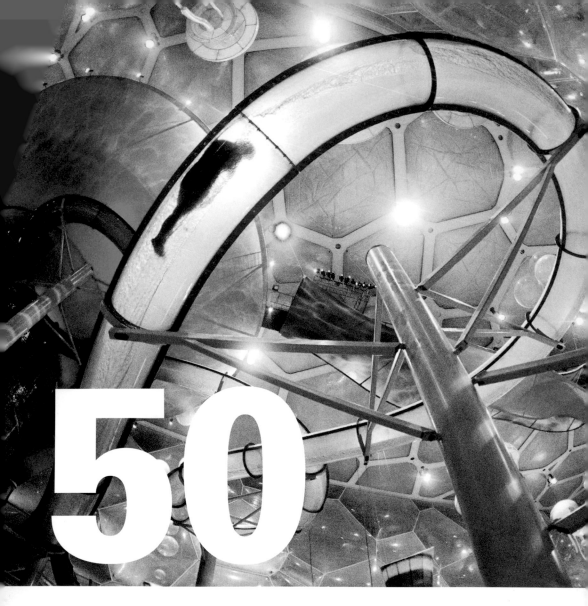

50

Relax at the Happy Magic Water Cube in Beijing

Location Olympic Green, Beijing, China
Complexity Sit and ride. Height
restrictions may apply

Cost ○○○○○○
Lasting Sentiment An out-of-sensory
experience

Step into an indoor world of phantasmagoric colour. Look up to see iridescent pastel bubbles and giant jellyfish hanging from the ceiling like Tiffany lamps. Gaze across the lapping lagoon with its umbrella-shaped jellies floating in the water. Prepare to be thrilled on one of 18 impressive water rides. Unwind as you get flushed down one of 50 brightly coloured water slides or simply float around on a giant inflatable, drifting down the lazy river that circumnavigates the scene.

You step in and are directed to lie on your back. The entry to the 'AquaLoop' capsule is then closed. The anticipation is monumental. Made of transparent Perspex, the capsule resembles a cryogenic test tube from a futuristic movie about aliens. A trap door in the floor suddenly drops out, making your stomach lurch. You may scream without meaning to. You are free-falling – at least, that's the sensation. You drop about three storeys on to a bed of water. Then suddenly the tube rises up. The momentum drives you and your water cushion uphill. It's a fast, breathtaking rollercoaster ride on water.

You're up next for the park's most impressive attraction, the 'Tornado'! Clamber on to the four-leaf clover inflatable, sink your bottom comfortably into the rubber hole and grab the handholds on either side. The rider opposite giggles as you wait a few seconds for the inflatable to be released. Down into the giant funnel you descend on a white-water rapid, eyes wide open. Shrieks of enjoyment flow from your throat as the centrifugal force spins you round the rim of the giant funnel. You end up gripping the handles for dear life as half of each turn takes you round upside-down. Round and

Opposite © White Water West / whitewaterwest.com **Below** © Stefan Zwanzger / thethemeparkguy.com

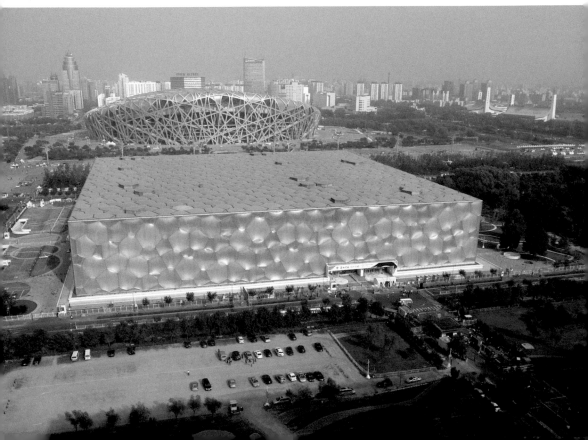

round you go in tighter circles, as if caught in a deep vortex. The water flow is fast. You are about to go down a plughole, a tunnel of darkness. Neither you nor your riding partner have any idea what lies beyond. Finally you get spat out into an open pool, relieved and yet disappointed that the ride is over. The whole experience is only minutes long, but you clamber out feeling thoroughly invigorated!

The Happy Magic Water Cube is the largest indoor water park in the world and the second-most visited tourist spot in Beijing after the Great Wall of China, located an hour away. With enough space for 30,000 swimmers, the Water Cube was originally designed and built for the 2008 Beijing Olympics. An architectural feat in its own right, the building won a number of awards even before Michael Phelps walked away with eight gold medals for swimming in its Olympic pool. The building's exoskeleton is a steel structure, which frames a pattern of hexagonal bubbles made from Ethylene tetrafluoroethylene (ETFE) pillows 0.2mm thick. An energy efficient membrane, the ETFE is a fluorine-based plastic that lets in more light and heat than traditional glass. The best time to visit is therefore later in the day, because at night an incredible LED lighting system turns the Water Cube into a kaleidoscope. The interior lights, which vary with each ride, shine out to illuminate the surrounding area.

Half of the building continues to function as a working aquatic centre with pools open to the public, as well as swimming galas and diving competitions hosted in the main Olympic arena. Subject to seasons and schedules, a ticket to the water park may also gain you access to the 'Water Ballet' synchronised swimming performances.

For local residents, what is decidedly unhappy about the Happy Magic Water Cube is the price. Catering more to the emerging urban elite than the masses, the entry fee may be a barrier for some. The high cost does, however, eliminate the elbow-to-shoulder overcrowding seen at other water parks in China. Weekdays are less busy than weekends, when there may be longer queues for rides.

Enjoy a day of fantastical escapism. Line up for an adrenalin-pumping, heart-pounding, water-spraying experience, or simply loll around in the water, waiting for your friend or family member to be sluiced out of the many rides. Fish mobiles spin overhead, water tubes crisscross everywhere and the temperature is tropical, minus the sun. Once subsumed into the intense blue, mood-altering environment, you may never want to go home.

Opposite and below © White Water West / whitewaterwest.com

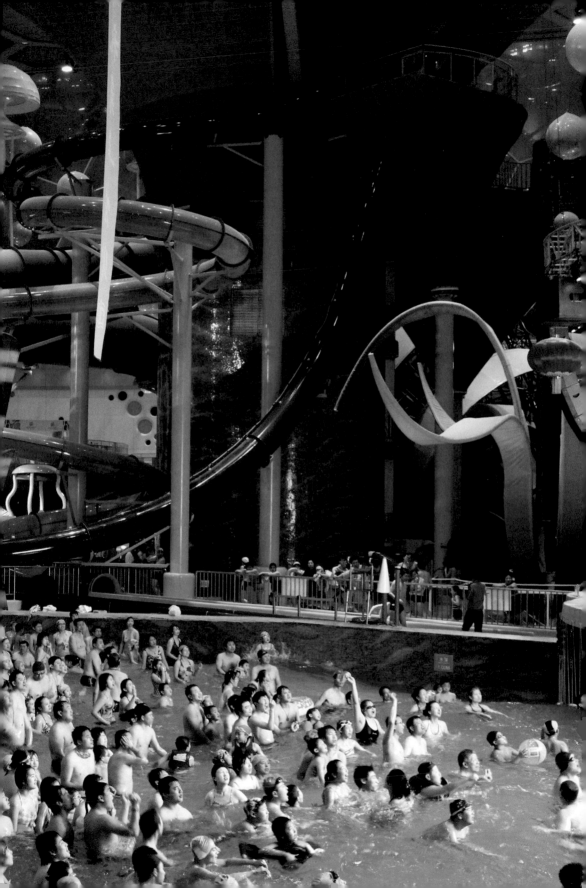

Acknowledgements

Thank you to the following people who kindly gave up their time to be interviewed:

1. Bog snorkel in Wales
Andy Torbet – adventurer

2. Fly fish for salmon in Scotland
Innes Morrison – Amhuinnsuidhe Castle estate manager

3. Compete in the Glen Nevis River Raft Race in Scotland
Frazer Coupland – partner No Fuss Events

4. Tour Ireland's west coast by RIB
Phillip Fitzgibbon – owner Waterworld Watersports, Castlegregory

5. Go coasteering in the Channel Islands
Budgie Burgess – owner Adventure Sark

6. Stay at the ICEHOTEL in Sweden
Martin Smedsén – ICEHOTEL Jukkasjärvi

7. Wild swim in France
Daniel Start – author of the book *Wild Swimming*

8. Try deep-water soloing in Majorca
Miquel Riera – author of the book *Psicobloc Mallorca*

9. Learn to row like a Venetian in Italy
Jane Caporal – owner Row Venice

10. Go canyoning in Switzerland
Stephanos Gaitanos – Outdoor Interlaken

11. Bathe in Iceland's Blue Lagoon
Atli Sigurður Kristjánsson – Blue Lagoon

12. Sail on a tall ship in the Canary Islands
Adam Purser – owner Classic Sailing

14. Cruise to St Helena and Ascension Island on the last working Royal Mail Ship
Donald Hawkes – Andrew Weir Shipping Limited

15. Windsurf the Lüderitz Speed Challenge in Namibia
Sophie Routaboul – Lüderitz Speed Challenge

16. Dive with sharks in the Western Cape
Dave Caravias – owner Shark Bookings

17. Sail the Nile on a traditional felucca
Hannah Green – Explore, The Adventure Travel Experts

18. Night scuba dive in the Red Sea
Kirsty Andrews – dive master

19. Freedive the 'Blue Hole' in Egypt
Linda Paganelli – SSI freediving instructor, owner Freedive Dahab

20. Packraft in Alaska
Roman Dial – author of the book *Packrafting! An Introduction and How-To Guide*

21. Surf a river wave in Hawaii
Ader Oliveira – global editor of Waves.com.br and Surfbahia.com.br

22. Kayak-camp in British Columbia
Jaime Sharp – guide and co-founder of World Wild Adventures

23. Joyride a Hydro Bronc in California
Rod Blair – inventor of the Hydro Bronc and owner of Sportogo Inc
Luke Blair – extreme Hydro Bronc user

24. Swim from Alcatraz to San Francisco
Pedro H. Ordenes – swim coach, owner Water World Swim, LLC

25. Try paddleboard yoga in a geothermal crater in Utah
Julia Geisler – instructor, owner Park City Yoga Adventures

26. Inner tube the Colorado rapids
Tobi Rohwer – owner Pagosa Outside Adventures

27. Stand-up paddleboard the Mississippi
Dave Cornthwaite – adventurer

28. Master flyboarding in Miami
Claire Brzokewicz – Zapata Racing

29. Kiteboard in the Dominican Republic
Laurel Eastman – owner Laurel Eastman Kiteboarding

30. Fish for big game in Mexico
Ryan Donovan – owner Red Rum Cabo

31. Transit the Panama Canal
Deborah Shadovitz – yacht crewmember

32. Visit the deep sea in a recreational submarine in Costa Rica
Shmulik Blum – submarine pilot Undersea Hunter

33. White-water raft the Futaleufú River in Chile
Eric Hertz – owner Earth River Expeditions

34. Go on a cruise to Antarctica
Paul Schuster – polar travel adviser Quark Expeditions

35. Swim with whale sharks in Australia
Ben Fitzpatrick – PhD and lead marine scientist Oceanwise Expeditions

36. Experience the Panapompom Canoe Regatta
Clare Pengelly – event participant

37. Heli-hike a glacier in New Zealand
Jo Wisniewski – Fox Glacier Guiding

38. Snorkel the Great Barrier Reef
Robert Moore – Lady Musgrave Cruises

39. Wreck dive the SS *President Coolidge* in Vanuatu
Stuart Rae – dive master

40. Riverboard in New Zealand
Huw Miles – riverboarding instructor
Neil Harrison – owner Serious River Fun Surfing

41. Swim with jellyfish in Micronesia
Tova Bornovski – owners Fish N Fins

42. Island hop to Gili Meno
Callie Porter – islander

43. Bodyboard a tube in Indonesia
Dave Heard – owner Bodyboard HQ
Aidan Salmon – bodyboarding coach, BaliBodyboarding

44. Sail a leg of the Clipper Race
Melanie King – yacht crew Clipper Round The World

45. Go iceboating in Siberia
Gretchen Dorian – iceboater and specialist iceboating photographer

46. Float in the Dead Sea
Rana Tabello – Mövenpick Resort & Spa Dead Sea

47. Dine in the Ithaa Undersea Restaurant in the Maldives
Katherine Anthony – Conrad Maldives Rangali Island

48. Waterski Indian-style in Kashmir
Midhun Menon – waterski participant

49. Cruise on a houseboat in Kerala
Phil Crook – Brit resident in India

50. Relax at the Happy Magic Water Cube in Beijing
Matthew Niederhauser – international photographer resident in Beijing

I would like to say a special thank you to Alastair Maher who read and reread as I wrote and redrafted; and to my family and friends for their unwavering support and encouragement throughout the production of this book.

Index

A
abseiling 47
Africa 64–87
Alappuzha (Alleppey) 213
Alaska 6, 7, 90–3
Alcatraz 106–8
Alps 35–6, 49
American River 102, 104
Amhuinnsuidhe Castle 17
Amman 202
Andes 143
Antarctica 148–51, 190
Antigua 59
Arctic Ocean 92
Argentina 148–9
Arizona 6, 36
Ascension Island 64–7
Asia 184–219
Aswân 76–8
Atlantic Challenge 59
Atlantic Ocean 7, 58–61, 75, 128, 137
Aurora Borealis 52
Australia 6, 12, 154–7, 159, 166–9

B
B&B (Burger & Bed) 101
Baikal Ice Sailing Week 199
Baja Peninsula 132
Balboa Yacht Club 137
Balearic Islands 38, 40
Bali 185
Beagle Channel 149
Beijing 216, 218
Bemidji 121
big game fishing 130–3
Blue Hole 7, 84, 86
Blue Lagoon 50, 52–3
boat
 batela 44
 dugout canoes 159–60
 felucca 7, 76–7
 gepos 160
 gondola 43
 houseboat 212
 jetski 123
 lakatoi 160–1
 rigid-inflatable boat (RIB) 2–43, 149
 sailing canoe 160
 shikara 209
 tall ships 54, 56
Boddal 210
bodyboarding 94, 96, 175, 189–91
bog snorkelling 7, 10–13
Bog Snorkelling World Championships
 10–13
British Columbia 7, 98–101
Brooks Range 90
Broughton Archipelago 98, 101

C
Cabarete 126, 128
Cabo San Lucas 130, 132
Cala Ferrera 40–1
California 102–9
Canada 12, 98
Canary Islands (Canaries) 54–8
canyoning 7, 46–9
Cape Town 64–6, 70, 75
Captain James Cook 168
Caribbean 58–9, 111, 128
Channel Islands 7, 26–9
Chile 6, 142–5
China 192, 216–19
Chli Schliere 46, 49
climbing 38–41
Clipper Round the World Race 7, 192–5
clipper route 55
clipper ships 59
coasteering 7, 26–9
Cochin 215
Cocos Islands 138, 141
Colon 137
Colorado 114–17
Coral Sea 159, 167
Costa Rica 138–41
cruise 64–7, 148–51, 212–15
cruise liner 173
Culebra Cut 136

D
Dahab 84, 86
Dal Lake 208–10
Dead Sea 200–2
deep-water soloing 38–41
Dingle Peninsula 24
diving 72–5, 80–7, 170–3, 179
 freediving 84–7
 night diving 80–3
 scuba diving 80–1, 179
 with sharks 72–5
 wreck diving 170–3
dolphins 23, 56, 139, 155, 167
Dominican Republic 126–9

E
Egypt 7, 76–87
Espiritu Santo 170, 173
Europe 10–61
Everest 61, 202
Exmouth Peninsula 154, 156

F
felucca 7, 76–7
fish
 angelfish 207
 barracuda 81, 86, 207
 bonito 167
 dorado 59, 131–2
 lionfish 81
 marlin 131–2, 155–6
 moray eel 186, 207
 mullet 27
 parrotfish 81
 pufferfish 81
 rainbowfish 207
 roosterfish 131
 sailfish 139, 155
 salmon 14–15, 99
 shark 24, 72–5, 139, 167, 205, 207
 basking shark 24
 black-tip reef shark 205
 blue shark 73, 75
 cow shark 73
 great white shark 73, 75
 mako shark 73, 75
 seven-gilled cow shark 75
 snapper 207
 starfish 101, 167
 tilapia 213
 trevally 155, 207
 tuna 131–2
 wahoo 131
float and bloat trips 101
Florida 122
fly fishing 14–17
flyboarding 122–5
Flyboarding World Cup 124
Fort William 16, 21
Fox Glacier 162–5
France 28, 34–7
Franky Zapata 124
freediving 7, 84–7
freedom camping 101
Futaleufú River 6, 142, 143, 145

G
Galapagos Islands 139
Gansbaai 72
Gates of the Arctic National Park 92
Gatun Lake 136
geothermal crater 6, 110–12
geothermal lagoon 50–3
Gili Isles 184–6
glacier 162–5
Glen Nevis River Raft Race 18–21
Global Positioning System (GPS) 61, 69
Golden Gate Bridge 107–8, 193
gondola 43
gondoliering 42–5
Gouliot Caves 27–8
gourmet wilderness paddling 101
Grand Canyon 6, 36
Great Barrier Reef 166–8
Great Wall of China 218
Gulf of Aqaba 86

Gulf of Mexico 121

H
Happy Magic Water Cube 216, 218
Hawaii 94–7
heli-hiking 162–5
Himalayas 209
Homestead Crater 111–12
houseboat 212
Hydro Bronc 102–4
hydrospeed 175

I
iceboating 6, 196–8
ICEHOTEL 30–1, 33
Iceland 50–3
India 208–15
Indian Ocean 155, 190, 205, 207
Indonesia 184–91
inner tubing 7, 114–17
Interlaken 49
Ireland 22–5
Isle of Harris 14, 16
Israel 202
Isthmus of Panama 134
Italy 6, 42–5
Ithaa Undersea Restaurant 7, 204–7

J
Jellyfish Lake 179
Jewel Cave 27
Jordan 200–3
Jukkasjärvi 30, 33

K
Kashmir 208, 210
Kawarau River 174–7
kayak-camping 7, 98–101
Kelly Slater 96
Kerala 212, 213, 215
Kerry 23
kettuvallam 213, 215
kiteboarding 126–9
Kochi 215
Koror 179

L
La Gomera 55, 59
Lac de Sainte-Croix 34–7
Lady Musgrave Island 166–8
Lake Baikal 196, 198
Lake Itasca 119
Llanwrtyd Wells 12
Loch Ulladale 15
Longwood House 66

Louisiade Archipelago 158–61
Lüderitz Speed Challenge 6, 68–71
Luxor 77–8

M
Magharee Islands 23–4
Majorca 38, 40
Maldive Islands (Maldives) 7, 204–7
Manhattan 61
marine invertebrate
 box jellyfish 168
 Irukandji jellyfish 168
 jellyfish, mauve stinger 6
 manta rays 156, 167, 207
 Mastigias (golden) jellyfish 179
 octopus 81-2, 139
 Spanish Dancers 186
 stingray 139, 186, 207
Mediterranean (Sea) 35, 40, 78
Mexico 6, 130–3
Miami 122–5
Micronesia 178–81
Midway 112
military troop carrier 171
Milky Way 193
Minneapolis 121
Minnesota 118, 121
Miquel Riera 40
Mississippi River 118–21
monofin 85
Mumbai 210

N
Nagin Lake 209–10
Namibia 6, 68–71
Napoleon Bonaparte 66
New Delhi 210
New Zealand 156, 162–5, 174–7
Newfoundland 173
Nile 7, 76–7, 79
Ningaloo Reef 6, 154–6
North America 90–125
Northern Lights 33, 51–3

O
Oahu 94–6
ocean rowing boat 59
Oceanwise Expeditions 156
Olympic Green 216
Olympics 159, 197, 218
Outer Hebrides 14

P
Pacific Ocean 107, 132, 137, 139, 179, 192–5
packrafting 6–7, 90–3

paddleboard yoga 6, 110–13
PADI Advanced certificate 80
PADI Open Water certificate 75, 80–2
Pagosa Springs 114, 116
Palau 178–81
Palestine 201–2
Panama Canal 134–7
Panamax 135
Panapompom Canoe Regatta 158–61
Papua New Guinea 158–61
Park City Yoga Adventures 112
penguins 148, 150
Philippines 6
Polar Plunge 150
porpoises 59
psicobloc (or 'psycho-bouldering') 39
Puerto Rico 128

Q
Qatar 124
Queensland 165, 167–8, 176

R
Rangali Island 204, 207
rapids 7, 104
Red Sea 80, 82, 86
Reykjavík 52–3
rigid-inflatable boat (RIB) 22–5, 149
river wave 94
riverboarding 174–7
RMS St Helena 64–7
RMS Titanic 173
Robinson Crusoe 168
Rock Island archipelago 179
rowing 42–5, 58–61
Royal Mail Ship 64–5
Russia 196–9

S
Sacramento 104
sailing 7, 127, 161, 192–5
Sainte-Croix-de-Verdon 36
San Francisco 106–7, 108, 193
San Juan River 116–17
Sark 28–9
Scandinavia 33
Scotland 14–21
sea lions 101
Sea of Cortez 130–2
seal 24, 101, 148–9
 crabeater seal 149
 leopard seal 149
 Weddell seal 149
semi-submersible 167
Seven Hogs 23
seven natural wonders of the world 168

Seventeen Seventy 167–8
shark 24, 72–5, 139, 167, 205, 207
Sharm El Sheikh 80, 82, 86
Shelter Bay Yacht Club 137
Siberia 6, 196–9
Sinai Peninsula 82
'snice' 31, 33
snorkelling 75, 166–7
South Africa 12, 64, 72–5
South America 55, 130–45
Spain 38–41
Srinagar 208, 210
SS *President Coolidge* 170–3
SSI (Scuba Schools International) 86
SSSI (Site of Special Scientific
 Interest) 11
St Helena 64, 66
stand-up paddleboarding 118–21
Stockholm 33
submarine, recreational 138–9
surfing 94–7, 127
Sweden 30–3
swimming 6, 34–7, 106–9, 154–7,
 166–9, 173, 178–81
Switzerland 7, 46–9

T
tall ships 54, 56
Torne River 31
Tralee Bay 23
Turkey 104
turtle 66, 86, 167, 185–6, 205

U
Umberto Pelizzari 86
United States Coast Guard 104, 108
UK 10–21
USA 6, 90–125, 192
Ushuaia 148–9
Utah 6, 110–13

V
Vancouver Island 99, 101
Vanuatu 170–3
Vembanad Lake 213, 215
Venice 42–4
Venice of the East 212, 215
Venice, Louisiana 119
Verdon Gorge 36–7
Victoria Flats 163
VIVA Voga Veneta 44

W
Waen Rhydd Bog 10, 12
Waimea River 94–5
wakeboarding 127
Wales 7, 10–13
Water World Swim, LLC 108
water-skiing 127, 208–11
West Indies 55
Western Cape 72
whale 24, 59, 65, 99, 148, 150, 155, 167
 humpback whale 167
 killer whale 99
 minke whale 139
 pilot whale 24
 sperm whale 155
whale shark 6, 154–7
white-water rafting 6, 142–5
white-water sledging 175
white-water swimming 175
wild swimming 34–7
windsurfing 6, 68–71
wreck diving 170–3

Z
Zambezi River 104